EALING

A CONCISE HISTORY

EALING
A CONCISE HISTORY

JONATHAN OATES & PETER HOUNSELL

AMBERLEY

ACKNOWLEDGEMENTS

A number of people have helped in the creation of this book. Professor Brian Kemp read the first chapter and gave me the benefit of his knowledge of the Middle Ages; Paul Fitzmaurice, Paul Howard Lang, and Dr Piotr Stolarski and especially Dr Peter Hounsell read the whole text and made many valuable comments, as did Ian Potts for the final chapter. The pictures in the book are from the collection at Ealing Library, except those on pages 21 and 41. These are from the collection of Paul Fitzmaurice. This book is dedicated to John Curnow, a former Ealing resident.

First published 2014

Amberley Publishing
The Hill, Stroud
Gloucestershire, GL5 4EP

www.amberley-books.com

British Library Cataloguing in Publication Data.
A catalogue record for this book is available from the British Library.

ISBN 978 1 4456 3369 5 (print)
ISBN 978 1 4456 3381 7 (ebook)

Typesetting and Origination by Amberley Publishing.
Printed in the UK.

CONTENTS

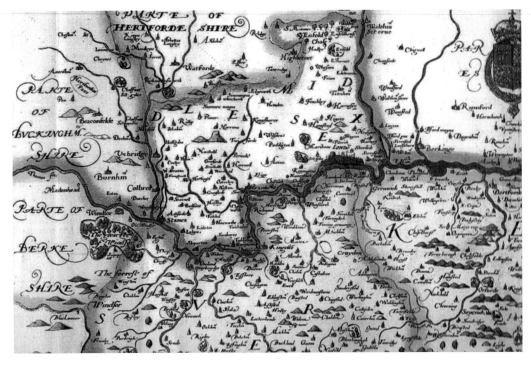

Map of Middlesex, 1575.

INTRODUCTION

Among the large and diverse collection of local history material at Ealing Library for which I am responsible, there is not a single one-volume history of Ealing from earliest times to more or less the present day. This is not to say that Ealing's history has been neglected – far from it. There have been weighty tomes that have dealt with it. At the end of the eighteenth century, the Revd Daniel Lysons included a chapter about Ealing in his multi-volume history of Middlesex. In the following century, Thomas Faulkner wrote about the history and antiquities of Ealing, Brentford and Chiswick. Another nineteenth-century history, which, for the first time, solely concentrated on Ealing, was by Edith Jackson. A few years later, at the dawn of the twentieth century, Ealing's veteran borough surveyor, Charles Jones, wrote two volumes of memoirs about his municipal achievements over the course of a half century.

There has been no let up in the past century, either. Cyril Neaves wrote a book on the history of Greater Ealing, of the parishes that made up the borough in 1931. After the Second World War, there was volume seven of the magisterial Victoria County History of Middlesex, which covered Ealing, Acton and Chiswick. Easier to follow was the thematic approach to Ealing's nineteenth-century history by Peter Hounsell in *Ealing and Hanwell Past* and, by the same author, a later volume, *The Ealing Book*, full of facts about Ealing's personalities, buildings and events, covering a rather wider time span. The very readable and popular *Ealing Walkabout* by Kate McEwan gave readers brief histories of all the districts in the modern borough, plus a large number of walking tours. There have been books about particular parts of the borough, such as Brentham and Little Ealing, and about particular topics such as the Second World War and local murders. Finally, there have been, since the 1980s, numerous books showing Ealing in old photographs (two by this author).

This book offers the reader, who may already have bookshelves groaning with the above works and others on Ealing's history, a concise account of (what seem to this author) the main events and personalities in Ealing's history, from earliest times to the beginning of the twenty-first century. The definition of Ealing taken here is the district of Ealing, and later the borough, covering the modern postcode districts of W5 and W13. It does not include those parishes and boroughs that were incorporated into Ealing in the twentieth century (Greenford, Hanwell and Perivale from 1926, Northolt in 1928, Acton and Southall from 1965).

Nor does it include Brentford (including Gunnersbury), part of Ealing parish until 1863, unless separation is indiscernible. It should be noted that the parish of Ealing, established in the Middle Ages, included Brentford as well as Ealing, but was known by the latter name. It was divided into the upper and the lower parts (presumably based on the fact that Ealing was higher than sea level compared to the lower adjoining the Thames), with Ealing proper being

the upper part, and Brentford and Gunnersbury being the lower part. Inhabitants from both districts shared the parish church of St Mary's, which was roughly in the centre of the parish.

However, the book is not parochial. Ealing was not an island. External events, such as the reformation, civil war, plague, wars and immigration, all had an impact on Ealing and these will be recorded and discussed. Ealing residents often worked elsewhere or had dealings with those in London and further afield. It will also deal with the interaction between Ealing and larger bodies of which it was part – namely Middlesex and London — and will address the changing nature of Ealing's identity.

This is a story of both the famous and the less well known. There is a place for the world renowned Ealing Film Studios, of course, and those celebrated men and women such as Henry Fielding, Lady Noel Byron and Fred Perry, who have resided, however briefly, in Ealing. But it also concerns many less well known individuals, those who made Ealing, not the world, their canvas. These include parish officials, clergymen, diarists and civil defence workers.

Ealing has a rich history, from its origin as a Saxon settlement, to its being a haunt of the gentry and even royalty in the eighteenth century, Queen of the Suburbs at the turn of the twentieth century and a centre of Swinging London in the 1960s. This book examines all these centuries but particularly the twentieth century in three of its seven chapters. Given a greater and more diverse population, there was more activity, but also, it is precisely this century that has been relatively neglected hitherto. The structure is basically chronological, dealing with administrative, social, economic, political and religious history, and, where relevant, military history. The chapters have been divided mostly by changes in local government structure and then by theme.

This history relies on a myriad of sources, many of which have been underused. Firstly, there are the specialist studies, both published and typescript. Then there are the records made by individuals' memoirs, letters and diaries. Official records made by the parish, borough, county and government are used. Other contemporary published material, newspapers, directories, county and borough guides are utilised, too.

It is probably worth spending a little time at this stage to comment on Ealing's geography, since this helped shape its destiny. As Bismarck observed, 'History changes but geography stays the same'. Ealing was a large district, covering almost 3,000 acres in 1901. This made it far larger than its neighbours (Brentford and Hanwell possessing about 1,000 acres apiece, for instance). It also, since the Middle Ages, straddled one of the two main roads from London westwards and was only 7 miles from the capital's centre. Most of the land to the south of Ealing is flat, and even when it rises, at Hanger Hill and Castlebar Hill, neither is particularly steep. Although no rivers run through Ealing, it is bordered to the north by the Brent. Ealing is bordered by Brentford to the south, Hanwell to the west, Perivale to the north and Acton to the east. The implications of these geographical facts were not immediately apparent until the nineteenth century, but they enabled Ealing to enjoy good modes of communication and transport, and to be potentially densely housed and populated by the early twentieth century.

We will now start at the beginning, at a time when Ealing as we know it did not exist, and then work our way forward in a chronological fashion. This history does not pretend to be comprehensive, but as a survey outlining what seem to this author to be the major events, developments and personalities that shaped Ealing's history and may well help guide its present and future.

A note on money: until 1971, England's currency was measured in pounds, shillings (abbreviated to *s*) and pence (abbreviated to *d*). Twelve pence made up one shilling and 20 shillings were in a pound.

1

EALING'S ORIGINS TO 1601

Unlike the New Towns of the post war decades, it is impossible to point to a year (or even a century) and state with certainty when Ealing commenced its existence as a settled community. Much the same can be said about most English villages and towns. Many are first recorded as such in the under-documented centuries of Saxon rule, from the end of Roman Britain in the fifth century to the Norman Conquest 600 years later. In Ealing's case, the settlement is first noted at the end of the seventh century, but this does not necessarily equate with the beginning of its existence.

So perhaps we should first turn to Ealing's prehistory. There is certainly some evidence of human life in the district later to be called Ealing. Flints have been found under what was later Ealing Common and near the later roads – The Grove, Grange and Beaconsfield. These were created by Stone Age men, but even their approximate age is disputed. Fragments of pottery were also found under the Common. Whether these traces equate to a settled community or to nomadic hunter-gatherers is uncertain, though perhaps the latter seems more likely.

Moving on to the centuries following Christ, there are indications of a Roman presence to the west of their British capital of Londinium. But there were no forts or towns here, so close to London. What has been found are six Romano-British funeral urns, made of Samian ware, and a rare golden coin of Macedonian origin, dating from the second century BC. Again, this may be evidence of a small settlement, perhaps of limited duration. Yet most of what is now Ealing was probably covered with woodland.

It seems certain that the first fixed human habitation in what became Ealing took place in Saxon times. It was first recorded as Gillingas, part of the manor of Fulham owned by the Bishop of London from the late seventh century. The extract from the relevant deed (dated between AD 693 and 703) reads as follows:

In the Name of the Supreme God,
I, Ethelred, King of the Mercians, with the consent and permission of my councillors, give to you, Bishop Wealdhere, a portion of land in the place which is called Gillingas, that is, ten hides for the increase of the monastery in the City of London.

It has been surmised that the name Gillingas is derived from words meaning 'the people of Gilla'. However, from the seventh to the thirteenth centuries, nothing is known of Ealing's history except for the first reference to the parish church, though we can deduce that the Saxons chopped down much of the woods, built houses, ploughed the land and worshipped

God. Ealing was part of the larger territorial unit founded by the Middle Saxons from a least 704, known to us as Middlesex.

Over the next few centuries, the place was spelt variously in documents: Gilling in 1243 Yellynge in 1307 and Yelyng in 1512. It was only in the sixteenth century that an approximation to the spelling as known today was used: Elyng in 1553. Likewise, the names given to the districts that made up Ealing varied widely over the centuries: Fordhook was Forthehoke in 1462, Hanger Hill was Hangrewode in 1393. However, Drayton Green was Dayton from 1387, Northfields was Northfeld in 1455 and Pitshanger was Pittleshangre in 1294.

There was no record of Ealing in the Domesday Book of 1086. This was because the Norman survey only recorded manors and Ealing was not a manor in its own right, but part of that of Fulham. This manor, which included Acton, Brentford and Chiswick, contained 12,187 acres and perhaps had a total population of 830. The entry in *Domesday* for Fulham notes that the manor included land held by foreigners (Frenchmen?) and burgesses of London, as well as at least thirty-four villeins (unfree tenants) and twenty-two cottagers, who were free. There was meadow for forty ploughs and wood for 1,000 pigs. During Edward the Confessor's reign (1042–1066), it had an annual value to its manorial lord of £50, but was now rated at £40, perhaps suggesting that some of the manor had been damaged during William's Norman invasion of 1066. It was one of many manors held by the Bishop of London.

Ealing was not just one settlement, but several. The main one was centred around the church and therefore known as Church Ealing in the thirteenth and fourteenth centuries To the west was Drayton Green, first named as an entity in 1387, which grew up around a large house. West Ealing was first recorded in 1234, though was known as Ealing Dean in 1456. To the north of the main settlement was Pitshanger Park, called Putleshangre in 1222. Finally, to the east, bordering with Acton was Forthehoke.

It seems that Ealing became a manor in its own right in the fourteenth century, for its manorial courts were held from at least 1382. It was centred on Ealingbury, its manor house near Gunnersbury Lane by 1422. The bishop, as with most lords of the manor, was absentee and leased the land to farmers and derived an income from them. The known leaseholders include Robert Eustace and his son, John, in the fourteenth and fifteenth centuries. William Honyng of London, servant to Sir Thomas Wriothesley, a senior politician, was leasee in 1539.

Then there were the submanors, leased either by the bishop directly or by the holder of Ealing Manor. West Ealing or Coldhall existed from at least the fourteenth century. Another was Pitshanger Manor (not to be confused with Pitzhanger Manor House), which was to the north of Ealing, from Hanger Hill to the boundary of the Brent. This was named after the Putelshanger family in the thirteenth century. The manor house was Pitshanger Farm House, which stood near to what is now Meadvale Road, off Pitshanger Lane.

Apart from the manors, there were other landed estates in Ealing, mostly smaller in acreage than the manors. North of the main road was Castlebar Hill, a 90-acre estate. It was first recorded in 1423, when Richard Barenger was the landholder. To the west of Ealing Common was the Elm Grove estate, which included woodland, and belonged to the Frowyks in the fifteenth and early sixteenth centuries.

In the Middle Ages, local administration was in the hands of the manorial courts, which dealt with property disputes, inheritance and payments due to the lord of the manor, and also minor criminal matters. They were held in Fulham from at least 1383, twice a year

They also appointed officials to carry out the decisions of the manorial courts. A constable was appointed for Ealing in 1492 and, in 1509, one was nominated for Little Ealing. From 1522–1834, a constable, two headboroughs (deputy constables) and an ale taster were annually appointed, in order to deal with infringements of both the law and to determine that local brewing was of an acceptable standard.

Most economic activity in the Middle Ages in Ealing was agricultural and chiefly arable. The crops sown from the fourteenth to the sixteenth centuries varied. Rye, wheat and maslin, and later oats, seem to have predominated. Yet around three quarters of farmers were probably subsistence farmers; a survey in 1527 showed that of seventy-nine households, nineteen had surplus supplies of grain but sixty had not. There was also livestock farming. Yet by the sixteenth century, arable farming was on the decline, as more land was used for meadow and animals. There were also grazing rights on the common land, but these rights were contested. Market gardens and orchards existed from the sixteenth century. Some men had mixed farms; Simon Baringer, a yeoman in 1551, left his wife two oxen, three horses, twenty ewes, twenty lambs and 16 acres of wheat and oats. The proximity of London meant that there was a ready market for any surplus agricultural produce, especially hay for the numerous horses of the capital, whose population was approximately 100,000 in 1550.

Yet not all residents were involved in farming. Known medieval Ealing craftsmen included a tailor, a carpenter, a ploughman, a smith, a chapman, a tanner, a painter, a scrivener, a baker and a thatcher. In the fourteenth and fifteenth centuries, there was a mill that had to be rebuilt on at least one occasion. All these were essential adjuncts to the agrarian economy.

But Ealing was not wholly caught up with its own concerns. There were residents who had dealings with the wider world, especially in London. John of Bristol, an Ealing resident, though probably not a native, was involved in a number of transactions with Londoners. In 1344, he was owed £20 by John de Brauncestrai, a London goldsmith, but in following years it was he who was the debtor. In 1346, he owed John de Ilkelyngham, a London tailor, £40, and Roger Belet, the Queen's butler, £50 in 1350. John Ponde, a fifteenth-century Ealing fisherman, had dealings with Thomas Ayleward, an Enfield maltman. William Broune of Drayton owed £13 9d to London merchants in 1360. Several other Ealing men did business in London in the mid-fifteenth century too: John Botelier, a painter, Robert Baister, a baker, Thomas Homade, a scrivener and John William, a chaplain. In their cases, their fates were unhappy; they were found guilty of high treason in 1443 and hung, drawn and quartered, with their heads put on London Bridge. Another was Richard Amondesham, an Ealing landowner and merchant in the late fifteenth century. He and his large family are commemorated by a brass in the parish church with the following inscription, 'Hereunder lyeth Richard Amondesham, otherwise called Awnsham, some tyme mercer and marnchaunt of the staple of Calys, and Kateryn, his wyff, on whose soules Jesus have mercy.' Finally, there was Sir John Spellman, who was on the commission that tried Sir Thomas More and Anne Boleyn's alleged lovers for treason in the 1530s.

For these men, communications were important. The road passing through Ealing was called the Oxford Road in the Middle Ages, and roughly formed the route that the current Uxbridge Road follows. On two occasions in the fourteenth century, money was collected locally for its upkeep. Yet travellers little noticed Ealing at this time. There were no known inns to tempt them to stop there until later centuries.

The most important institution that governed the lives of residents was the Church – to a degree unthinkable in our less devout age. The Church was not just for baptisms, marriages, burials and Sunday worship, but also involved in what would now be regarded as secular matters. Ealing undoubtedly had a church in Saxon centuries. Its origin is unknown, as is its location, though it was probably on the site of the present parish church of St Mary's. There was certainly a stone church there in 1130; in that year, its first rector, Henricus Radulphus, is recorded. Although there are no pictures of this church, a little is known about it. In the fourteenth century, it is recorded as having a chancel, nave and north aisle. At least by the end of the fifteenth century it had a bell tower, and there was also a rood screen and a feretory (a reliquary) at that time. There was an image of the Holy Trinity there by 1504. In 1446, the church was known as St Mary of the Assumption.

The rector was the clergyman who collected the income from the church's lands and its parishioners, and was responsible for the provision of a priest to supervise the benefice. Until at least the eighteenth century, it was common for the rector to be possessed of several parishes, and to employ another clergyman (a curate or vicar) to run the parish on his behalf. The first known resident vicar was Gerard de Aylesbury, but nothing is known of this Buckinghamshire man, except that he was vicar in Ealing in 1315, and presumably of French descent. In 1308, the resident clergyman, then termed the 'perpetual curate', received £10 per year or a third of the profits accruing to the church lands in the parish (namely from several fields, animals, woodland and the tithe – a tenth of the incomes of secular manorial tenants). However, there was controversy between the clergyman, the bishop and the chancellor of St Paul's Cathedral (the diocesan administrator) in 1315, over the division of the income. It was decided that the vicar would receive a house to reside in, and income from the tithes from the villagers. In return, he was to maintain the church's 'books and ornaments', as well as to keep the church in a good state of repair. In 1536, the vicar's annual income amounted to £13 6s 8d.

The resident clergyman lived from 1315 in the vicarage, which was probably on the site of the later vicarage, to the east of St Mary's Road, between what were later the Park and Warwick Roads. There was also a building, known as Church House in 1492, which was designated to the relief of the poor, and which was still in existence in 1547.

We know virtually nothing about Ealing's medieval vicars until the sixteenth century, apart from their names and, mostly, the dates of their incumbencies. There was certainly a high turnover between 1372–1400, when six are listed, though Baldwin Bagatour was vicar from 1407–37. Richard Burton, a late fifteenth-century Ealing vicar, had attended Cambridge University. Of the rectors, the best known was Thomas Bradwardine (c. 1290–1349), who was briefly Archbishop of Canterbury in the last year of his life, but we cannot be sure he ever visited this one of his many parishes.

Ealing's vicars in the sixteenth century are a little better known. Thomas Rycroft (1530–82), vicar from 1562–82 and his successor, Thomas Knight (1547–1604), vicar, 1582–91, had both been educated at St John's College, Cambridge. Neither seems to have held another incumbency at these times, so possibly both lived in Ealing. Another vicar, the Revd Oliver Stoning, educated in Oxford, appears to have been non-resident as he was also rector of St Peter's, Paul's Wharf in London.

During the sixteenth century, there were revolutionary changes to England's religion, as the blast of the Protestant reformation was felt throughout Catholic Europe. Henry VIII

broke from Rome and founded the Church of England, with the monarch replacing the Pope as its head in the 1530s. This led to the dissolution of the monasteries in the same decade. The established Church became Protestant under his son, Edward VI. Yet there is no evidence that this had any sudden impact on Ealing itself. Men continued to write Catholic sentiments in their wills in the 1540s, with phrases such as, 'to our Lady Saint Mary the Virgin, his glorious Mother and all the holy company of Heaven'. Yet in the 1550s, these phrases were shortened and disappeared altogether in the next decade, symbolising the triumph of Protestantism over the old religion.

While Henry VIII had been content to suppress the large religious houses, the more radical Protestant government of Edward VI was eager to take the reformation to its next step. The parish churches were targeted by the church commissioners because of their internal ornamentation, which smacked of the Catholic ritual they were determined to stamp out. St Mary's church in Ealing was no exception. On 10 March 1552, the boy king's commissioners visited the church and there the vicar gave them no trouble, as the men recorded that they made the valuation as being 'by the consent of William Harvard, clerke, Vicar of the same parysshe'.

An Act of Parliament of 1550 decreed that all images, which were commonplace in pre-reformation churches, be removed. The commissioners took all such ornamentation and sold them to various City merchants, such as a goldsmith and an iron founder. As far as is known, this all passed off peacefully without any public protest, as sometimes occurred in places more distant from the seat of power.

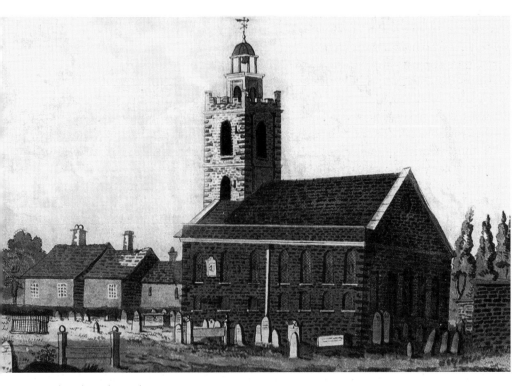

St Mary's church, eighteenth century.

Yet local adherents to Protestantism may well have been afraid following the fates of six men in Brentford in the summer of 1558. In one of the last of the public burnings in the Catholic Mary's reign, the Butts in Brentford saw the burning at the stake of six Protestants, who refused to renounce their faith and return to the Catholic fold. One man was from Ipswich, but although we don't know where the others came from, it is likely that none of them were local.

Because of the fortuitous creation and survival of a late Elizabethan census, we have a detailed snapshot of Ealing's people at this time. In 1599, there were 426 residents divided into 85 unequally sized households. At the top of society was Edward Vaghaun, a fifty-eight-year-old Justice of the Peace, and a deputy clerk of the pipe in the Exchequer. He lived with a sizeable household. There was Elizabeth, his fifty-two-year-old spouse, and a staff of four clerks, presumably to assist him in his official duties. Then there were thirteen servants. These included a butler, a cook, a coachman, a gardener, a bailiff and a waiting gentlewoman. One of the servants was an orphan, kept out of charity, and we will learn more about Vaghaun's benevolence in the next chapter. Another servant was Mrs Vaghaun's niece. Two other men there helped farm Vaghaun's land.

There were three other significant households. One was that of the vicar, Dr Richard Smart, a widower aged fifty-four. He lived with his four adult children, including the wife of one of his sons, though they only had one servant. Dr Lanckton, another resident of note, lived with his wife and seven servants. Finally, there was Thomas Harward, who lived with his elderly father and ran a private boarding school for boys in his presumably large house. There were eighteen scholars, aged between six and seventeen years; they were mostly the sons of gentlemen, though some were the offspring of merchants and farmers. This is the first known school in Ealing. At the other end of the social scale was Mrs Collyns, a forty-three-year-old widow who lived alone, and Elizabeth Talbot, aged thirty-six, and her son, Paul, aged seven.

Most of Ealing's residents lived in fairly small one-family households. In 1599, eighty-two of such people were employed in agriculture, as we would expect given the basis of the local economy. One such was John Taylor, a twenty-five-year-old husbandman, living with Agnes, his wife, and her son, Thomas Butterfeld, aged seven, presumably from a previous marriage. There was also a miller and a shepherd. Apart from those in the larger establishments already mentioned, thirty-three of Ealing's residents were employed as domestic servants. There were also a few craftsmen: two tailors, a smith, a bricklayer, a carpenter and a wheelwright. Again, one would expect these in a rural society, but two men had distinctively unusual occupations. One was a Yeoman of the Guard and another Her Majesty's mole catcher.

The population was relatively small. In 1527, it numbered 320 and in 1599, 426. Some of this increase can almost certainly be attributed to people moving to Ealing to live; the natural growth rates otherwise seem stable. Between 1582 and 1592, there were 298 births, but there were also 290 burials (these figures also refer to Brentford). People often died young as evidenced by wills leaving property for children who had not reached maturity. In the 1599 census, the oldest resident was aged sixty-one 'or thereabouts', and that was Richard Philips, a gentleman. There were also few marriages in the parish church, an average of six per year in the first five years (1582–87) for which parish registers survive.

It also appears to have been a respectable, law-abiding place, if the assessment by Richard Phillips, the constable, and William Gernall, the headborough, in 1599, is accurate. Although there were no inns, there were two premises that sold alcoholic beverages. Yet the two local officials stated, 'We think them that inhabit them honest persons for they are of good name and fame.' Gambling and plays were thought to be unknown. Everyone went regularly to church (not to do so for adults was then a fineable offence); there were no local Catholics or Puritans. There had been no crime of late, though two decades earlier, one Edward Smythe, gentleman and James Darker, yeoman, both of Acton, stole a dun mare of one Mary of Ealing. The two miscreants were captured and tried. Both were sentenced to death by hanging. Luckier was one Thomas Doland, an Isleworth man who stole a horse from John Bukworth of Ealing, for he was pardoned.

Nor were there any vagabonds who had not been dealt with (presumably sent on their way). As for the local poor, all was as it should be. The aged and unwell were 'provided for by a assessment heretofore among us made and weekly collected and paid over by the overseers and churchwardens to them'. Those who were in need and able to work were given employment. Of course, it is arguable that the officials may have made such a rosy assessment in order to avoid any harsh reflections being made upon them.

Apart from any public assistance, there was also sporadic help given to the local poor from private individuals. It was commonplace for wills to leave money for charitable purposes. Robert Ingham, a fishmonger of the City of London who resided in Ealing, in his will of 1556, directed that 'xii [12] gowns of mantel frize vi [6] for men and vi for women which men and women shall be taken out of the parish of Ealing and Braynforth [Brentford]'. He also instructed the executors to distribute a penny to twelve poor people each Sunday. Thomas Skelton, a husbandman, left 6s and 8d to the 'poor man's box' in 1563. Symon Richardson of Drayton, a labourer, left, in 1556, a bushel of malt 'to the poor people of Ealing'. Joan, wife of Sir Thomas Frowyk of Ealing, left 4d to lepers in Hammersmith and other lazar colonies, in return for masses to be said for her soul, in her will of 1504.

From the origins of Ealing as a fixed settlement by the end of the seventh century, the place had grown to become a series of settlements, with the largest centred around the parish church to the south of the main road. It was very sparsely populated, but was not isolated for, though most of its residents worked on the land or as servants, a significant minority had interests in London and elsewhere and as a result, were, anachronistically, commuters.

2

THE EMERGENCE OF THE PARISH, 1601-1729

Seventeenth-century Britain was a time of national crises: plague, religious strife, civil wars and revolutions. These affected Ealing, too, and we will explore these before turning to the more peaceful activities of the era.

Religion was an overarching concern in the seventeenth century, just as it had been in the sixteenth. Conflict between differing strands of Christianity was one reason that led to war in 1642 and revolution in 1688, as well as to numerous political crises at other times. Government was Anglican (except during the 1640s and 1650s), which led to conflict with Protestants who did not recognise the monarch as their head. The Catholic minority was often hated and feared, and though persecution was enshrined in legislation going back to the sixteenth century, it tended to be intermittent in practice.

Even so, we hear locally of Sir Christopher Roper, who did not attend St Mary's church (he was a Catholic), being fined from 1613-17. Another Ealing notable, the Earl of Argyll, was similarly fined in 1638, as were, two years later, Mrs Woolsey, wife of a yeoman, and John Penruddock, a gentleman and resident in Ealingbury. These people would have worshipped outside Ealing, for there were no Catholic churches in Ealing until the late nineteenth century, and no Catholics were recorded as being resident here in the early eighteenth century.

Although the Revd Edward Abbot, educated at Balliol College, Oxford, vicar from 1611-16, seems to have been resident and moved to a London parish on his resignation from Ealing, most Ealing vicars at this time were not resident, as had been the case in earlier centuries. Richard Taverner, educated at the same college as Abbot, was vicar from 1615-38. Yet he was absent at times, for in 1634, Edmund Lyneold lost his living because of his 'long continued inconformity to the rites and ceremonies of the Church of England … as yet unresolved to conform'. Presumably he may have had puritanical leanings. After Taverner's death, Elizabeth, his widow, had a plaque erected to him in the church, with the following text: 'I had rather be a doore keeper on the House of my God than to dwell in ye Tents of wickednesse.' A skull and crossbones was part of the plaque.

As tensions between Crown and Parliament rose during Charles I's reign, one measure that exacerbated them was the imposition of the Ship Tax in 1635, to pay for coastal defence. In 1638, the collectors appointed in Ealing were Messrs Maynard, Waller and Ivory. They were summoned to appear in September of that year to account for their low collection rate. They explained that many people had left the district so as to avoid payment of the tax, and that 150 of the poorer residents were unable to pay.

The direct impact of the Civil War on Ealing is unknown. Certainly there was a bloody battle at Brentford in November 1642, between Prince Rupert's Army and the defending Parliamentarians. The latter were routed, but the King's Army could not pass the Parliamentary defenders at Turnham Green, who forced them to turn away from the march on London and retreat. Inevitably, there was damage to civilian property in Brentford, but how far this spilled over to Ealing proper is unknown.

St Mary's was also the centre of disputes. As with many Anglican clergymen in the 1640s, the vicar since 1638, the elderly Revd Robert Cooper, was ejected from his benefice in 1645. This was because the county and national authorities saw many clergymen as being loyal to the monarch and thus disloyal to the Parliamentarian cause, which was in rebellion against the King. Given the influence of the clergy over their parishioners, this could not be allowed. There was probably local animosity towards Cooper and his cause, as there was a reference to local 'malcontents' acting against him. One Daniel Carmarthen had replaced Cooper and, in the parliamentary survey of that year, he was noted as 'an able and honest preaching minister'. Because the bishops had been abolished following the defeat of the royalist cause, church patronage passed to other hands; in this case the right to appoint the vicar and a lecturer (the latter being worth £40 per annum to the incumbent) had been leased to Thomas Lidcott at £22 per annum. At this time, the vicarage had 60 acres and a total income of £350 per annum, mostly made up of tithes. Carmarthen did not last long in the post and in 1651, Thomas Gilbert, a Scottish Congregationalist, was vicar. He was not wholly popular. Hugh Cotton, an Ealing cheesemonger, was bound over on behalf of John Smith 'for questioning, disturbing the minister of Ealing aforesaid in the time of publique and divine service' in 1655.

These years were also difficult for Sir John Penruddock, a Catholic landowner. It was claimed in 1653 that 'In 1642, before the war, [he] had his houses in Ealing, Middlesex … plundered and destroyed' but it is unknown why this was so. Possibly an anti-Catholic crowd may have been responsible. His estate was seized by Alderman Francis Allen of London by 1654, and his tenants petitioned the government concerning their rents paid to Allen.

The return of Charles II in May 1660 resulted in the 'intruded ministers' being in their turn ejected. Gilbert was required to attend the Quarter Sessions in October 1660 and to read from the Book of Common Prayer. Not being Anglican, he refused and was turned out by the end of the year. The young Revd William Beveridge (1638–1708) was instituted Vicar of Ealing in January 1661. As with many Ealing clergymen, he had been educated in St John's Cambridge, and remained vicar until 1671. He was a great scholar and wrote much in Greek and Latin, some of these books being published when he was in Ealing. He finished his career as bishop of St Asaph's in Wales. Another scholarly clergyman – also from St John's - was Dr Thomas Mangey, vicar from 1719–52. Although he held a senior position at Durham Cathedral, he was occasionally resident in the parish as evidenced by his signature in parish accounts in 1720 and 1725.

Not everyone approved of the new order in church and state. On 7 June 1662, Thomas Anderson, a baker, and Elizabeth Lawrence, a widow, both of Ealing, were bound over to keep the peace for £40 apiece. Their crime? Speaking the following words before a witness, namely, 'the Kinge's Majestie [who] is dead was lawfully put to death and that his sacred Majestie [Chares II] shall not raigne one year'.

More dangerous, it was thought by those in authority, was Nicholas Cordey of Ealing. During the civil wars, he had been a captain in Colonel Baxter's regiment of the Parliamentary Army. In 1664, a republican plot had been unearthed in the north of England and Cordey was seen as a potential supporter. This was despite the fact that he had taken an oath of allegiance to the new King and appeared to be living peaceably enough as a chandler. He was questioned, nonetheless as to whether he had had any correspondence with the plotters. Cordey claimed he had had nothing to do with Baxter since he left the army and was wholly innocent. It seems he was left alone after that for he is listed as living in Ealing for some years hereafter.

After the Restoration of the monarchy and bishops, laws were passed against the Nonconformist sects that had flourished under the republican regime. Chapels were deemed illegal. Nonconformist ministers had to stay 5 miles away from any corporate town (as London counted as one, some lived just outside, in Acton and Ealing).

One well-known Nonconformist was John Owen (1616–83), who had moved to Ealing Towne by 1680. He had been a leading Nonconformist in the 1650s, as vice chancellor of Oxford, and earlier, he had ministered to Cromwell's troops. Because he endorsed the right to take up arms to defend religion and allegedly did not mention the King in his prayers, as well as being prosecuted for breaching anti-Nonconformist legislation, he was deemed a suspicious character. In 1683, he was arrested over his possible involvement in a conspiracy against the King's life known as the Rye House Plot. Although it appears that he was aware of it and knew many of the plotters, he was never tried due to lack of evidence. He claimed his trips to London were to see his doctor due to kidney stone problems. In any case, he died later that year. Other Nonconformist ministers are noted as being in Ealing in this period: Gabriel Sanger in the late 1660s, who was on the run from the law, and later, a more fixed resident was Matthew Sylvester in 1693.

In any case, towards the end of the seventeenth century and the beginning of the next, the threat to the government and monarchy came from a different quarter. Ealing residents were aware of these turbulent times when, in 1688, the Protestant William of Orange's forces marched through Ealing. Soon afterwards, the Catholic James II had been exiled and William became William III. On 27 December, the 480 horses and men of the Dutch Horse Guards were encamped at Ealing, Chiswick and Fulham; on the following night, the 156 men of Obham's cavalry were at Ealing, Chiswick and Brentford. This 'Glorious Revolution' did not pass smoothly. Following rumours of a plot to assassinate William on Turnham Green in 1696, there were orders to have Ealing and Acton searched for any of the former King's supporters (known as Jacobites), though none are known to have been found. In 1715, a major attempt was made in England and Scotland to overthrow George I by James II's son. Although there was no whiff of conflict in Ealing, the bells of St Mary's were rung to celebrate the anniversary of George I's birthday and his Coronation. On 7 June 1716, the national day appointed to celebrate the defeat of the rebellion, Ealing's church bells also rung. When the king returned from his native Hanover in 1719, the bells rung again. Clearly Ealing identified with the existing monarchy against his Jacobite rival, probably on religious grounds.

Much of Ealing's history in this time was more settled. The major development in the seventeenth century was the emergence of the parish as the principal unit of 'local government', displacing the manor, though that still remained important concerning the holding of manorial land and the appointment of the constables. This was because

the Tudor and Stuart governments passed laws that placed the bulk of what we would now call 'local government' on the existing parish structure. For the next two to three centuries, the parish was not only a religious institution, but the lowest level of the State, and the one that more people would come into contact with – certainly far more than the national or county government (in the hands of the Middlesex Quarter Sessions until 1889). The sessions were the next rung of government above the parish, and could arbitrate between parishes as well as deal with criminal matters. The parish of Ealing included Ealing proper, of course, and the more populous but more geographically compact and populous Brentford (which included Gunnersbury), and these were usually delineated as Upper and Lower, respectively.

Overseeing parish affairs was the vestry, who met at least twice a year at Cross House, just north of St Mary's church (a former water fountain now stands on part of the site) to decide on how much money in the form of rates they would need from the ratepayers, and to appoint the unpaid officials who would serve for a year. These were two churchwardens, who dealt with the upkeep of the church fabric, and two overseers, who had the more onerous task of dealing with the parish's poor. Sometimes men would serve for two years, such as John Cromwell and Francis Batt, who served in both 1674 and 1675, whereas John Bates was churchwarden in 1692, having been overseer in 1688. William Atlee was a churchwarden in 1640, and the Atlee family continued to serve the parish in various capacities for the next three centuries. In 1702, George Friend and Thomas Filtch were both churchwarden and overseer. Generally speaking, though, the men who were the churchwardens were more affluent than those who were the overseers. Between 1675 and 1712, the churchwardens included a bricklayer and a flaxdresser, but, significantly, four gentlemen, whereas one overseer was a publican and the other a butcher.

Twice a year, the vestry decided on how much in the pound of rateable value each property owner in the parish should pay. In 1707, a rate of a shilling in the pound raised £130 5s from Ealing rate payers and £106 11s from Brentford ones. The overseers then had to collect the money 'for and towards the necessary reliefe of the poor of the said parish'.

The principal business of the parish was to pay for the care of the parish's poor. In part, this was to ensure that those who were entitled to relief received it, but those to whom relief was properly paid out elsewhere were sent there. A parish out paid to those who were legally settled within its boundaries – those who were born there or married a resident, or had been employed there for a set length of time. Those not meeting these criteria were given marching orders and no relief, and this sometimes resulted in arguments between parishes over the responsibility for payment. In these cases, the arbitration of the county sessions was required.

In 1690, Judith Weaver and her child from Kensington claimed legal settlement in Ealing, but the churchwardens contended this, though the result is unknown. A successful case, from the viewpoint of the parish of Ealing, occurred in 1693. Edward and Eleanor James and their two sons were returned from Ealing to Spitalfields. A different outcome was arrived at when John Chapman and his family, who had lived in Harrow in 1694 and were returned to Ealing. Women with settlement rights, but no income, were reluctantly provided for, though at times the parish had to be ordered to do so by the quarter sessions. In 1615, Sybil Harryson and the husband of Agnes Rogers absconded, leaving the said Agnes and her children, whom the parish was forced to support. Two years later, Dorothy Carter could prove she had resided in the parish for a year and half; again, the parish relieved her.

The relieved parish poor were obliged to wear badges to show others that they should not be given private charity. Not wearing the badge meant that public assistance was cancelled, as widow Gowan found to her cost in 1727. Legitimate objects of parish relief were treated otherwise, however. Craftsmen were paid to take poor children to be apprenticed and learn a trade. William Ludlow was apprenticed to Jonathan Stevens, of Ealing, a brickmaker, but was discharged. John Ravenor, a 'poor parish child' was apprenticed to James Ravenor, a butcher, in 1712. Other costs met by the overseers included, in 1674/75, paying for shoes and clothing for needy children, paying a midwife 2s 6d, and paying 9s to hire a cart to take one Robinson's corpse to the grave and then for a coffin and burial expenses. A family was given 10s 9d for bread, and a shilling given to Mrs Harmon, who was 'in distress'. Payments were made to those suffering from sickness (often termed 'in distress') in body or mind – Mary Attlee was in receipt of several shillings for 'being lunatick' on several occasions.

Apart from one-off payments, there were regular weekly pensions paid to the elderly, most of whom were inevitably female, and these were noted frequently. Many suffered from sickness, lameness, blindness and 'old age, deafness & poverty'. In 1727, they ranged from 4s to 12s, and were given to eleven women, five of whom were widows, and one man. In 1723 it was ordered that 'the widd Evans be settl'd upon the pension att 5s per week by reason her husband being Dead and she having three small children and not able to maintain her self & family without the said pension and that she has the said pension so long as the parishioners shall seem most meet.'

The other regular set of payments were to local women who received small children from the overseers of other parishes, perhaps in central London, and for a fee, looked after them. This was probably because it was thought that the air in rural Ealing would be more beneficial to the children's health. In 1727, there were four nurses, paid between 6s and 8s per month, presumably depending on how many children they cared for.

The travelling poor were assisted on their way with small payments. Of particular importance were pregnant women (often Irishwomen), whom it was important to move on lest they give birth in the parish and so become a permanent liability by gaining settlement rights. Sarah Jones was travelling to Tooting in 1727 and passed through Ealing. She appears to have fallen ill and so was given 7s and 7d for lodging, and then 1s and sixpence 'when she went away'. In 1707, a shilling was given to 'a Great Bellied Travelling woman to help her on her journey'. Strangers who died in the parish had to be buried; in 1727, the accounts read that 7s were paid for 'the burial of a man that died in Mr Savage's barn'. But others were given similar small sums, too. In 1714, £5 was spent on giving money to poor soldiers and sailors; in the next year, nearly 100 distressed sailors were given a few pence each, though probably most of these were passing through the Thameside Brentford, rather than Ealing proper. Maimed soldiers were also given money; in 1715 this amounted to £48. The relatively high number of former servicemen is accounted for by the fact that, in 1713, the War of Spanish Succession came to an end and with it the inevitable large-scale demobilisation as men returned home.

Those staying in the parish without an obvious source of income were dealt with stringently. In 1715, there is a reference to the uniformed parish beadle being given 50s for 'his trouble and Expenses in keeping Intruders out of the parish'. Those found were often temporarily housed in the village cage, 'in which men and women were kept who had strayed into the parish'. In 1727, one man even died there and the parish had to pay to bury him. On

nother occasion, food had to be bought for 'the woman and child in ye cage' (near to the hurch in what is now St Mary's Square). Searches were often made in the parish to locate ny vagrants who might be lurking there. In 1726, expenses were given for 'searching [for a] ·ig bellied women and getting her out of town'.

In 1698, the vestry noted that they intended to 'take and provide one or more houses for ·vork houses to employ the poor of this parish to work in, and also to provide a sufficient tock and implements at the charge of the said parish to employ and set the poor to work'. ·his was accomplished in 1701. A building was chosen, but £50 was needed to repair it and ·o accommodate eight poor people, but this would, it was thought, save the parish £12 per ·nnum (in 1701 the parish expected to pay out £16 in poor relief). The parish applied for ·ermission from the county to raise a rate of three pence in the pound from the ratepayers to ·aise the money for the workhouse repairs, which was granted.

However, this proved inadequate. In 1718, there was discussion about levying an eight ·ence in the pound rate to build two houses for the poor. The subject was not raised again ·ntil 1724, when it was stated, 'the poor of this parish daily increase, and that there are no ·vays or means used to employ such poor'. In 1727/28, a workhouse was built opposite ·he church at the cost of £400, advanced by four wealthy parishioners (including Jonathan ·urnell, a Quaker). It was managed by a governor, the first being Stephen Avis, paid £20 per ·nnum, and Elizabeth Coombes, as matron at £5 per year, 'for ye government and care of ye ·inen and making thereof of other things relating to ye women'.

·he Workhouse.

The inmates, initially four men, sixteen women and thirty-nine children, were taught to spin wool. They were given 204 pounds of wool and this was later sold at 5*d* per foot, earning the parish £26 9*s* 7*d* that year, which hardly covered costs. The inmates were given a basic diet – for breakfast, either beef broth or milk pottage, then either boiled beef, pease pottage, rice milk or pudding at dinner, and then supper of bread and cheese. Small children were kept in the attic away from the workroom, and were supervised by two women.

Concerns about expenditure on poor relief surfaced in this decade. In 1724, it was stated, 'the said overseers have hereby charged divers summes of money in their accounts as given to big bellied women, soldiers & sailors with passes and other poor persons who have no real settlement in the said parish to the great impoverishment of the true poor of this parish'. Furthermore, in the following year, it was agreed that the parish should no longer receive children from other parishes to nurse lest those children gain settlement rights and become potential future burdens on the parish. Charity should not only begin at home, but also end there.

It was not only public relief that helped the poor. We have already noted that wealthy Ealing residents left money in their wills for the resident poor. This became rather more formalised in the following centuries. Edward Vaghaun, who had been at the apex of village society in 1599, as noted, was the first to establish a charity here. His will of 1612 left the rent from 4 acres of land to provide meat, coal and bread for the local poor of Ealing and Brentford each Christmas. John Bowman endowed a lectureship worth £40 per annum and also left property, the income of which was to be distributed at Christmas and at other times. In the following century, Richard Taylor also left property in his will of 1715 towards coal for eight Ealing and eight Brentford poor.

Churches also collected money for individuals and villages in need of relief by means of briefs; authorised by the bishop and collected throughout the diocese. Between 1662 and 1666, the congregation of St Mary's Ealing gave 23*s* 10*d* for relief of those who had suffered from a fire in Fleet Street, as well as places in Suffolk and Somerset. Individuals assisted were John Osborne, a 'Russia merchant', to the tune of 13*s* 9*d*, and one Rose Wallis, a widow.

Charities also paid for the education of the poor. St Mary's Church School opened as a charity school around 1714. Jane Rawlinson left £500 to clothe and teach twenty girls, but there was no separate girls' school until much later, and initially boys and girls shared the same building on what was later South Ealing Road. Several schoolmasters were licensed in Ealing (teachers and other professionals needed a licence from the bishop in these centuries in order to practice). Some of these teachers may have taught small number of pupils in their own homes in these years. Zachary Pearce, later bishop of Rochester, attended a school in Ealing Towne in the early eighteenth century. However, there is scant evidence that the Great Ealing School (and more of this school in later chapters) was established in 1698, as is often alleged.

The upkeep of the church fabric was the principal concern of the churchwardens. In 1633, they paid for repairs to the church bells and for washing of the church linen. Thomas Ballansate was paid for three days unspecified work 'donne aboute the church and church yeard'. The church was also a place where people were married. Between 1653 and 1659, 134 people were married at St Mary's. Of these, fifty-eight were from Brentford and fifty-six from Ealing, but another twenty were from other parishes and some from as far afield as Essex and Surrey. Generally speaking, there were few marriages in any one year – between 1664 and 1666, only fourteen annually.

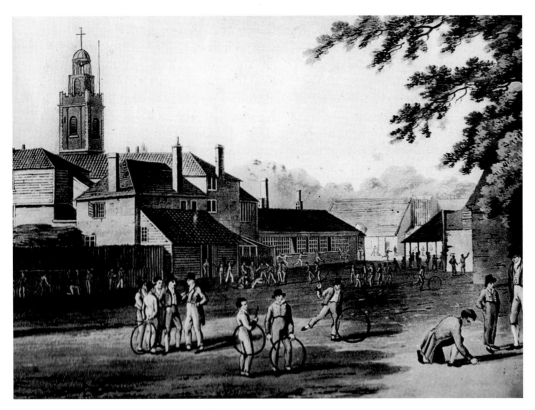

The Great Ealing School, 1809.

One result of the 1688 revolution was the passing of the Toleration Act in the following year, allowing Nonconformists (but not Catholics) freedom of worship. In 1705, Ealing had its first Nonconformist chapel, properly licenced at Quarter Sessions in property belonging to Robert Goodenough. It is not known where this was and it may have only existed briefly; Nonconformist chapels opened in Brentford and so Nonconformists probably went there to worship.

Political and religious issues were not the only ones to vex parishioners. The state of the roads was less than ideal, but there was a local reluctance to obey the laws stating that they work (unpaid) for six days per year to repair them. In 1614, the Quarter Sessions noted that Ealing's residents had not repaired that 1 mile of road at Hangerwood Hill, and they were also indicted for allowing a bridge to fall into decay. In 1616, John Collins and John Beade of Ealing were indicted for not repairing the highways. Yet when the parish did appoint a man to act as surveyor of the highways to pay for the work of local road repair, they were slow in reimbursing his costs and had to apply to the sessions for permission to levy a special rate to pay for this in 1694. It was noted that William Peirson, the surveyor, had paid out £12 16s 9d and it was only after his death that his widow was properly reimbursed.

Middlesex Quarter Sessions occasionally made other demands of Ealing's purses. In 1615, the parish was ordered to pay, along with the county's other parishes, £25 towards the building of a house of correction in London to gaol suspects prior to trial. In 1637, the parish

contributed 30*s* towards relief for plague sufferers. Not all were willing to pay their share. William Rawlins refused his 3*s* towards the gaol.

We have already seen that the parish of Ealing was made up of several distinct settlements. Ealing Towne (once Churche Ealing) remained the largest; in 1679 there were fifty rateable properties there, headed by Sir William Smith, who was then assessed at £5 14*s* 6*d* for his rates. Drayton and Deane to the west of the parish was next largest, with thirty-two ratepayers, followed by Haven and East Heath, to the east of the centre, with twenty-six rate payers. To the south west of Ealing Towne was a newly emergent hamlet of Little Ealing with ten rateable properties.

Population was slowly rising, but in 1665 faced a check. The plague broke out in London in the summer of that year and there are numerous references to people in Brentford dying because of it. We do not know how badly Ealing was affected, however. The Revd Beveridge reported, 'There is scarce a home in Eling wherein there is not one dead'. The parish registers noted 286 burials in 1665, far above the average annual burial rate. The dead of Brentford and Ealing were probably buried in holes in a field in Brentford known as Dead Man's Graves, later bordered by the Great West Road, a railway line, with Carville Hall Park to the west and Green Dragon Lane to the east, though the excavations for these roads did not reveal any skeletons. Most of the deaths may have been in the crowded streets of Brentford. The Hearth Tax returns for Ealing noted there were 116 occupied houses in 1664 and 120 in 1666, rising to 172 in 1670. This does not suggest a great fall in population due to plague.

As ever, Ealing was occasionally annoyed by crime. A highway robbery on an unknown man in Ealing in 1608, resulting in the victim being robbed of a stole cloak worth 6*s* 8*d*, rabbits and pigeons, led to one assailant turning King's Evidence, another being hanged, and another suffering slow death by *peine et forte* (being pressed to death), in order to avoid having his goods forfeit to the court. In 1613, Robert Taylor, a yeoman, had a dozen sheep stolen. It seems the culprit was fellow resident, Henry Chamberlayne, who also stole sheep from others. Chamberlayne successfully pleaded the benefit of clergy, meaning that he was able to prove he was literate and therefore have his sentence changed from execution to being branded. Thomas Hobbes, an Ealing yeoman, assaulted, in 1629, one Richard Sherren, who subsequently died of his injury, but as the court deemed this manslaughter rather than murder, Hobbes escaped with a branding (again he pleaded the benefit of clergy). Edward Nowell and Arden Baggot were even more fortunate, for they were pardoned following the murder of Thomas Gleed, an Ealing man, in 1670. Not even the wealthiest were immune from crime, for a horse of Thomas Penruddocke, worth £6, was stolen in 1616 and the only suspect was found not guilty.

Agriculture was still predominant at this time. Orchards and market gardens increased in number, with fields giving way to this new use, especially in the south of Ealing. Animals were common, too. Yet the manor passed regulations to control them. In 1687, no cottager was allowed to have over ten sheep and landowners were limited to two sheep per acre of arable land and three per acre of meadow. Farmers who let their cattle trespass were also dealt with; owners of large cattle were fined a shilling and smaller animals 3*d*. Beasts found wandering were rounded up into the pound (located in what is now Dean Gardens) and could only be released by paying both the Hayward and the poundkeeper one and two shillings respectively, according to a rule passed in 1723 by the manorial court. But other professions

carried on in Ealing. In the 1650s, there are references to a butcher, a miller, a cordwainer, a cheesemonger, a tallow chandler, three tailors and a bricklayer. Some were quite prosperous, as at least three Ealing gardeners made wills in the 1720s. In 1704, there was also a barber and even a brewhouse in 1728. Several Ealing men in the seventeenth century were granted licences to work as kidders (pedlars).

There was no ale house or inn noted in Ealing in 1599. Residents William Eustage and Alice Andrews, a widow, had their alehouses closed by order of the magistrates in 1691. Eustage's was close to the Common and Haven Green. Unfortunately, we don't know the names of these pubs, and so, though Ealing's first known inn was named The Plough in Little Ealing, dating from the early eighteenth century, this was clearly not Ealing's first.

Ealing was becoming somewhere that wealthy Londoners bought a country home. Sir William Trumbull (1639–1716), a senior civil servant, bought Hickes on the Green, near to Ealing Common. Richard Savage, the fourth Earl Rivers, on retiring from soldiering, bought Ealing Grove in the late 1710s. In Little Ealing, at Place House, there was John Loving, once Teller of the Exchequer, who died there in 1697, and later resident at this house was biblical scholar Sir Richard Ellis.

Communications were slowly improving in these decades. From 1680, there was a postal service for letters and parcels up to a pound in weight to be paid on receipt for the district 10 miles around London. Deliveries to Towne Ealing and Little Ealing were made daily. In order to improve the roads, the Uxbridge Turnpike Trust was founded in 1714, and turnpike gates set up along the road to charge horse drawn travellers and goods for the upkeep of the thoroughfare. The 'Flying Machine' was a stagecoach which ran through the parish in 1669, boasting it was so fast that it could carry a traveller from Tyburn to Oxford along the Uxbridge Road in twelve hours, if 'God permit'. A more regular, daily service began from London to Bath via Ealing in 1716.

It is appropriate to end this chapter with the fall of Ealing's church. Although this was not to occur until March 1729, the indications were already apparent in the preceding years. A rate of two pence in the pound was agreed in 1720, in order to raise money 'for necessary repairs to the Church & Steeple'. At a vestry meeting on 20 August 1722, it was noted that a carpenter and bricklayer should 'take a strict view and search of dangerous state of church & steeple'. A week later, another two men were asked to give a second opinion. In 1724, another two penny rate was levied for repair work. In 1724/25, £32 14s 9d was spent on this.

In the meantime, contingency plans were taking shape. Land was sought near to the church in order to have another structure fit for worship built there, Richard Peters, a carpenter, having made proposals for 'making or building the intended tabernacle as to how strong and how large they are to build it'. The Bishop of London was petitioned to grant the parish leave to build the tabernacle in the following year. It seems permission was granted, for there is a reference to 'cleaning ye Tabernacle' in 1726. Yet it probably still came as a surprise when the worst came to the worst. According to *The Ipswich Journal* of 29 March 1729, 'On Friday last between Four and Five in the Afternoon, the steeple and great part of the Parish Church of Ealing in Middlesex fell down and broke several Tomb stones in the Church-yard; the clerk was to have rung the Bell at Four for a Funeral, but going to Brentford, did not return in Time, by which happy stay he saved his Life.'

3

THE LATER PARISH, 1729–1863

We know a lot more about Ealing in the later eighteenth and nineteenth centuries because contemporaries began to take notice of it. *The Ambulator* of 1794 had this to say:

Ealing, Great and Little, two villages between Brentford and Acton. At Great Ealing are many handsome villas among which the most distinguished are Ealing Grove House, Mr Bayly's, Rockwork Gate House, the elegant residence of Mr Matthias, and a house, lately built by Mr Wood, on a fine eminence on the right hand of the road from Acton to Hanwell. At Little Ealing, is Place House, the villa of Sir Charles Gould, and the house of General Lascelles and Mr Fisher.

Little more than two decades later, Ealing was described in a county handbook as 'a parish ornamented by many handsome mansions', and in detail:

The village … is situated in the immediate vicinity of the Uxbridge Road, on the south side of that thoroughfare. The site of the village is flat, but the principal dwellings are detached; and a desirable air of retirement and country quiet prevails throughout the neighbourhood.

Many of these houses were on the Green, as the same source explained 'near the entrance of the village, are several respectable houses'. Ealing House was 'a large gloomy residence'; Ealing Grove 'the substantial and capricious residence', while the vicarage was a 'respectable and commodious building'. Little Ealing was 'a hamlet on the southern side of the parish … contains … several respectable buildings'.

At the end of the eighteenth century, the main location of the bulk of the parish's population was, as it always had been, along the main road running south from the Uxbridge Road towards Brentford, with small hamlets around Drayton Green, Pitshanger and Little Ealing. There were very few houses along the Uxbridge Road, and then only near the inns. There were a handful to the east and north of Haven Green and to the west of the Common, and three along Castlebar Road. Most roads had few or no houses along their route. For example, Northfield Lane, running from the Uxbridge Road to Little Ealing, was uninhabited, as was the smaller Love Lane from the Green to the Common.

One of the main motors for change in Ealing in this period was population growth. In 1801, there were 1,039 male inhabitants and 965 female, totalling 2,004 people. In 1811, there were 973 males and 1038 females, so a slight rise in there being 2,011. But in 1841,

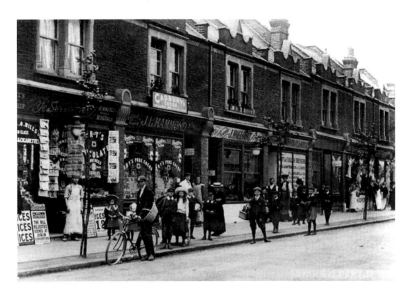

Northfield Lane,
c. 1910s.

here were 3,349 (with a slight predominance of women: 1,710 to 1,639 men). This was an increase of over 50 per cent in four decades.

One reason for this population growth was the fact that more babies survived into adulthood and so the birth rate overtook the burial rate. In Ealing alone, in 1813, there were seventy-one baptisms and fifty burials, in the following year seventy-one and fifty-four respectively. In 1820, there were, in the combined parish, 220 baptisms and 179 burials. From 1845–49, baptisms totalled 373 and burials 255. Yet the death rate of infants was still high: for Ealing and Brentford combined, 104 out of 259 deaths in 1781 were of children under seven. In 1788, three children from the same family died. While most of the burials were of children in poor families, death was no respecter of wealth and, in both 1777 and 1778, Francis Burdett, baronet of Ealing, had to bury a child. Or, as draper's wife, Mrs Rebecca Fountain, recorded in 1851, 'Poor Julia Jephson died … This is the third death from our house in seven months'. It is also worth noting that some of those buried were non-parishioners; in 1778, 'A Man name unknown was buried' and in 1780, 'A Stranger, Name Unknown' was interred.

Yet the population increase in the nineteenth century cannot be accounted for merely by baptisms outstripping burials at a higher rate than in the previous century. A sample of 200 residents in Ealing in 1861 reveals that only a minority were actually born there: seventy-three (37 per cent). Another forty (20 per cent) were born in Middlesex/London. Another seventy-seven (38 per cent) were born elsewhere in England, with two residents being born in Wales and four from overseas, though these were mostly pupils boarding at school in Ealing. On 10 March 1811, the baptism register recorded one Dennis Thomas, an eighteen-year-old black servant, there being a vogue at that time in having such staff.

The population rise resulted in there being more inhabited houses, from 291 in 1801, to 298 in 1811 and 618 in 1841. In the latter year, there were 646 houses in total in Ealing, and 20 in Little Ealing (which had a population of 129). Population density per house was very variable. In 1801, there were 485 families living in the 291 houses. Although there were eight single resident homes, most houses had between two and nineteen inhabitants, and two had

over fifty (probably the workhouse and the Great Ealing School). There was less crowding in 1811, with 337 families in 298 houses.

The biggest single employer of labour was, until the nineteenth century, agriculture. In 1777, there were six large farms in Ealing: Brent Farm to the north-west of the parish, Fordhook Farm, Hanger Hill Farm and Mr Wood's Farm to the east. Pitch-Hanger Farm was to the north and there was another on Mattock Lane. Yet farming was in relative decline and was not the predominant occupation in Ealing by 1801. Only about 5 per cent (106) of its inhabitants were noted as being involved in agriculture, though the figure was about 12 per cent (252) in 1811. Instead, the rather loose heading of 'Trade etc.' accounted for 960 people in 1801 and 496 in 1811. Numbers fluctuated, though. In Ealing and Brentford in 1831, there were at least 288 families involved in farming, but this was out of a population of 7,783, and this may have been an under estimate because farming is very much a seasonal occupation. Many of those employed in market gardens were women. Men earned between 10s to 15s per week.

Although most of the land in this period was used for agriculture, the proportions altered. In 1799, 1,377 acres was meadow and pasture, but this rose to 1,600 in 1814 and to 1,976 in 1839. Land devoted to market gardening rose, too, from 289 in 1799 to 469 in 1841. Arable land usage fell from 1,027 in 1799 to 800 in 1814, before making a modest revival in 1841 at 834 acres. It was observed that these changes

> had chiefly arisen from the conversion of arable land into market gardens, a natural consequence of the proximity to London, which by constantly enlarging the circle whence it supplies are drawn, must gradually make the cultivation of the surrounding district more artificial and productive.

Between the farms, in 1843, 1,300 tons of hay and 3,485 sacks of potatoes were produced. Other crops were wheat and oats, then barley and beans. Almost all of this work was by hand, for there was 'only one threshing machine exists in this parish and that one has been recently introduced'. There was also some pasture farming: 73 horses, 62 grazing cattle, 95 cows and 1,200 sheep are noted as being then in existence.

Farms benefitted from the large amount of horse dung that was transported from London, so little artificial fertiliser or crop rotation was needed. Most farms were small, between 10 and 40 acres, and were rented on twenty-one-year leases, at 40s–60s per acre per year, though market garden farms (between 2 and 96 acres in size) were considerably dearer at about £10 per acre.

Another major concern outside work was religious life, centred on the parish church. The collapse of its tower in 1729 was clearly a matter needing urgent remedy. Firstly, the remains of the church had to be cleared away. In the same year of its fall, money was spent 'for taking care of the Materials of the Old Church & carrying the Load &c. to the Work House'. Yet most of the 'rubbish of the old church' was not removed until 1731, and at the cost of £14 6d. In the meantime, worship took place in the newly created tabernacle. It cannot have been a very sturdy building for it required a great deal of repairs during its short existence and, in 1734, was described as being 'a slight timber tabernacle, built by voluntary contributions, which is also now become ruinous and not capable of containing all the inhabitants'.

Positive steps were taken too, beginning in 1731. A public meeting of the vestry decided that an estimate of expenditure be drawn up. It was also decided that application be made

o the county sessions to request permission for a certificate in order to obtain a brief, which allowed a collection of money be made by voluntary subscription to pay for the new church. Rebuilding was also financed by levying a church rate for that purpose too. Finally, having got the certificate, Parliament had to be applied to for an Act to obtain the necessary brief, all of which took three years.

In 1734, the parish officials were able to make rounds of the parish to collect money for he building of the new church, initially envisaged as costing £1,500. In the following year, he foundation stone of the church was laid. Bells were hung in 1736. The church building was complete in 1739, following a second Act of Parliament for a further brief, allowing the parish to raise a further £1500 by voluntary subscriptions, but its internal furniture was not completed for some years later. A new church wall was also built. The church was described thus in 1816 as being 'a spacious brick structure … an oblong square with galleries at the two sides and at the west end. Over the latter is a small organ, given by Mrs Fairlie, of Ealing Park, in the year 1804. The font is of veined marble, and is placed near the reading desk, in he eastern part of the nave.'

Once built, it had to be maintained. One major danger to the internal fabric of the building was animals. These included hedgehogs, sparrows and polecats. In 1771, twenty hedgehogs, two polecats and innumerable sparrows were killed to prevent their harming the church building. In 1810, the galleries in the church were enlarged to ensure additional seating in he parish. As with all meetings of the vestry that dealt with matters that were not routine, meetings relating to them were well attended by most of the parish's notables (including Spencer Perceval MP and Dr George Nicholas, headmaster of the Great Ealing School). On a lighter note, there were occasional perambulations of the parish by the parish officials and any parishioner who cared to attend. Once finished, they had a dinner at the parish's expense; if this sounds like misuse of ratepayers' money, it should be remembered that most parish officials were unsalaried, though by 1832, it was stated that diners should pay for themselves.

The vestry was also concerned, as ever, with the relief of the poor. This became increasingly difficult as the years went by and the population increased, and with it, expenditure and thus higher rates. Between 1729 and 1765, numbers in the workhouse were fairly constant; there were between seventeen and fifty-nine inmates. Numbers rose thereafter; there were eighty-six inmates in 1779 and over 100 in the next decade. Whereas in 1753, £301 was spent on poor relief, by 1796/97 it was £3,025, and by 1834, over £5,000. Where once the annual rates were just over a shilling in the pound, by the end of the century it had risen to 4 or 5s. The principle behind the workhouse was that those inside would earn enough money to earn their keep, but this was becoming more and more of an unrealised vision (in 1794 it made a loss of £24 per year).

Life for those in the workhouse was not easy. There were thirty beds there, and so most would expect to share a bed. There was nothing unusual in this at this time, though. It is also possible that the master and matron were dishonest; in 1735, they were discharged 'for several mismanagements' and a matron was sacked in the next decade for a similar reason. While women in the workhouse were employed in spinning, men were employed outside on the common, levelling the ground there in exchange for their board, lodging and tobacco money. Boys worked in beating hemp and sacking, but many found it dull; 'Many of them run away', as an observer noted. Once children of both sexes were old enough, the parish often paid for them to be apprenticed (girls as servants, boys to various tradesmen

and craftsmen) and so relieve the burden on the parish. Sometimes adverts were placed in newspapers to attract men in need of apprentices.

By the early nineteenth century, the workhouse system was in crisis. The workhouse opened in 1727 was far too small for the demands placed upon it at the dawn of the following century. Gross overcrowding was common. In 1801, the vestry resolved that a new workhouse was vital. Yet they concluded 'on account of the high price of materials consideration of the erection of a new workhouse for the present be postponed'. Yet the issue did not go away, and fears of higher rates and disease caused a rethink. There was discussion over extending the existing workhouse and it was decided in 1812 that Parliament be petitioned. It was decided to approach Spencer Perceval, parishioner and Prime Minister, but eventually cost prevented this step being taken.

The coming of the New Poor Law in 1834 resulted in parishes joining together in poor law unions, whereby a common workhouse be built and controlled by overseers chosen from each contributing parish. Finance would be from ratepayers as before, collected by the overseers. Thus, with the formation of the Brentford Union in 1836 and the building of Isleworth Workhouse, the parish workhouse was surplus to requirements and sold in 1839. These houses are now No. 72 and No. 74 St Mary's Road.

There were other ways of providing relief, of course. Many people still received casual relief (often food or clothing rather than cash) to tide them over temporary illnesses and unemployment. Pensions were paid to many elderly people. In 1832, poor emigrants from the parish were encouraged. Despite injunctions against giving strangers temporary relief, instances are still recorded in these years. In 1796 and 1797, there was additional cause for concern due to bad winters and poor harvests. William Eden recalled that 'very considerable subscriptions were raised ... and brown bread was made which distressed families were allowed to purchase at a reduced price'. Yet the quality was poor, as Eden recorded, 'many labourers thought the bread so extremely course and unpalatable' that they returned the vouchers given them to purchase cheap bread.

The cost of relieving poverty led to perceived high rates, and these were often complained of, both by ratepayers and by the parish, which had to contribute to county and police rates. In 1832, Lord Reay had not taken possession of his property and so thought he should not be liable, but the parish concluded otherwise. Ealing residents objected to paying rates for expenses 'peculiar to the town of Brentford', but they had no success.

Another problem was in collecting the increased sums of money from an increasing population while using the same number of overseers as in the seventeenth century. In 1812, a salaried position of assistant overseer was created in order to overcome this difficulty, and the division of the parish into two sides for collection purposes was ended in order to simplify collection.

Parish officers also had to deal with corpses found in the parish. In July 1772, they claimed 17s 2d for 'Expenses attending Jospeh Allen killed by a Waggon'. It cost 10s 7d to bury a woman 'who died in ye Cage'. They also had to attend inquests, too. Travel was another part of the overseers and beadles' lots. They might have to attend sessions courts held at Hicks Hall in London to learn the fate of a poor person they were dealing with, or they might have to accompany someone to a hospital or asylum in London.

The parish was not the only body that tried to alleviate poverty. In 1832, the Bishop of London allowed 20 acres of waste land in Ealing Dean, which he held as lord of the manor, to be divided

into allotments for the use of the poor. There were 146 allotments, rented at 5s per annum. Tenants had to show they were sober and industrious, and there was a waiting list. Although produce grown on one of these allotments was insufficient to keep a family fed, it did serve to provide when other work was scarce, and it, along with parish payments, also prevented elderly labourers from being forced to enter the workhouse. It was possible to fill twenty sacks with potatoes in a year 'yielding not only a supply for a labourer's family throughout the year, but sufficient for the keep of a pig, and leaving a surplus for sale'. This was the Bishop's last act as lord of the manor, for the Ecclesiastical Commissioners became lords of the manor in the same year.

There were also the almshouses, built on the Uxbridge Road, on what is now the south side of the Mall, in 1783. They were paid for by Henry Beaufoy Esq. of Castle Hill Lodge, who died in 1794, in return for his having enclosed wasteland along the same road. Unlike the workhouse, the select number of inmates received free food and fuel, as well as lodging, but without having to work. In 1832, the almshouses were in need of repair, and by 1840, there were divided into seven 'flats'.

Local government changed considerably throughout the later eighteenth and nineteenth centuries. More was expected of it and fresh problems resulted in ad hoc bodies being created in order to deal with them. But instead of replacing existing establishments with new ones, they co-existed, and the newer ones were often offspring of the older ones. Just as the manor and the parish worked at the same time, so the parish co-existed with additional bodies.

In 1767, a Highway Board came into being following an Act of Parliament, as petitioned by the parish's ratepayers, to improve the care of the 13 miles of roads in Ealing (other than the Uxbridge Road). These included Gunnersbury Lane, North Field Lane, Mattock Lane, Green Lane (now Argyle Road), Gypsy Lane, Guys Lane (now Warwick Road), Frog Lane (now Church Lane) and Love Lane (now The Grove). This was because 'the Highways within the parish of Ealing … are of great Extent, and in a ruinous condition, and in many Parts so narrow that two carriages cannot pass each other without Difficulty and Danger … the present methods provided … having been found insufficient for the Repairing of the Highways within the said Parish.' The board's trustees often included local clergymen,

Cottages in Church Lane.

including the parish's vicars such as the Revd Charles Sturgess and the Revd Colston Car⟩ and also schoolmasters, such as the Revd William Goodenough, and Joseph Gulston, ⟨ major landowner. The board levied rates twice a year at about five pence in the pound fo⟩ the payment of the surveyor who oversaw the work of labourers repairing roads and ditches

The Uxbridge Road was maintained by the Uxbridge Turnpike Trust, which had a to⟩ house near to the Old Hat pub, West Ealing, charging fees for horse- and oxen-draw⟩ transport: a penny for a horseman and sixpence for a coach with five horses. John Middleton who travelled on the road in the late eighteenth century, was unimpressed with the quality o⟩ the road and wrote,

> During the whole of the winter of 1797/8, there was but one passable track on the road and that was less than six feet wide and eight inches deep in mud. All the rest of the road was from a foot to eighteen inches deep in adhesive mud. The track was thronged with wagons, many of them drawn by ten horses. The road continued in this infamous fashion the whole winter. No exertions were made towards clearing it.

The increasing amount of transport on the road served to make them deteriorate eve⟩ more, not helped by the type of transport used; 'country carts used in Middlesex have th⟩ reputation of being the most clumsy vehicles in existence'.

Yet the Vestry, shorn of its duties to administer the poor law in 1834, still had a purpose. I⟩ continued to meet, to appoint overseers and churchwardens and to oversee its accounts. On⟩ of its chief purposes was to administer the various parish charities, both educational an⟩ distributive. It also acted as a forum for local opinion, which could have an impact on othe⟩ local bodies.

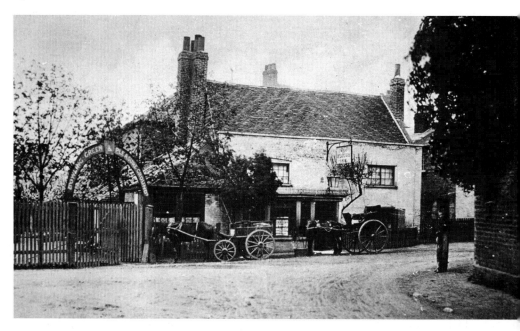

The Plough Inn, Little Ealing.

National events had an impact on Ealing. The parish accounts for 1746 noted that £5 was spent on account of the late rebellion'. This was a reference to the defeat of the final major attempt of the exiled Stuarts to regain the throne. Ealing residents can have been under no doubt where the vestry's sympathies lay, as the money was probably spent on ringing the church bells to celebrate the defeat of the rebellion and perhaps on a bonfire.

Of greater significance were the French Revolutionary and Napoleonic Wars of 1793–1815. The vicar had preached a sermon in 1792, encouraging loyalty towards George II, and his successors seem to have been no less loyal. Thomas Harrington Esq. was the colonel of 'The Ealing and Brentford Armed Association and Voluntary Corps', who were armed and equipped by the government, but other expenses were met by the volunteers themselves. The men numbered 200, but given the cessation of hostilities, were stood down in 1801 and their flags deposited in the parish church.

In 1800, the parish obeyed a government mandate to promote economy in use of food so as to prevent rising food prices leading to discontent among the poor. The wealthy were exhorted to eat less bread, meat, butter and cheese, as these were prone to high demand and would otherwise be too expensive for their poorer neighbours.

In 1803, with the outbreak of renewed hostilities and the threat of invasion, the vestry agreed to help in the national crisis by raising volunteers for defence. They noted, 'They therefore declare, that they feel themselves imperiously called upon to use their strenuous exertions in defence of their King and Country'. A committee was appointed under the aegis of the parish's most prominent inhabitant, Edward Augustus, Duke of Kent (owner of Castlehill Lodge, 1801–12) and son of George III. Companies of volunteers were raised, paid for by a rate levied by the parish and administered by a committee, which included the Revd Colston Carr and Dr Nicholas. Colonel Drinkwater was in charge of the Ealing and Brentford Volunteers of five companies. They took part in military exercises and attended church parades; 'the Corps evinced their well grounded instructions in military tactics, performing various evolutions and firings with great strictness and precision'. They never heard a shot fired in anger, however, and were stood down in October 1806, knowing that the French were unable to invade, having had their fleet destroyed in the previous year at Trafalgar.

The death of George III in 1820 led to the succession of his eldest son as George IV. This became controversial because the King and his wife, Caroline, were bitterly estranged, with adultery on both sides. There was also a political dimension because the King and his supporters were opposed to the Queen being officially acknowledged. Opponents of the government, including radicals, supported the Queen's interests for their own sakes. There was local division, too. A meeting was called in Ealing, not to address the Queen, but the King, and a hostile source noted, they 'proposed one of the fulsome compositions so much in vogue of late among a certain class'. Yet some residents wanted to include, among the loyal address to the throne, criticism of the present government; others wanted it to be uncritical, but the latter met with 'miserable success', according to the contemporary press.

Another national crisis in the nineteenth century had resonances in Ealing. In 1848, there were revolutions in Europe – the French King lost his throne and other monarchs were imperilled. In England, demands for political reform coincided with economic crisis, and the radical Chartist movement seemed strong enough to force the government to listen to its demands. In Ealing, special constables were enrolled 'to protect the property in the village

during the late disturbances', with Dr Francis Nicholas, George Wood and the Revd John Smith, the vicar, being prominent in leading the forces of order. Although nothing untoward occurred locally (and nationally the Chartist movement fizzled away), the special constables celebrated their success at the Assembly Rooms on the west side of Ealing Green, to the north of the former workhouse, and loyal and patriotic speeches were heard.

Danger was foreseen from the French again in the late 1850s, when the Second Empire of Napoleon III appeared threatening. Volunteer Rifle companies were formed throughout the kingdom and Ealing was no exception to this general rule, one being founded here in 1860. Unlike their predecessors of 1803–06, this force remained in being for decades after the military reason for their existence ceased. Initially men paid a fee of a guinea per year for membership, thus barring the poorest. John Fitzmaurice was the first chairman and Spencer Walpole, MP of the Hall on Ealing Green, and Ealing's foremost citizen, supported the company.

Yet not all national events were reactions to potential calamity. In March 1863, the parishioners gathered together to celebrate the marriage of Edward, Prince of Wales (and grandson to the Duke of Kent) to Princess Alexandra of Denmark. As a newspaper noted 'Clergymen of the Church of England, dissenting ministers, the gentry, the tradesmen and the working classes, all seemed to vie with each another in making the day a glorious, happy and comfortable one'. The vicars of St Mary's and Christchurch and Wood and Walpole were prominent – the latter giving a short opening speech before the public dinner began, followed by games, a concert and a bonfire in the evening.

We now turn to Ealing's society. As ever, a number of well-known figures resided in the parish. As John Yeoman recorded in 1777, when he attended St Mary's, 'there was such a Grand Congregation. The place consisted mostly of gentlemen's seats, so I'll leave the Reader to Judge the Grandness of the Congregation.' They included, in 1753/54, at Fordhook Henry Fielding, playwright, novelist and magistrate. Veteran of Culloden, Lieutenant General John Huske, lived at Ealing Lodge in the same decade. Dr John Ranby, a royal physician, lived in Ealing too. Ann Cattley, actress and mistress of General Lascelles lived in Little Ealing in 1787–89, and left £5,000 in her will. More socially prominent was Mr Fitzherbert, 'wife' of George, Prince of Wales, who had Castlehill Lodge as an occasional residence from 1796–1801. Then, a younger brother of his, Edward Augustus, Duke of Kent, installed his French Canadian mistress, Madame Marie St Laurent, there. John Soane, a prominent architect, bought Pitzhanger Manor on Ealing Green, demolished part of it, rebuilt it and remodelled its grounds between 1800 and 1810. In 1808, the Chancellor of the Exchequer, Spencer Perceval (1762–1812), bought Elm Grove, off Ealing Common, for his country house. In the following year, he became Prime Minister, a post that he held until his assassination in 1812.

The will of a prominent eighteenth-century Ealing resident gives an insight into the opulence of his life. Lt General John Huske lived at Ealing House near the Green from 1753 until his death nine years later. His will totalled £41,000. His household included three housemaids, a cattle boy, a housekeeper, a groom and coachman, a footman, a valet and valet's wife, and three men working in the garden. He was a childless bachelor, and certainly generous, as £12,400 was given to his staff on his death (and only £3200 to his family). This was a particularly opulent residence, however.

In the nineteenth century, Spencer Walpole became the most prominent man in the parish. He was born in 1806 and became a barrister and an MP. In 1835, he married one of Spencer Perceval's daughters, Isabella, at St Mary's and, from 1844, lived in the Hall (now demolished), a mansion to the south of Pitzhanger Manor. He rose to political prominence by being Home Secretary on three occasions. Locally, he supported causes such as the preservation of the common as an open space, and his son (of the same name) was prominent in the Ealing Rifle Association.

Other important figures in Ealing's history lived just outside Ealing, at Gunnersbury. One was Princess Amelia, who lived there in the summers from 1761–86. Then there were the Rothschilds, who bought the rebuilt Gunnersbury Park in 1835. Nathaniel Rothschild died in the following year, but his son, Lionel, resided there afterwards, and he and his family played a part in parish affairs. Both the Princess and they proved to be notable benefactors. Another was the Wood family, prominent landowners in north Ealing since the eighteenth century. George Wood had been a member of the Highway Board, churchwarden of Christ Church, and had given land for that church to be built. He also helped rebuild the girls' school on the Green and paid towards renovating the parish church. He died in 1864, but his family were to be important benefactors to Ealing later in the century and usually appeared at important local occasions (just as the mayor and MP would from the twentieth century onwards).

We are on a surer basis to understand why Ealing was a popular place for so many prominent people. Proximity to the seats of power and pleasure in London, Windsor and Kew was clearly a prime reason, but it was not the only one. Health concerns for oneself and one's family were cited by both Fielding and Perceval. It was also deemed a pleasant place to live, certainly for those with money. Mrs Delaney wrote in 1734, 'I have not spent a summer in the country with you since we were at Ealing, and don't you remember how sweet that was? I am sure you do. The churchyard and the fields, even the dusty lanes, all were charming'. The proximity of other affluent residents also acted as a magnet.

We know a little about the lives of the better off in the parish in the early nineteenth century because of two surviving diaries. Many lived leisured lives. John Quincey Adams, American ambassador, lived in Little Ealing from 1815–17, and recorded attending many social functions, some of great splendour. More modestly, Mrs Rebecca Fountain, in her diary of the mid-nineteenth century, recorded visiting London to attend missionary meetings and for days out. She recalled friends visiting, 'Tuesday, had a party of 19 friends, went off very well, trust it was not altogether an unprofitable entertainment'. Her life and that of many residents relied on domestic servants, of which most middle-class families employed one or two. Yet, as Mrs Fountain recorded, they were not always what was expected of them, as an entry on 25 January 1850 noted: 'Monday, gave Charlotte warning after a great deal of unpleasantness in consequence of an intimacy between Martin and herself by which all work and duties have been neglected of late'. In the following year, Charlotte and Martin are no longer listed as being employed at Mrs Fountain's house.

Given this wealth, it is unsurprising that there were a number of private schools in Ealing. The most illustrious was the Great Ealing School, which can be dated back with certainty to 1766. It was initially located near to St Mary's church and enjoyed its greatest fame under the headmastership of the Revd Dr George Nicholas from 1791–1829. It was known for its

excellence in Classics. In 1813, Charles Hawthorne wrote,

> I know of no school so likely to answer your purpose as that of Dr Nicholas at Ealing, Middlesex. Each of my three brothers in law had a son there, and all of them speak highly of the school. There are more than 200 scholars but there is no want of attention in any respect.

It was a boarding school for boys, with between 200 and 300 in the early nineteenth century. Adams sent his three sons there, and among its famous alumni were John Newman, William Schwenk Gilbert and Thomas Huxley, later achieving fame, respectively as a cardinal, part of Gilbert and Sullivan and as a scientist. Under Nicholas' sons it fell into relative decline, and by 1847 was in a new building on the west side of the road, called The Owls.

Apart from this, there were a number of other small schools, many run by clergymen. The Revd William Dodd taught a number of boys in the 1760s in a house on Gunnersbury Lane. In 1777, this former royal chaplain gained notoriety by forging a bond from the Earl of Chesterfield, a former pupil of his, and was hanged for forgery at Tyburn. The Revd William Goodenough was another clerical schoolmaster in Ealing in the late eighteenth century. By 1826, there were nine schools in the parish: three girls' boarding schools, three boys' schools and three preparatory schools, as well as the parish and charity schools for the poor. One interesting school was the Ealing Grove School, founded by Lady Noel Byron and in the charge of Charles Atlee. It catered for boys: fifty boarders and thirty-three day scholars. Three hours per day were spent gardening, with more academic subjects also being covered and occasional lectures in Chemistry. It charged 2*d* per week.

The two National Schools, run by the Church of England with some public money, taught ninety boys and sixty-nine girls. Boys learnt reading, writing, arithmetic and basic grammar, along with history and geography. Girls learnt reading, writing, scripture and arithmetic. The only book used in these schools was the Bible. A British School was founded on Lancaster

The Revd William Goodenough.

Road in 1858 to offer non-sectarian education, and was funded by the state, school fees and voluntary contributions. Lessons from the Bible were read daily.

By 1842, there was also an Infant School, teaching twenty boys and thirty girls; six Dame schools (where one woman would teach a few children in her own home), teaching in total twenty-two boys and thirty-eight girls; two common day schools teaching thirty-four boys and three middle day schools teaching twenty-two boys and fourteen girls. Dame Schools charged between 3 and 6*d* per week and though the teachers were Anglicans, local Dissenters often sent their children there. In all, in 1842, 339 local children were receiving some form of education, and this overlooks the wholly private schools. Further education was limited to St Mary's church, which offered evening classes for boys over fourteen, men and women.

There were also a number of individual teachers who advertised their services. These included a French Professor to teach French, a German teacher to teach German, a music teacher and a former drillmaster to teach drill. One lady described herself as having 'much experience in tuition, residing in Ealing', and taught a few girls aged nine to fourteen in English, Music, French and drawing.

Crime was an ever-present issue. Highway robbery was increasingly common. The reality was rather different from the version portrayed in fiction. Ealing's uninhabited stretches of road have already been remarked upon. Add to this the complete absence of street lighting in this period. In January 1747, Samuel Verry, a wealthy Perivale farmer, and his son, were returning home along the quiet Castle Bear Road after a drink in The Feathers. Two men stopped them. Verry resisted, but was shot and then robbed. Despite managing to return to the said inn, the injured man died two days later. He advised his listeners 'to be cautious of travelling late, or making Resistance if attacked by such Villains'. Although two men were brought before the Justices of the Peace, they were released without being charged, and though a reward was offered, no one was ever brought to justice for this murder. A different result occurred when Sixteen String Jack Rann robbed Dr Bell on Gunnersbury Lane (another lonely stretch of road and a favourite location for highwaymen) in 1774. The highwayman was later identified, tried and hanged. Yet it was believed that highway robbery was less prevalent as the century progressed: 'The road across the Common is not so dangerous as it was formerly, because of Sir John Fielding's mounted Patrol.' This was a reference to the mounted patrols that were in operation on the highways around London, though they were very few in number. Burglars were a problem and in 1811, Elm Grove, on the common, the house of Spencer Perceval, was robbed on two occasions.

Little is known of the leisure interests of the majority of the population. Cricket matches against other village teams in west Middlesex are recorded in the summer months. There were also annual activities to look forward to. In June 1819, there were pony races on the common, though stalls were not allowed to be erected. A longer-lasting activity was the Ealing Fair, dating back to at least 1766 and carried on throughout this period. It was a three-day event held each June on Ealing Green. There were pig races, the prize being the pig, tea drinking competitions for old women, the prize being a pound of tea, sack races for both men and women, and most oddly, a grinning competition. There were also stalls selling food and trinkets not easily purchasable locally. The event was given the blessing of the Misses Perceval in the 1850s, who lived at the Manor House (now Pitzhanger Manor) just behind the Green, and the fair did not begin until they had toured it.

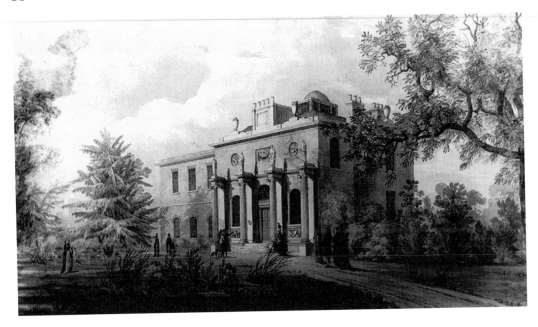

The Manor House.

The first known club in the parish was the Ealing Toxopholites, who wore green uniforms, practised archery in the summer and enjoyed dinners in colder months, in 1795. Dr Nicholas was later the society's president. For the village elite, the social centre was the Assembly Rooms. It was rebuilt in 1831/32 as the Hall of Variety. Annual balls, beginning at nine and not ending until five, were held there in the 1850s. Concerts were also held there, some organised by the Ealing Mutual Improvement Society. In 1858, there was a performance by African singers known as 'The celebrated and original Ethiopian Serenaders from St James'. Clubs and societies were beginning to be formed. There was the Ealing Harmonic Society, with weekly meetings in the Assembly rooms, and there was the Ealing benevolent society formed in 1848 to help the needy poor. The churches held evening lectures and the Mutual Improvement Society had discussion groups, in 1861 discussing whether the execution of Charles I had been justifiable.

Although there were no newspapers published in Ealing until later in the nineteenth century, James Acworth, a local printer, produced *The Illustrated Ealing Magazine* in 1858/59 and then *The Ealing Parish Magazine* (the purveyor of 'Useful Knowledge and Intellectual Amusement') from 1860–63. These were monthly publications, mostly containing stories and features on natural history and celebrities. There were also adverts for property and for goods and services, as well as train and omnibus times and details of church activity. Acworth also ran a circulating library in, which for an annual subscription between £1 1s and £2 2s, books could be borrowed.

Communications were far improved by the early nineteenth century compared to how they had been a century previously. In 1826, stagecoaches passed to and from London every half an hour. Mail arrived from London at eight in the morning and was despatched both then and at three in the afternoon. In 1845, mail went via Brentford and collections were now four times daily.

One major long-term event was the construction of the Great Western Railway from London Paddington to Bristol, which route would have Ealing as its first halt (until 1868). An agent of the company attended a vestry meeting in 1835 to show them the plan of the route, which would cut through both Ealing Common and Haven Green. This did not win approval, as the vestry minutes noted, 'the dissent of the parish be recorded and expressed to the Agents for the Great Western Railway'. A vote was taken at the next meeting; eleven votes against the railway plan and only four in favour. This dissension probably led to the company amending their plan, presenting the vestry with another in the following year, in which the route had been altered so that it only affected Haven Green. This won the vestry's approval and, in the following year, the company paid compensation to the parish for the loss of its land, which was used to liquidate debts owed by the vestry. The company also had to pay rates to the parish, too, though this resulted in the loss of the southern part of Haven Green.

Train services commenced on the line on 4 June 1838, but Ealing station did not open until 1 December 1838. Yet we should not exaggerate the immediate impact of the railways. Initially there were only six local services every day. The first did not arrive in Paddington until 9.05 a.m., and the next was an hour and a quarter later. Even on reaching Paddington, there were no underground trains until 1863, and so coach drawn transport was needed to reach the City. It was also expensive (no third-class accommodation). By 1858, there were eleven trains from Paddington and eight to Paddington stopping at Ealing each day (seven in each direction on Sunday), and the time taken varied from ten to fifteen minutes. However, the railway did attract visitors to Ealing. Kelly's Directory of 1845 noted, 'The town is small, but improved since the introduction of the railroad, there being a station here, inducing people to visit this (until now hardly known) but pretty village'.

Yet the railway coexisted with horse-drawn transport. Stagecoaches stopped in Ealing regularly from at least 1826. In 1845, the Wycombe and Uxbridge coaches stopped at Ealing three times both to and from London per day, the Banbury and Oxford coaches stopped daily and Ives' omnibus stopped six times a day from the New Inn per day. By 1860, there were also thirteen omnibuses per day travelling through Ealing from Acton to Hanwell and vice versa, between 8.05 a.m. and 6.40 p.m., stopping at both Christ Church and St Mary's. Mrs Fountain recorded, 'Left Ealing by the nine o'clock omnibus … and we alighted at Regent Circus.'

There were some changes in the shops in Ealing in this period. The first known list of Ealing shopkeepers in the *Pigot's Directory* dates from 1826 and lists forty-seven. There were six general dealers and five of each of the following: bakers, bootmakers and carpenters. There were also four butchers. There were fifty-seven businesses twenty years later. Again, general dealers and bootmakers were prominent, with five of each within the parish, but there were six off licences and five grocers, whereas there had been none of the former and only two of the latter in 1826. There were fewer bakers and butchers and no carpenters. By 1845, Ealing boasted a mechanics' institute with a library, and a police station headed by PS John Pasco (the Metropolitan Police covered Middlesex and London from 1829).

Yet in 1853, there were 182 shops listed in *Mason's Directory*. These included service industries, such as the dozen laundry services and fourteen lodging houses. Grocers and bootmakers (eleven of each were listed) were still there in strength, and there were many businesses catering to the agricultural market: a cattle dealer, a hay seller, three smiths and a

harness maker. It is also worth noting that the location of Ealing's businesses were shifting to the Uxbridge Road and away from the traditional centre of the parish. There were seventy-five listed on the Uxbridge Road and thirty-nine on Ealing Green. One reason for this shift may be that of the gentlemen and ladies who were listed in Ealing at that time, forty-two had addresses on the Uxbridge Road and a dozen on Haven Green, while there were twenty-five on The Green.

Shops also advertised their wares; clearly word of mouth was no longer universally seen as being sufficient. One in 1858 read as follows: 'C.N. Abbott, near the New Church, Ealing W. Purveyor of the finest Scotch Beef; Scotch and South Down Mutton, Lamb and Country Veal; Fine Hams and Pickled Tongues. Families supplied or contracted with on the most reasonable Terms'.

Public houses soared in number in this period, probably because of better communications with the increased stagecoach services, as well as an increased population. After The Plough, in Little Ealing, The Feathers, at the corner of the Uxbridge Road and Haven Green, was perhaps Ealing's oldest inn, dating from at least 1747. By 1777, there was also the Old Hats and The Green Man on the west end of the Uxbridge Road and The Bell near the Common. The Fox and Goose was to the far north east of the parish, near Vicar's Bridge at the north end of Hanger Lane. By 1826, there were a dozen and in 1853, nineteen. To combat perceived intemperance there was, from 1860, a coffee tavern, partly financed by subscriptions. Here patrons, about fifty per day, could read newspapers provided, play chess and draughts, and buy food and non-alcoholic drink. Both travellers and local men took advantage of this facility.

St Mary's church was still an important force in this period – in part because, until 1852, it was the only Anglican church in Ealing. It was extremely active. During the economic downturn in the 1850s, it did much to alleviate local suffering. A soup kitchen was established, blankets were lent and coal distributed. These were paid for by subscriptions given by the wealthy parishioners. The Church also founded a coffee tavern (alcohol was then seen as leading men to vice and poverty) and a reading room, freely open to male inhabitants, on the proviso that they did not utter foul language. In the same decade, the parish's two other churches followed suit and began initiatives to alleviate the lot of the poor.

Missionary work was also seen as a major concern by the Church at this time. Mrs Fountain referred to collaborating with the Revd Adeney of the Congregational Church in missionary meetings. There was an Ealing Association for Missionary Purposes founded in 1854. This organised lectures about missionary work in East Africa and elsewhere. Another overseas concern at this time in Ealing was the Indian Mutiny of 1857, and the outrages caused by 'the brutal soldiery' of the rebels was noted. As well as prayers being said for the sufferers, money was raised to alleviate the lot of widows and children. In all, £355 5s 5d was raised. Prominent among those giving money were the Walpole and Perceval families.

There was also an increase in the number of churches in the parish, both Anglican and Nonconformist, almost certainly as a result of the increasing population. Yet the rates that all parishioners had to pay towards the upkeep of the church became a thorny issue. When new Anglican churches were established, such as St George's in Brentford (1762) and Christ Church in Ealing (1852), it was questioned whether the parish rates should be allocated to them as well as St Mary's, but this was turned down and so each levied its own. In 1854, it was argued 'as the levying of a tax for the support of any kind of religious worship is believed to be alike prejudicial to the cause of this religion and unjust to those who differ from the

kind of religion so maintained'. This proposal was turned down, and the like occurred in 1856 when the issue returned.

Interestingly enough, the seconder for the above proposal in 1854 was a John Rymer, and he was involved in further religious controversy in the same decade. William Lambert was the first minister of Christ Church. He attended a séance at Rymers' house on Ealing Green in 1855. Despite trying to defend himself, the bishop's court suspended him from his post for five years. He was also alleged to have made one of his young female parishioners pregnant.

There had been a rector of St Mary's Ealing since the Middle Ages. Its last rector was the Revd Richard Richardson, who remained in the role from 1792 until his death in 1839. Then the rectorial estate, which had provided rectors with an income hitherto, became vested with the Ecclesiatical Commissioners, who took control of Church land in the early nineteenth century.

A more conventional clergyman replaced Lambert as curate at Christ Church. This was Joseph Stephen Hilliard. The church was built with money from Rosa Lewis (who lived in north Ealing and died in 1862) in memory of her parents, who were from the parish of Christ Church, Liverpool. It was built by George Gilbert Scott and was of Kentish rag, with Bath stone details in the manner of the gothic revival. It was dedicated in 1852.

There had been a Congregationalist presence in Ealing since the beginning of the nineteenth century. They had worshipped in a house on Ealing Green, then from 1822 on a chapel on the Grove. In the late 1850s, growing numbers and wealth led the members to demand a purpose-built structure for worship (costing about £4,000), and bought land on Ealing Green. In 1859, work commenced, based on plans submitted by a young newcomer and co-religionist, Newington born architect Charles Jones (1830–1913). At the laying of the foundation stone was fellow Congregationalist, the Lord Mayor of London, whose wife was presented with a bouquet by Lady Rothschild.

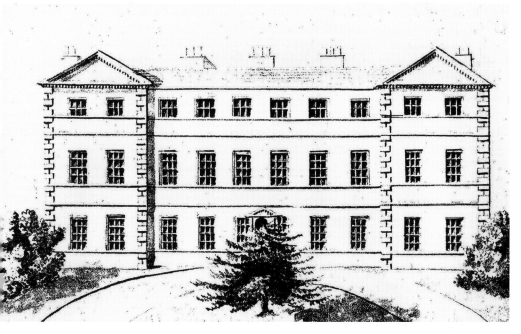

The Grove.

St Mary's churchyard was also causing concern, for in 1807, it was stated as being full. There was discussion about enlarging the grounds, but in 1846 the committee who looked into it found there was no prospect of it. But with population increases and this being the only place in Ealing and Brentford for burials, demand was high; there were 987 burials there from 1855–60. Yet the proposal was not put to the ecclesiastical commissioners until four years later. In 1858, when it was stated, 'the places of Burial of the Dead in the said Parish are insufficient', a burial board was founded by the vestry, who chose its nine members; though they were unpaid, they employed a salaried clerk from 1861. They had to decide where the new burial ground would be and the initial suggestion was that it should adjoin the existing churchyard, which had also been suggested in 1850. This did not find favour, for 'such fields are objectionable for a Burial Ground and disapprove of the Burial Board … purchasing the same'. In 1859, four sites were suggested. At first, Upper Hagbush Field was selected, but in 1860, another site, Little Sirett's Piece (near South Ealing Road), costing nearly £4,640 for 8 acres of land, was decided upon, and money borrowed to cover the cost. A further £2,000 was borrowed to pay for two chapels, a lodge, walls and drainage. Yet burials still occurred in the parish churchyard, though at a lesser level – 817 from 1861–66.

Lighting was another subject explored by the vestry, for once the daylight hours were over, Ealing was in darkness. In 1857, there was a public meeting to discuss lighting in Ealing and a proposal mooted that would entail £450 being raised in rates and nine inspectors being appointed, but this was turned down. In 1861, there was correspondence with Brentford Gas Light Company and inspectors were appointed, and eventually five were paid. However, it is uncertain as to whether any gas lights were erected in these years. It would appear there was not, certainly not by the parish, for there is a reference to ladies walking to church in winter evenings by the light of their own lanterns. Two or three street lamps were erected on the Green by private individuals, but they were expensive and so did not remain long.

The other local amenity for which there was a pressing need was drainage. The vestry took this matter seriously from 1854. Progress was slow and it was not for another five years that this was discussed again, and then the results were only negative. This was despite statements being made, such as 'the urgent necessity of improved drainage for the parish' and that 'the said Act should be adopted'.

This legislation was the Health Act of 1848, formulated to deal with typhus and cholera, which killed thousands in London due to the capital's poor sanitation. It enabled a district to set up a body known as a local board of health, with revenue raising powers to improve a locality's health, but only if a petition of over 10 per cent of ratepayers agreed to its adoption. The powers that would be conceded were the construction of sewers, street cleaning, the provision of public lavatories, the creation of a safe water supply, the purchase of land for parks, street paving and the licence of slaughter houses. Ten years later, the Act was amended to give the board more powers, including street lighting, the building of public baths, and regulation over cabs, fire prevention and dangerous buildings.

At the same time, there were residents who were unhappy with the status quo. Decades later, Charles Jones recalled,

About the year 1856 however, a feeling of interest began to make itself felt; several new residents came to the village, who, attracted by its sylvan beauty, had taken up their abode in the place, and

realised the fact that after sunset they might as well be living in the wilds of Canada or New Zealand, and an agitation was formed, consisting of some four or five of the older residents, with two or three newcomers, and, after many meetings and much consultation, it was decided to take action.

Those newcomers certainly included Jones, architect of the church on the Green, who arrived in the parish in 1856, and possibly Ebenezer Pearce, new schoolmaster at the Great Ealing School. His allies probably included George Wood JP, Charles Atlee and Alfred Johnson, all of whom had served as churchwardens. Their efforts were probably assisted by the new Highway Act of 1862, which ordered that districts be grouped together for administrative purposes unless they were formed into local boards. Most places did not want to be affected by the new Act, and so the latter option seemed preferable. Thus, because of a combination of local demand for the formation of a new system of local government, provided for out of recent legislation, and the threat posed by the Highway Act, a petition was sent. It was supported by a sufficient number of the ratepayers and delivered to the local government department of the government, requesting that Ealing be granted the status of a local board. In 1863, this became law and the districts of Brentford and Ealing were forever separated.

Population increase led to extensive building in the parish by the 1860s. Whereas until the 1820s the bulk of housing had been as it had always been, along the Green and near to the church, four decades later there had been extensive building along the Uxbridge Road and between that road, the High Street and the Grove. Housing along the Uxbridge Road was chiefly semi-detached, with a few more detached houses on Castlebar Road, the common and the Haven Green. As a contemporary historian noted, 'This part of the parish has greatly increased of late in houses of a respectable character, and in population, in consequence of its proximity to the GWR Station'. There were also many more modest terraced houses to the east of the High Street. These included those houses on Lancaster Road, Charles Street, Wells Place, Oak Street and

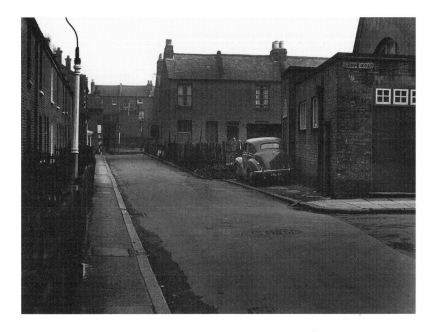

Grove Place, 1960.

Grove Place. Similar humble dwellings could be found on Haven Lane and in West Ealing, at Williams Road, for example. Other roads had been laid out near to the Uxbridge Road and to the east of the parish church: Marlborough Road, Blandford Road and Ranelagh Road. This land had been purchased by the Conservative Land Society, and, unsurprisingly, the roads built there were named after prominent Conservatives.

It may be thought that all this development was making Ealing into a very different place from that implied by Edward Lytton's comments made earlier in the nineteenth century:

> The country round that village … was rural enough for a place so near the metropolis … lanes that were themselves retired and lonely … Through two or three fields, as undisturbed and lonely as if they lay in the heart of some solitary land far from any human inhabitation.

Yet much the same could still have been said of Ealing in the early 1860s. Despite the growth in housing as outlined above, there were very few buildings to the north of the Uxbridge Road east of the railway station, nor to the west of South Ealing and St Mary's Roads (save for the hamlet of Little Ealing), nor to the north or west of Castlebar Road. Ealing was a large village at this time. Yet change to Ealing there had been. It had cut one ancient link with Brentford and the prospect of independent development beckoned. Because of population growth, it was also beginning to acquire the amenities of a small town: more places of religion, more varied shops, more schools and local societies to cater for leisure interests. Transport facilities in the form of the railway were slowly improving communications with London and elsewhere.

EALING HAVEN STATION. 1840.

Ealing Haven station.

4

SECULAR GOVERNMENT IN AN AGE OF RELIGION, 1863–1901

The memorial to the Revd Joseph Stephen Hilliard (1827–95), which stands in front of Christchurch, Ealing, includes the words, 'the period of his incumbency was marked by the rapid growth of his charge', and the last four decades of the nineteenth century were to see Ealing transformed from a populous village to, in the words of one journalist, 'a Country Town near London'. Edith Jackson, Ealing's first historian, wrote in 1898, 'The rapid changes of recent years, in such a growing neighbourhood as Ealing has become, seemed to render it necessary to place on record'. So what drove this transformation? The agents of change seem to have been a rise in population accompanied by housing growth, new forms of transport and an active local administration. These in turn led to a blossoming of local churches, schools, shops and clubs.

In 1861, Ealing's population was 5,064. The steady growth that had taken place since 1801 would be dwarfed by the dramatic rise in subsequent decades. By 1871, there were 9,959 people (a 97 per cent rise), in 1881, 15,764 (a further 58 per cent increase), in 1891, 23,787 (51 per cent more) and, in 1901, 33,031 (a rise of 39 per cent). So, in forty years, there had been a six-fold increase and neither before nor since has Ealing's population grown in number, or proportionately, so quickly. Of course, Britain's population was also rising at this time and London's population doubled in the same period; nowhere was this more evident than in London's outer suburbs (more than a five-fold increase).

Part of this increase can be accounted for by a falling death rate. In 1877, the Ealing death rate was 15.8 per 1,000 people, in 1888 it was 10.9 (compared to London's 18.5), and in 1898, it was down to 8.95 (in Harrow it was 12.5). Births were usually twice the number of deaths; in 1877, they were 336 and 187 respectively, in 1888, 510 and 250, and in 1898, 539 and 309. People were living longer; in 1888, 68 people died aged 65 and over (27.2 per cent), and in 1898 it was 106 (34.3 per cent of the deaths). There was a reduction in the impact of infectious diseases such as typhoid and cholera, through better public health measures, of which the most important were the introduction of an efficient system of sewage removal and the provision of clean drinking water. Public health became the responsibility of Ealing Local Board of Health from 1863. The local board was a new type of local government, which replaced the parish vestry in many aspects of local administration, and was the government's response to the outbreaks of cholera that affected the country in the 1830s and 1840s. Introduced initially as a temporary expedient, these boards became a permanent option after the passing of the Public Health Act of 1848. The government could impose a board in areas where the death rate was high, but other areas, like Ealing, could petition for

one if local residents desired it. Unlike the vestry, the Local Board's area of jurisdiction did not include Brentford, nor the largely unpopulated area of Ealing, north of the Uxbridge Road. The local board's priority was the completion of a main drainage scheme for Ealing. Up until then, houses were dependent on cesspits to collect the wastes from their toilets. The new sewers were connected to a treatment works established at South Ealing Road in 1863, and extended three times between 1868 and 1881. A second one was constructed in the north of the parish in 1872, close to the River Brent. To improve the supply of drinking water, the Grand Junction Waterworks Company built the Fox Reservoir at Hanger Hill in 1888, which had a capacity of 3 million gallons.

 In addition, there were better medical facilities available in Ealing to cater for its growing population. In 1871, a modest cottage hospital with just three beds was opened in Minton Lodge at the north end of Northfield Lane, funded by voluntary subscriptions and independent of the council. Initially, there were three paid members of staff, who were assisted by two doctors working in an occasional voluntary capacity. Over the years, as demands on it rose, the building was enlarged and by 1886, it had sixteen beds. It was rebuilt in 1893, with nineteen beds and a dispensary. From 1871–1901, a total of 3,471 in-patients were admitted. Infectious diseases still posed a threat, and an isolation hospital was built on Clayponds Lane in 1884/85, funded by the Local Board, which had twenty-four beds by 1902. However, natural increase and better public health could not, on their own, account for the dramatic rise in Ealing's population. Numbers of people from elsewhere moved into Ealing as they always had. Most came from other parts of the British Isles, especially from inner London and the southern counties of England.

 In the population in 1901, women outnumbered men significantly – 20,014 and 13,013 respectively. Two reasons account for this. Firstly, women tend to live longer than men. Secondly, Ealing had a large, mostly female, servant population (4,616) to cater for its largely middle-class residents; Ealing's ratio of servants to the population as a whole was second only to Kensington in the Greater London area. Aside from domestic service, the largest employer of female labour was the laundry industry, with 387 employees in 1901. The biggest employers of local men were the building trades (1,458) and transport (995); neither is surprising given the amount of building taking place in Ealing and the number of railway, omnibus and tram services. Clerks, who kept the bureaucracy of the period ticking, numbered 495.

 The physical manifestation of this population boom was the large quantity of new houses. While this changed Ealing's character significantly, not all of the village atmosphere was lost. In 1876, Thorne could still write that Ealing was 'lined with houses, old and new, patches of greensward, gardens, shops, inns and chapels, very irregular, in parts very picturesque', with 'many good old fashioned mansions', as well as 'modern villas and cottages of the semi-detached class'. Many new streets were built in the second half of the nineteenth century. In 1861, there were 1,007 houses in Ealing, and in 1871, there were 1,664 inhabited houses, 181 uninhabited and 60 in the process of being built (an increase of 89 per cent in a decade). By 1881, there were 2,595 occupied houses (a rise of only 55 per cent) and 6,262 ten years later (a further rise of 141 per cent). By 1901, the figure had leapt again to 13,176 (a 110 per cent increase). Dr Charles Patten, Ealing's medical officer, noted in 1898, 'The very large increase of building operations and the construction of new roads during the last two years have surpassed anything previously known'.

In the 1870s, housing and shops were built on the west side of the High Street and extended further southwards, and continuous housing existed along the eastern side from the Uxbridge Road to the Green. More houses and shops were also built along the Uxbridge Road, extending eastwards as far as the common, and westwards towards Ealing Dean, as well as near the railway stations on Haven Green. Detached houses lined the west side of the common and along North Common Road. Houses also sprang up to the east and west of the old parish centre, near St Mary's church.

Some land was developed in small parcels by builders, but some was acquired by Land Societies. The Conservative Land Society bought the rectory estate near Ealing Green in the 1860s and built twenty detached and semi-detached villas. Building land became available with the break-up of large landed estates, as landlords saw the way demand was going and could get a better return from housing than farmland. Ealing Park and its 70 acres, for example, was sold for housing in 1882, though the house remained in use as a convent, with the land fetching between £536 and £574 an acre. By 1894, the new houses in Murray, Carlyle, Darwin and Lawrence roads, and Ealing Park Gardens were chiefly homes for clerks, who travelled to work in central London by the District line. Charles Jones lamented the demise of Ealing Park: 'As has been the case with so many beautiful domains, its splendid avenue was cut down, its lakes were filled up, its fountains disappeared, and the park once thronged with the youth and beauty of the land, became the prey of the speculative builder.'

Similarly, in 1892, the Elm Grove estate (near Ealing Common) was sold by the Rothschild family for housing. Edward Wood, Ealing's most substantial landowner, with almost 1,000 acres, began selling his land for housing, chiefly in the north of the parish and along the Uxbridge Road. The quality of Ealing's housing was variable, but in the north of the parish it tended to be very high. Not all speculative building was successful, however. Henry de Bruno Austin planned an ambitious upper middle-class housing estate in north Ealing, buying 230 acres from 1862–66, but despite laying out the roads, he went bankrupt in 1872 after only a few houses had been built. Other developers' schemes also failed at this time in north Ealing, partly due to inadequate drainage, over-optimism and poor transport links, while those closer to the railway station, such as at Eaton Rise, Oxford and Windsor Road, were successful. One man's failure could provide an opportunity for others; a consortium of Alfred Priest, a corn merchant, Dr Ebenezer Pearce, headmaster of Great Ealing School, and Charles Jones bought some of Austin's land and built a number of detached houses selling for a minimum of £700 each.

In contrast to these high-class developments, a builder by the name of Stevens put up a number of small cottages known collectively as Stevens' Town in West Ealing, between Green Man Lane and Brownlow Road, from the 1860s to the 1880s. These were inhabited by labourers and their families, where many women worked as laundresses or servants. It was said to be 'almost the only land in Ealing where houses of this class are permitted to be erected'. By the late nineteenth century there were 8,000 people living in 700–800 cottages and overcrowding was an issue. Conditions were often poor, as a contemporary described:

In Green Man Lane, we called at one of a row of old cottages that adjoins the road. Each contains four rooms – all small and low ceilinged, and the front door opening directly upon the little parlour. The rent, we were told, was 6s a week, except in the case when an extra shilling was charged on account of the back yard being a little larger than those of the other houses.

There were similar conditions in Ealing's New Town, to the south of the Broadway, the area later replaced by the Ealing Broadway shopping centre. Yet the poor had little choice, such was the scarcity of cheap housing, so they had to endure rats, peeling wallpaper and damp walls. Initially, demands for better housing fell on deaf ears.

To combat such instances of poor quality housing, the local board introduced model bye laws in 1880, which were added to in later years and set out building standards; builders who failed to comply were often taken to court in Brentford and fined. Builders had to apply for planning permission from the local board and its works committee was the de facto town planning authority, comprised of both councillors and the board's surveyor, Charles Jones. It would grant permission, withhold it, or ask for alterations to be made.

From 1890, local councils were given powers, under the Housing of the Working Classes Act, to build houses with public money and were pressed to do so by spokesmen for the working classes, but in the early days few decided to do so. In 1896, the matter was broached by the Local Board, but shelved for another three years, until a piece of land at the corner of South Ealing Road and Pope's Lane was bought and laid out for housing in 1899. One hundred and thirty-one houses and flats were built at the cost of £40,000. Rents charged initially were between 5s 6d and 11s per week. Despite this, one councillor claimed the council was 'not responsible for the housing of London's workmen, we don't want to attract them here', though admitting that working men were needed 'for the comfort of villadom'.

Nevertheless, we should not exaggerate the impact of this housing boom, significant as it was. In 1900, much of the south of Ealing, near Northfields Lane and Little Ealing, and towards Acton, and the north-east, towards Hanger Lane, was still not built on, and the busiest decade of house building was yet to come. However, it was not surprising that there was concern about the loss of green space. The local board and its successor local councils preserved a

Ealing Broadway, 1887.

Charles Jones.

number of open spaces. The old manorial lands owned by the ecclesiastical commissioners were passed to the board to manage: Ealing Common (47 acres), Ealing Green (4 acres), Haven Green (7 acres) Ealing Dean and Drayton Green. The council also bought 22 acres of land for Lammas Park in 1881 and, more significantly, two decades later, what became Walpole Park. On the death of Spencer Walpole, the council purchased from his son the Manor House and its 30 acres of grounds, while allowing his aunt, Frederica Perceval, the last surviving daughter of Spencer Perceval, to reside there until her death in 1900. Charles Jones remarked that, 'there is no better investment which a public body may make than the securing of open spaces – a boon for the present and an inheritance for generations yet unborn', while the local Medical Officer, Dr Patten, thought the new Walpole Park was

> so magnificent a lung in virtually the centre of our town, [that it] cannot result in other than great gain to the health and enjoyment of a large section of the population, because year by year the difficulty of getting into the country will be increased by the ever widening fringe of buildings, springing up on the outskirts of the district.

The local board, under Jones' supervision, also caused large number of street trees to be planted; these, growing to maturity, together with its many open spaces, would give Ealing a reputation for being a green borough.

Ealing's economy was also changing. Although arable farming reduced as houses were built on farmland, and the number of sheep and pigs fell from 794 in 1869 to only 387 in 1887, other aspects of Ealing's agricultural economy remained buoyant. The number of cattle increased from 506 in 1869 to 612 in 1887, as a result of the establishment of dairies to supply milk both locally and to London, since before refrigeration fresh milk had to be delivered daily. For example, Cotching, Son & Co. had a large model dairy farm at the south end of Hanger Lane. Market gardening also remained relatively prosperous, forming a

quarter of all agricultural land in Ealing in 1887. Green vegetables, root crops and soft and hard fruit were all grown, and in 1901, there were still 405 men employed in farming.

By contrast, local industries were very few and small in scale. In 1893, there was Cocks Ltd, a bicycle factory on the High Street and Hilton and Co., mineral water manufacturer on St Mary's Road. In West Ealing there was the Autotype Works (from 1877) and, on Northfield Lane, there was the Ealing District Steam Laundry.

Another major part of Ealing's economy emerged in these decades as the number of Ealing's shops increased. They also tried to publicise themselves to both locals and newcomers. As the publicity booklet *Ealing Illustrated* stated in 1893, it aimed 'to bring the attractions of the town more prominently before strangers' notice, and also to remind residents of its abundant commercial resources' and 'The matter relative to the general commerce of the town will be of value alike to those who are already residents, and to those who contemplate making a home in the district'. Quality and 'reasonable price' were emphasised throughout.

According to this booklet, the town's shopping streets were deemed impressive:

> The Broadway, The Mall, The Parade and High Street are all handsome thoroughfares; after these, but by no means insignificant, come Spring Bridge Road, and one or two others, while there are absolutely no poor streets at all. The commercial part of the town is very compact, and the thoroughfares being very wide and well lit, they form very agreeable promenades wither by day-light or in the evening.

One of the long-established and most impressive shops was that of Eldred Sayers, which was on the north side of the Broadway, in a building known as Western House. It was

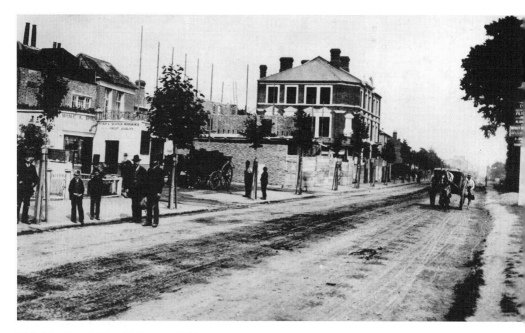

Uxbridge Road, West Ealing, *c.* 1880.

established in 1872 after Sayers bought a drapery business created in 1837 by Abraham Fountain (husband of the Mrs Fountain of diary fame). As well as local business, they claimed to supply 'many families resident in the Colonies and India, who making a temporary stay in Ealing now and again, when they return abroad still continue to deal with Messrs Sayers & Son and have their necessary supplies of drapery and millinery goods sent out to them'. Messrs Waite, 'tailors and habit makers' similarly stated that they 'have a good Indian and Colonial connections, and outfits are supplied in large number every year'.

Several of Ealing's leading shopkeepers were also councillors, such as Eldred Sayers, Henry Kasner (a coal merchant) and Mr Johnson, a dairyman. Although most shopkeepers were men, there were some women; Mrs Smith's 'Court Florist' at No. 34 The Broadway and Haven Green was one, and Madame Marie Ellis, Artiste in Costume, at No. 19 The Mall was another.

Of the forty-five 'Leading Business Houses' in *Ealing Illustrated*, twenty-seven had been established for less than sixteen years. A newcomer to the Ealing scene was John Sanders, who began in business as a department store in 1865, and later moved to a prominent site opposite Sayers in The Broadway.

It was not always necessary for buyers to visit the shops and collect their purchases, certainly where perishable foodstuffs were concerned. Messrs Stevens Bros., Family Butchers of No. 27 The Broadway, promised that they 'make punctual deliveries by means of their own carts in all parts of the Ealing, Hanwell and Greenford districts daily, and their assistants call regularly for orders at any reasonable distance from their shops'. Others did the same. Stevens also had branches in two parts of Ealing, as did other shops.

There were also a number of shops along the Uxbridge Road in West Ealing, a poorer part of town. These were more suited to the needs of the residents in the immediate district and included staples such as bakers, butchers, bootmakers and drapers. The fancy goods shops, which were located in central Ealing, did not take root here.

Communications underwent major changes in this era, as Ealing became far more physically accessible in the later nineteenth century through improved transport links. As a result, more people could live in Ealing and work elsewhere, making it far more desirable for people of diverse incomes. More people were using the railways; from 1861–67, there had been an increase of 164 per cent in the passengers between Ealing and Paddington, but there were limitations to the train services provided by the Great Western Railway; one complainant in 1870 asked, 'Are we not all tired of high fares and inefficient means of communication?'

Services did improve in the 1870s. Trains along the GWR increased in number, with a second pair of tracks being built, allowing express and suburban traffic to be separated. A second station was built in Ealing, Castle Hill and Ealing Dean, opening in 1871, and serving the western part of Ealing. In 1899, it was renamed West Ealing station. The main Ealing station gained its 'Broadway' suffix in 1875. In the same year, third-class return tickets could be bought and, in the following year, there was an early morning train to Paddington, both of great help to working men. In all, there were an additional ten trains in each direction per day at the end of the decade. Yet we should not exaggerate, for even in the 1890s there were few early morning services, and fares tended to be beyond the reach of many working people.

Then came the underground railway. The first line, the Metropolitan Railway from Paddington to Farringdon in 1863, gave access to the City and so was a benefit to Ealing

Uxbridge Road, Ealing, *c.* 1890.

residents who wished to work in London. The Metropolitan District Line was built a decade later; its western extension reached Ealing as its terminus in 1879, with a station just north of the GWR Station on Haven Green. There was another station at the eastern end of Ealing Common. *The Middlesex County Times* claimed that the opening of this line was the most important piece of railway news, as far as Ealing was concerned, since 1838. However, it was remarked that the last services from London left too early for Ealing residents to see a play and return home by that route. The MDR also constructed a line towards Hounslow through the south of Ealing, which opened in 1883, with a station at South Ealing.

The railway became a well-used form of transport, and a cab rank was sited near the station to transport passengers on the final leg of their journey home. The waiting cabs are clearly visible on early photographs of Haven Green, and modern cabs still pick up in the same place. Horse drawn transport was still being used for passenger travel, but the day of the stagecoach was over by 1879; omnibuses, however, which could carry more people than the coaches, remained a common sight. There were operated by a number of small companies; for example, Mr Crockford ran three daily services from Hanwell to Regent's Circus, via Ealing.

Horse-drawn carts were used for every kind of work, as Major Cattley recorded:

Nearly all the transport was horse-drawn, and tradesmen delivered goods to their clients by horse drawn conveyances … Very characteristic of this period were the two wheeler corporation

dust carts, which were used to keep the roads clean ... Horse drawn funerals were constantly seen on the road to the cemetery ... the road became noisy when the trams arrived as well as horse buses along the Uxbridge Road and High Street.

One form of horse traffic that was never seen in Ealing was the horse-drawn tram, despite attempts to introduce it. In 1870, the Southall, Ealing and Shepherd's Bush Company planned to open a route from Shepherd's Bush to Southall, via Ealing, along the Uxbridge Road. Initially, there was approval in Ealing, because of the shortcomings of alternative forms of transport, but the company only built the section of track from Shepherd's Bush to Acton before falling into liquidation in 1875.

In 1883, the Brentford and Isleworth Tram Company wanted to extend their line from Brentford northwards as far as Ealing Lane. The local board objected and refused to grant permission. Five years later, the West Metropolitan Tramways Company resurrected their predecessor's plan for an Uxbridge Road line. Again, Ealing Local Board unanimously objected, citing the fact that the roads were too narrow, though some residents approved of the plan. It was withdrawn. When it resurfaced in 1890, the council, prompted by a petition of 1,700 names, rejected it once more.

A more determined company was the London United Tramways in 1897, planning to use electric traction with overhead wires. Ealing opinion was divided on the issue, and this came to a head in the council elections of 1898. Pro-tram candidates addressed a public meeting at the Victoria Hall under the banner of 'Electric Tramways, Incorporation and Progress'. The company joined in with seven issues of tram propaganda. Following the election, the new council debated whether it should run its own municipal tram service or should accept the LUT proposal. Opponents of the trams argued that they wanted to keep Ealing rural, that trams would depreciate property values and result in an invasion of cheap houses and shops, and that any tram service should be kept in the council's hands. Supporters denied that trams affected property prices, and claimed trams were efficient and cheap. They championed trams as a boon to the working man, who found trains too expensive and inconvenient. Councillors also argued that to continue opposition would be expensive and futile. Eventually, in 1899, they decided, by nine votes to two, that the council should cease their opposition to the trams and accept the LUT's proposals.

The council certainly got a good deal; the company had to pay all the money the council had spent in opposing the plans, as well as annual rates for the use of the road, and an additional £400–500 per annum. The council's surveyor was to supervise the building of the tramlines and the tram poles were to be used by the council for street lights. The Tramways Bill became law in 1900 and work began in Ealing in the following year.

Another transport innovation was the motor car. The first car was seen in Ealing in 1896. This belonged to John Sanders, the prominent local draper; he offered 10-minute rides in it in exchange for a shilling towards hospital funds. Another car was seen in Ealing in 1898, belonging to Mr Ravenshaw, who later gave a talk on his new toy to the Ealing Natural History Club. At this time, cars were restricted to 17–18 mph.

The growth of Ealing in the second half of the nineteenth century was overseen by Ealing Local Board, which came into existence on 25 May 1863. At first it was made up of nine elected members and only ratepayers had the vote. Three members were farmers, two were

schoolmasters, one was a lawyer, one a landowner, one a retired chemist and one a retired admiral. Its first chairman was Alfred Johnson, one of the farmers. At the 1868 elections, there were 623 electors, men who had properties worth £12 or more in rateable value. Initially, the area of the board's jurisdiction only extended to just north of the Uxbridge Road, but was extended northwards in 1874. As a result the number of elected members rose to sixteen, representing four wards, and these now included three merchants, two lawyers, two gentlemen, a stationer, an auctioneer, an engineer, an insurance manager, a teacher, an architect, an artist and an ironmonger.

Initially, its powers were limited and it only employed a staff of two: Charles Jones, its surveyor, initially paid £90 per year, and Alexander Hemsley, a solicitor, as its clerk, on £70 per annum. Neither post was full-time, for Hemlsey also became clerk to Acton Local Board in 1866, and Jones took other architectural commissions at this time. Jones was also made Inspector of Nuisances with a salary per annum of £10, and received 3 per cent commission on any public works undertaken. By 1896, the council employed at least fifty-three men.

As time went by, the board realised that the full council was a cumbersome method of discussing policy, and adopted a committee system. The main committees were: finance and works (1869), sanitary (1874), library (1883), baths (1886) and electricity (1892). Each was made up of councillors, officials and members of the public with particular expertise. For example, the library committee had a dozen members, of which, in 1883/84, five were councillors; three were clergymen and four lay members of the public.

Like the vestry, the board members initially met in the vestry hall, with meetings held at 4.30 p.m. every other Friday afternoon. The officials used rooms above a shop in the High Street until 1866, and then moved to further temporary premises. It was only in 1878 that a permanent headquarters was built. Designed by Jones in the Gothic style (as were all of his buildings), the building was erected on the corner of the mall and station approach, and included offices for the staff on the ground floor and a council chamber on the first floor, together with stabling and accommodation for the council's carts at the back. In 1886, this was felt to be too small, so land was bought on the Uxbridge Road from Edward Wood and Jones designed a larger town hall there in the same style. With much pomp, it was opened in the presence of the Prince and Princess of Wales in 1888. The older office buildings were sold to a bank, and continue to be used by its successor.

One of the board's first actions was to adopt a system of byelaws controlling the way it would operate, and then Jones was tasked with assessing the rateable value of all Ealing properties. As we have seen, one of main reasons for the establishment of local boards was to improve the sanitation of an area, and most districts did not have mains drainage. Jones had to report on the state of the sewers and inspect all the ponds in Ealing (there were a number on Mattock Lane, for example), and he then visited other districts to see how they dealt with this issue. A Drainage Sub Committee was formed, whose members reported how other towns operated their sewerage systems. Following this research, Jones drew up a plan for Ealing and, once a contractor had been chosen, he superintended the work himself. It was an ambitious scheme, costing £22,000, when the rateable value of the district was only £17,500 (this in 1863) and requiring the board to take out a loan. However, given the subsequent rise in population and thus rateable income (£58,233 in 1872), it proved a justifiable gamble

Sewers were laid along the roads and connected to properties, and the sewerage flowed by gravity to the treatment plant in South Ealing.

To pay for this, money had to be levied in the form of a property rate, much as council tax today. Richard Atlee was appointed as rate collector. He was unsalaried but would take a 2 per cent commission on the money he collected. The council decided on a rate of 1 per cent on the value of property and 2 per cent on the value of land. Initially this was expected to bring in £690 per year. Money was also borrowed, after permission had been sought from the Home Secretary.

Apart from the important question of sewerage, there was the matter of street lighting, as Ealing had none. After 1863, there were six gas street lights along the Uxbridge Road, four in Little Ealing, three on Castlebar Road and eight in another five roads. None were to be built on Drayton Green because the residents there were opposed to them. These lights would be lit on the evenings of every month from September to April. Electric street lighting became a viable option in the 1880s. Two companies lodged applications to supply Ealing, but the board opposed both and instead obtained powers, as did many other local councils in the London area, to run its own electricity supply from 1891. An electrical works was established in 1894 on South Ealing Road, built by Messrs Bramwell and Harris. By 1901, over 47,000 electric lights had been installed.

Although the local board took over many administrative functions in its area, the vestry and its adjuncts, the highways board and the burial board, continued in existence. These were to serve, as they always had, both Ealing and Brentford. The parish vestry continued to meet and appointed two churchwardens and four overseers (half of whom came from Ealing and half from Brentford); it collected the rates to give to the board of guardians for poor relief, and continued to administer the parochial charities and act as a local forum for other issues, such as transport and the almshouses (new almshouses being built in 1872). A burial board for Ealing & Old Brentford was established in 1858, and a site for a cemetery was purchased in South Ealing in 1860. Separate chapels were provided for Anglicans and Nonconformists, and the original 8-acre site was extended to 21 acres by 1890.

The Highways Board petitioned Parliament for its dissolution, leaving Ealing and Brentford independent, and ceased to exist in 1873. With the addition of the area north of the railway, the whole of Ealing now fell under the remit of the local board. Another sign of the times was that the toll gate near the Old Hats pub in West Ealing was demolished in 1872, as tolls were finally abolished on all London roads. The local board now had to maintain, and where necessary improve, 21½ miles of road (which had increased to 52 by 1901). All were provided with sewers, and most were paved, kerbed and channelled. Bridges over the railway had to be widened.

The council adopted the Public Libraries Act in 1883 and opened a library at Ashton House on the Green, later moving it to near the town hall in 1888. For many years, John Allen Brown, a local historian and magistrate, was its chairman. There were further changes in local government as the century progressed. In 1888, elected county councils replaced the quarter sessions as the management of the historic counties, and were given extensive powers. A new London County came into being, but Ealing remained outside it in the County of Middlesex. In 1894, new legislation abolished the local boards and, for towns with populations under 30,000, replaced them with district councils. Single parishes became

urban district councils, which gave them more powers over parks, cemeteries and planning issues. Each district returned two members by election to the Middlesex County Council. Ealing's first two members were Sir Edward Montague Nelson (a successful businessman and chairman of Ealing Local Board since 1877) and John Bolding.

More controversial was the question as to whether Ealing wanted to adopt the 1882 Municipal Corporations Act, which would increase its responsibilities. Discussion began in 1884, but it was not until 1892 that it became the subject of public debate, and support from the council at first was very limited. However, at the council elections in 1894, most councillors swung behind it and a petition of 2,000 residents supported the campaign. The Privy Council was petitioned but ruled against it because there was not unanimous support and the campaign lay dormant until 1898. This time there was complete support from all councillors, but opposition came from the county council, who feared that the county would be carved up if Ealing became a borough. Despite these misgivings, the second petition that was sent to the government was met with favourably, and Ealing was set to become a borough in 1901.

Party politics appeared to have been avoided in the local board and urban district council and candidates did not identify themselves by party labels, but by the issues they supported or opposed. In 1898, for instance, men stated whether they opposed or supported tramways, council housing and incorporation. In 1901, though, candidates identified themselves as being either moderates, progressives and independents, with the first of these in the majority.

In 1885, Middlesex was divided into seven single-member Parliamentary constituencies. One of these seven was made up of Ealing, Acton, Chiswick, Greenford and Perivale, but was given the name Ealing, with an electorate of 9,283 (male) voters. Lord George Hamilton stood for the Conservative Party and Dr Gordon Hogg for the Liberals. Voters had to go to Westminster to cast their vote and Hamilton was returned with 4,375 votes to 2,691. He was unopposed in the next two elections, but in 1892 had an opponent in Stephen Holman. Holman was an Ealing resident, board councillor, county councillor, President of the Ealing Liberal Club, Methodist and businessman. Campaigning on issues such as Home Rule and the enfranchisement of women, he was soundly beaten by 5,347 votes to 2,112, and this time Ealing's electorate could vote in Ealing itself. In 1895, Hamilton became Secretary of State for India and remained Ealing's MP until 1906.

Women's political involvement increased in the last decades of the century. Firstly, female householders could vote in local elections in 1890, and in 1901 two even stood in the council elections, though both lost. More positively, Miss Chard became Ealing's first female member of the Board of Guardians. There was also, in 1898, the first known meeting of women in Ealing to call for equal voting rights with men (to which Hamilton was opposed).

The Victorian Age is known as an age of religion and Ealing's experience was not unusual. Ealing's churches increased in number and were more diverse in terms of the denominations they represented. This is partly a reflection of population increase, bringing as it did people of various denominations, who became numerous enough to warrant building a permanent place of worship in Ealing rather than travelling elsewhere to meet.

The Anglican Church sought to meet the demand by further dividing the parishes of St Mary and Christ Church. The Ealing Ruri-Decanal Association was set up to help establish new churches with grants and loans. Given that population growth was highest in

the west and north of the parish, districts were assigned from the parish of Christ Church with mission churches, later becoming daughter churches. The first of these was St John's, in West Ealing, initially a mission church in 1865 with a wooden building on St John's Road, and from 1867, at the corner of Churchfield Road and Mattock Lane, where it was enlarged twice. A yellow-brick church was erected at the corner of Mattock Lane and Broomfield Close in 1876. Its long serving minister (1867–1903), first as curate and then as vicar, was the Revd Julian Summerhayes.

Following closely on St John's was St Stephen's. An iron church served in its first decade, before a stone church was built in 1875/76. Another church in north Ealing was St Andrew's, on Mount Park Road, renamed St Peter's to avoid confusion with the nearby Presbyterian chapel of the same name, the permanent church being consecrated in 1893. St Matthew's church was originally located on Grange Park in 1872, in an iron church lent by a local Congregationalist, until Edward Wood gave land on North Common Road; a Gothic style church was built there in 1883/84. Another mission church was St Saviour's in the Grove, from 1881. Finally, there was a mission church for one of the new churches, St John's, which became St James' in West Ealing from 1890.

There was also a major rebuilding of St Mary's church at this time. The Revd Relton believed that the eighteenth-century parish church should be both enlarged and made to appear more in keeping with the other churches and chapels being built or being planned. Samuel Sanders Teulon was employed to effect these changes and, between 1865 and 1872, he was responsible for 'the conversion of a Georgian monstrosity into the semblance of a Constantinopolitan basilica', in the view of Archbishop Tait, at the cost of £20,000.

Roman Catholics had not been able to worship openly in England since the sixteenth century until emancipation in 1829. The Catholic hierarchy was re-established in 1850. There does not seem to have been an immediate demand for a church in Ealing until 1893, when the mission church of St Joseph and St Peter opened in a private house in Windsor Road, relocated by 1897 to Mattock Lane, in the home of Father Richard O'Halloran. At the same time, Benedictine monks from Downside Abbey arrived in Ealing and bought a house at the corner of Charlbury Grove and Marchwood Close. They began to have a church built, St Benedict's, and, while still unfinished, began holding services there in 1899.

A number of Nonconformist chapels opened too. The Baptists established two chapels; one on a road in West Ealing, soon to be called Chapel Road, in 1865, and the other just off Haven Green, in 1880, but the latter grew so much that its seating capacity (872) was too small by 1893. The Methodists also secured a local presence with two chapels by the end of the century. Although the Wesleyan Methodists initially met in a house in the Mall from 1864, they had their sights on higher things. Beginning with a school chapel on Windsor Road in 1865, they had an adjoining church built in 1869 to a Gothic design by Jones and Tanning. Primitive Methodists in West Ealing finally acquired a permanent building on the Uxbridge Road in 1900 after nearly four decades of use of a temporary structure. The Congregational church on the Green continued to flourish, but Scottish members formed St Andrew's church, initially in an iron building on the Uxbridge Road opposite Christ Church in 1875. When funds permitted in 1887, they had a brick church built at the corner of Mount Park and Aston Roads.

Churches were very active in the community. The energetic vicar of Christ Church, the Revd Joseph Hilliard, founded a friendly society and working men's club in 1868. A St

Mary's coffee tavern opened in 1880 on the corner of Warwick Road, sponsored by several clergymen. This is quite apart from the numerous church schools that sprang up in, by both Anglican and Nonconformist churches.

However, there were some tensions between Protestants and Catholics. The Protestant Alliance founded a local branch to preach against the alleged evils of Catholicism, equating it with ritualism, idolatory and superstition, as opposed to the truth of Protestantism. The Revd Summerhayes was a supporter of this cause, which held lectures to publicise itself from 1890. Similar organisations were the Orange Order, established in Ealing in 1891 and the Loyal Layman's Union of 1899, which attacked alleged idolatry at St Saviour's (an Anglo-Catholic church). It was noted that these groups were 'unpopular in some quarters' according to the local newspaper.

Education was closely associated with religion. There were already a number of schools in early nineteenth-century Ealing, but more were needed as the century progressed, not only because of the rise in population, but also a result of legislation requiring school attendance. The Education Acts of 1870 and 1880 required public authorities to provide schools where they were insufficient in number, and stipulated that every child had to receive an elementary education up to the age of ten years.

Some local councils responded to this by building schools at the ratepayers' expense, and this occurred in neighbouring Acton and Hanwell. Nonconformists in Ealing were in favour of this approach, but Anglican clergymen led by the vicar, the Revd Relton, opposed it and carried the majority of Ealing residents with them. This led to the formation in 1877 of the Ealing Education Association, whose aims were to maintain religious teaching in elementary schools, to provide for the efficient operation of the 1870 Act, providing new schools where needed, and to prevent the establishment of a local school board. It would raise the necessary funding through voluntary subscriptions, not compulsory rates, and by arguing that 'the committee have no sympathy with the extravagant notions that appear to be entertained in some quarters as to the amount of education that should be provided for the poor out of the pockets of other people'.

A committee was formed, which included the local clergy, Jones and Hemsley. From at least 1887, the president was Montague Nelson and Walpole was one of the vice presidents. Initially, they supported six schools: St Mary's two schools, St John's, the British (i.e. Nonconformist) School and two schools in Brentford. In 1878, £323 5s 4d was raised by 372 subscribers, but finance also came from government grants and from the modest fee scholars paid (from 2d to 6d per week).

The largest of these schools were St John's School (founded in 1862 on Felix Road), with an average daily attendance of 466, and the British Schools, where 261 attended on average. In total, 1,168 children were educated by these schools. In 1895, the Brentford schools were no longer assisted. By 1900, there were 2,156 children in these church schools (five Anglican, one Wesleyan and one British School). Generally speaking, the standard of education was said to be good, with creditable work and promises of improvement, yet accommodation was not uniformly adequate, with one school described as being 'very much overcrowded' and another as 'too full to be comfortable'. The association took note and decided that 'further school accommodation is urgently needed' and planned a new school for the corner of Murray Road and South Ealing Road.

The other schools were those opened by Christ Church and St Saviour's in the 1860s and 870s, adjacent to the churches in question, and the high fee-paying Ealing Wesleyan School, founded 1864, St Stephen's in 1867 and located on Pitshanger Lane in 1882. St Mary's Girls' School on Ealing Green was rebuilt and extended in this period, as was the Boys' School on South Ealing Road. Of course, private schools survived and grew in number in these years. There were fourteen in 1871, twenty-two in 1880 and twenty-nine in 1900, of varying sizes. The Great Ealing School continued to exist, but under Charles Morgan's headmastership ran into financial difficulties in the 1870s, to the extent that it was sold to a Revd John Chapman, a prominent Jewish educator. He seems to have revived the school, largely attracting his co-religionists, though open to boys of all denominations.

Byron House School was run by Charles Atlee the younger from 1866–86, but was then acquired by Dr Brucesmith, who renamed it Ealing Grammar School. It prepared boarders and day pupils for passing public examinations. Likewise, at Rochester House, boys were prepared for examinations for the Army and civil service. Durston House was a preparatory school, founded by the sons of a former headmaster of Great Ealing School on Castlebar Road in 1886, which took day pupils only. Ealing College, founded in 1820 on Church Lane, had a number of different locations in these years.

New private schools opened or moved to Ealing, several catering for girls. A well known one was the Princess Helena College on Montpelier Road. Founded in London in 1820, it relocated to Ealing in 1881/82, occupying purpose built premises, which cost £10,000. It taught the orphaned daughters of soldiers, sailors and clergymen, but developed as a girls' public school and took fee-paying girls too. There were fifty-five boarders and 100 day pupils, with a kindergarten for children of both sexes. Heidelberg College was founded initially at No. 67 Gordon Road from 1893, as a girls' day and boarding school, by three spinster sisters. Another girls' school, run by Mrs Wristbridge and Miss Waghorn, was often on the move: at the Grove in 1866, Windsor Road in 1874 and on Ealing Common in 1883.

Other residential schools included St Helena's in West Ealing, founded in 1884 and run by nuns, with the aim of saving young women from a life of crime by training them for domestic service. The Ealing Girls' Home was relocated from Acton to Ealing in 1867, on St Mary's Road. It took about twenty girls per year, had a similar aim to St Helena's and claimed a success rate of 96 per cent. Another local school was the Training College for Teachers of the Deaf, located in Castlebar Hill from 1886, which also took fee paying deaf pupils.

There was also some limited provision for further education. In 1876, classes in science and art began at St Mary's and the British Schools, with a combined pupillage of twenty-nine, rising to forty in the next decade.

Life in Ealing was not all work and no play. Leisure became increasingly organised, and more diverse in the late nineteenth century. Cricket had been played in Ealing since the eighteenth century. The Village Cricket Club was founded in 1864, possibly using grounds near The Green Man pub. From at least 1871, there was another cricket club and the two merged in 1874. They then had their grounds near Corfton Road. Another ancient pastime that became more formalised in these years was swimming. Many ponds in Ealing had been formerly used, but in 1884 a swimming pool was built on Longfield Avenue.

Newer sports included tennis, golf, cycling and badminton. Ealing Lawn Tennis Club was formed in 1882, with courts off Madeley Road, and another tennis club was the Magpie

Club, off Castlebar Hill, in 1896. There was also a golf club at Castlebar in 1898, and the grounds of Hanger Hill House became a golf course in 1901. Cycling became popular in the 1880s, there were several cycle shops in Ealing, and serious riders could join the Ealing District cycling club. Badminton was a sport popularised in England by returning Indian army officers and civil servants, and was being played at Ealing Baths by 1893.

There were also pursuits for the more cerebral, too. The Ealing Microscopical and Natural History Society dates from 1877, and one of its founder members was Charles Jones. Then there were the political clubs, such as the Ealing and Hanwell Liberal Association, founded by 1880, with premises located on The Green in 1890. Perhaps more important were the Conservative Association and the Constitutional Club, which had premises like a gentleman's club in the Uxbridge Road. The Primrose League, established in 1884 to recruit a mass membership for the Conservative Party, very quickly had a branch, or 'Habitation', as they were known, in Ealing.

James Acworth had been printing a local journal since 1858, and by 1863, this was named *The Ealing Post* and began printing news as well as adverts. In 1868, it was renamed yet again as *The Middlesex County Times*. At first this had four pages, with adverts dominating page one, expanding to eight in 1884. Its news coverage included matters discussed by the local board, as well as local sport, crime, cultural activity and the public activity of the social elite. There was also some coverage of events in neighbouring parishes in Middlesex. The newspaper had offices on The Broadway, and became a limited company in 1892. It had a few rivals: *The Ealing Advertiser* in 1882, *The Ealing Guardian* in 1898, and *The Ealing Gazette* of the same year. Of these, all but the last were short lived.

Although there had been assembly rooms in Ealing in the early to mid-nineteenth century, they seem to have fallen into disuse in later years. A new concert hall opened on The

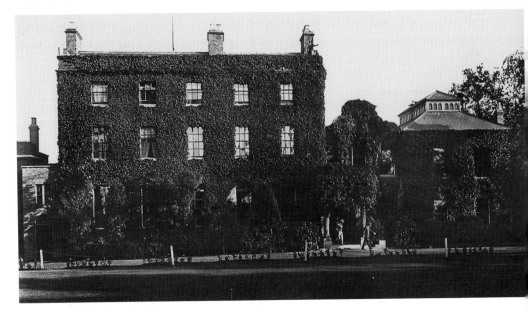

Hanger Hill Golf Club, *c.* 1901.

Broadway in 1881, renamed the Lyric Hall in 1883. It was rebuilt in 1899 as The New Theatre, but the Lyric still existed, albeit as a restaurant nearby.

There were several charitable bodies, such as the Ealing Philanthropic Institution, which had been founded in 1868 soon lapsed, only to be resurrected in 1881. These aimed to relieve poverty by raising charitable funds, assessing needs and then acting appropriately.

Local events included the shows of the Ealing, Acton and Hanwell Horticultural Society, which was established in 1865 by the Revd Hilliard. The society held an annual summer competition, which became increasingly popular and well attended as the years passed. These annual contests took place in the grounds of Ealing's surviving mansions, such as Elm Grove, The Manor House, the Vicarage and Gunnersbury House. By the 1890s, the event took place over two days and more and more people exhibited their garden produce. It was noted, 'As every year the number of exhibitors increase, especially in the class of cottagers' exhibits, the number of persons whose interest is aroused in its doings grows larger and larger.'

More traditional leisure activities persisted in this era, but became increasingly censured, such as the horse races near Ealing Common. Another was the annual Ealing Fair held on the Green, which was being seen by some as archaic, rowdy and unnecessary. Eventually, the Local Board requested the Home Secretary use his powers under the Fairs Act of 1871 and ban it, which occurred in 1880. Even so, a determined police presence was necessary to clear the Green, where it was traditionally held. By the end of the century, there were thirty-six pubs in Ealing, and of these, all but seven predated 1863, though many of the older pubs had been rebuilt.

Given the increased number of clubs and societies, many needed a place where indoor events, such as balls, dinners and entertainments, could be held. In the past, clubs had been content to use pubs to hold social events and meetings, but these were now seen as inadequate. In 1887, to mark the Queen's Golden Jubilee, a number of Ealing's elite decided that a subscription should be raised to provide the money for such a hall, to be named the Victoria Hall. Edward Montague Nelson, Lord Rothschild and Edward Wood made substantial contributions, but it was some years before the debt on the hall was paid off.

Whereas in the eighteenth and nineteenth centuries Ealing had been described by outsiders, by the eve of the twentieth century it began to describe itself, usually in glowing terms. The following, written in 1895 by Sykes, may be taken as typical:

Ealing and its vicinity abounds in noble mansions, large and stately dwellings, standing in rich and ornate grounds, surrounded by lofty walks and sheltered by noble trees. The situation is near enough to the Thames to make the loveliest haunts of the river easily accessible, and it is distant enough to be free of the fogs and low humours of a riparian situation; it is remote enough from London to be almost pastoral in its charms yet close enough to be reached by many routes within an hour. The streets of the town and the urban roads are broad and well made, the latter lined with noble chestnuts, that in the spring, are a mass of spiked bloom, suggesting the boulevards of continental cities rather than the prosaic highways of English life. It abounds in large open spaces, wide stretching greens and commons, everywhere foliage and bloom greet the senses. No noisome factories belch poison into the air. It is *rus in urbe* in effect. The man of business can be wafted almost without effort in the very heart of the business centre of the world, and yet his

home lies in gracious avenues lined with stately trees, and far removed from the toil and turmoil of the City and its eternal din.

This is a glowing and not entirely accurate view, but it is one that would be repeated, as we shall see in later decades.

It could not be said that all was rosy in Ealing's garden, as the transformation of the area had been bought at a price. Even Charles Jones, never a man to denigrate Ealing, wrote, after commenting on the once sylvan nature of Ealing's river, that, 'Its only river, the Brent, has long lost its beauty and its character.' Yet it was still possible to walk from Ealing and soon find oneself in the countryside. As Jones wrote in 1901,

> probably there is not a single inhabitant but has at some time or other wandered northward by Kent Gardens to Perivale, or by Hanger Hill to Twyford, in search of the old world beauty and rural simplicity, which, adjacent to Ealing and within sight of the great city, is to be found in either of the places to which we now refer.

Revd John Summerhayes later recalled that Ealing was, at the time of his youth in the 1880s, 'a pretty village with abundance of wild flowers, some of them growing within 30 yards of the continuation of Oxford Street [that is the Uxbridge Road].'

The end of the Victorian Age meant more than the death of Victoria in 1901. Two of Ealing's well known figures passed away, too. One was Sir Spencer Walpole, who was not an eminent politician, but an important local figure. He died in 1898 aged ninety-one. Another was his sister in law, Frederica Perceval, who died in 1900 aged ninety-four. Their passing meant that two more links with the first part of Ealing's nineteenth century were gone. Ealing had changed considerably in the last few decades of the nineteenth century, and the early twentieth century was to see yet more change, on an even more unprecedented scale.

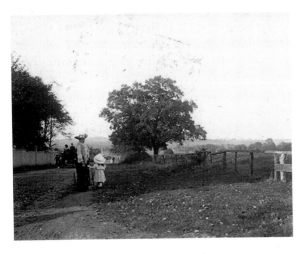

Argyle Road, *c.* 1890.

5

QUEEN OF THE SUBURBS?
1901–26

Ealing was granted its Charter of Incorporation on 3 June 1901, giving the district the formal title of 'The Mayor, aldermen and Burgesses of the Borough of Ealing'. It chose the motto 'Respice, Prospice', meaning 'look backwards, look forwards', and had a coat of arms with diocesan and county council crossed swords and an oak tree. There were eighteen councillors, equally divided between the six wards: Drayton to the north-west, Castlebar to the north, Mount Park to the north east, Lammas to the south-west, Manor to the south, and Grange (originally to be named Gunnersbury) to the south-east. However, these wards were unevenly populated, Castlebar and Manor each having over 1,000 burgesses (voters), the others having fewer. The first mayor was Alderman Henry Green. In addition to the councillors were six aldermen, one from each ward, all former councillors, who did not now stand for public election.

Council meetings were every Thursday at five o'clock. There were also a number of committees: baths, housing, public health, electric, fire brigade, works, highways, open spaces and tramways, general purposes, finance, Victoria Hall management, public library and the school attendance committee. Some met monthly, some weekly. As the years passed, the council took on other roles, and by 1920, there was a maternity and child welfare committee. Not all those on committees were councillors; the last mentioned included four women, none of whom were councillors, including Mrs Travers Humphreys, the wife of the famous judge and a prominent citizen in her own right.

On Charter Day, 10 July 1901, the charter, signed by the new King Edward VII, was read in public on the common to an assembled throng, by William Rushton, Town Clerk. Present were councillors of Ealing and neighbouring districts, clergymen of all denominations, friends and burgesses, and 'all went as merry as a marriage bell'. In the evening there was a banquet in the Victoria Hall, presided over by Edward Montague Nelson, Charter Mayor. Children's entertainments took place on the common and the day ended with fireworks, which 'wound up the all-important proceedings of the first public recognition of the new Borough of Ealing – the first in the County of Middlesex'.

Politically, parliamentary boundaries were altered in 1918 so that the Borough of Ealing alone became a constituency. It remained a solidly Conservative seat throughout this period despite the growth in population, which brought in more working-class voters, a national Liberal landslide in 1906, and the rise of the Labour Party as an important force

Henry Green, Ealing's first mayor, 1901.

in British politics after the First World War. Sir Herbert Nield, a barrister, succeeded Lord George Hamilton in 1906 and continued throughout the next two decades to become Ealing's longest standing MP. Maurice Hulbert was his Liberal challenger in 1910, and in the elections between then and 1924, only one Liberal candidate ever stood. His Labour opponent was Arthur Chilton, a railway signalman and councillor from 1917 for Lammas ward, in the elections of 1918, 1922, 1923 and 1924, but he never gained more than 6,765 votes, and Nield never less than 12,349.

There were other political forces emerging in early twentieth-century Ealing, building on movements already present in the previous decades. There were members of the West Middlesex branch of the London Society for Women's Suffrage, holding meetings in the town hall and Ealing Common to promote their cause, and taking part in marches in London. However, Ealing women were not unanimous on this subject, for in 1911 there was, in the town, the Non-Violent Suffrage League and the Women's Anti-Suffrage League. There was also a branch of the newly founded Independent Labour Party in Ealing.

Ealing was still a parish, and poor law responsibilities remained with a board of guardians. In 1901, there were six guardians, two of whom were women, five overseers and a vestry clerk. It was at this time that the phrase was coined that seems forever linked with Ealing. It was used by Jones in the preface to his first book, *Ealing From Village to Corporate Town* written in 1902. He wrote that 'the once comparatively unknown village is recognised as the Queen of Suburbs with a name which stands out, far and near, for its advance in sanitary work, and its retention to the fullest extent of its floriculture and sylvan beauty'. It is worth noting that the phrase was not original. In the late nineteenth century, it was already being used of Richmond and Surbiton. It is also important to stress that for some residents, the

dea of Queen of the Suburbs might have had a hollow ring, as twentieth-century Ealing had ts share of crime and poverty.

In the next decade, the phrase was commonly adopted and the 1925 Borough Guide eferred to 'Ealing, popularly known as Queen of the Suburbs'. In part, this was because of he parks and open spaces in the council's care. Jones wrote that

> the residents of Ealing… are proud of the title 'Queen of Suburbs' … and the cognomen 'Leafy Ealing' appropriately and tersely alludes to the many tree lined streets, forming, in the Spring, Summer and Autumn, very beautiful avenues, together with the numerous open spaces, parks and recreation grounds which are so great a feature of the Suburb.

ollowing on the acquisition of Walpole Park, further parks were created: 26 acres f Pitshanger Park to the north, 3 acres of Dean Gardens in West Ealing and the 5-acre Hanger Hill Park. By 1911, Ealing had 158 acres of public open spaces, about 5 per cent f the borough's total acreage. Lodges were built for some of the borough's larger parks as ccommodation for the park-keepers. In Walpole Park, a lake was constructed as relief work or the poor in the winter of 1904; tennis courts, croquet lawns, bowling greens and cricket itches were created in Lammas Park, and there were children's playgrounds set aside in outh Ealing. Public lavatories were built in or near parks.

In 1904, the booklet, *Ealing: A Country Town near London* made similar claims for the ualities that made Ealing 'Queen of the Suburbs', but suggested 'it were truer to speak of aling as a "country town near London" for, despite its close proximity … Ealing is a separate own, self-contained and self-sufficing in a sense, and to a degree not unusual in what are nown as "suburban districts". The brochure attributed Ealing's good health to its altitude,

ennis Courts, Lammas Park.

its gravel subsoil, its being well drained and having well-built houses and good sewerage, and also to its pure water supply and an abundance of sports clubs. There were fine open spaces, good schools ('no district around London, if anywhere in the country, affords more varied or better educational facilities') many churches, an active social life, efficient transport and affordable houses. Finally,

> Ealing has its negative as well as positive attractions. It has successfully resisted all attempts to make it a dumping ground for London's nuisances. It has no cemeteries except its own, no workhouse within its boundaries, no poor law schools, no lunatic asylums, and its police cases go to Brentford to be tried and is free from the manufacturing element.

Low rates were heralded as another point in Ealing's favour. In 1911, they stood at 6 11*d*, which made them among the lowest in the districts in Middlesex. Although rates had increased from 6*s* 6*d* in 1901, this reflected a modest reduction in district and poor rates, and the addition of the education rate, which was not payable in 1901. Although loans chargeable on rates rose from £119,470 in 1901 to £281,586 in 1911, the borough's rateable value had risen from £247,831 to £460,807. Yet the council was not seen as being economical enough by some, for in 1902, a Rate Payers' Protection Party was formed as the pressure group aimed at curbing the council's alleged extravagance. Calling for lower rates, it sponsored candidates in local elections who were sympathetic to these aims.

Just as the population had soared from 1861 to 1901, it continued to do so in the first decade of the twentieth century, from 33,031 to 61,222 (25,438 male and 35,784 female – the largest decennial increase in Ealing's history. Population growth slowed in the next decade, but despite over 1,000 men being killed in war, overall numbers reached 67,75. (28,911 men and 38,844 women) in 1921, continuing the gender imbalance noted in the previous chapter. The most densely populated parts of the borough were Lammas and Manor wards in the south, where the least affluent lived and housing density was highest.

Death rates continued to fall, from 11.5 per 1000 in 1911, to 10.6 in 1921 and 10 in 1925. However, the birth rate fell too, with 20.2 in 1911 reducing to 14 in 1926. Births still exceeded deaths, though; in 1911, there were 1,218 births in Ealing compared to 714 deaths and in 1925, it was 961 births (of which 4 per cent were illegitimate) to 685 deaths. Infant deaths also fell dramatically, from 151 in 1901 to 54 in 1925. This can be attributed to better health care facilities and advice, such as the provision of antenatal classes at the town hall and a maternity clinic in Mattock Lane. In 1907, medical inspections of school children began. A health visitor was appointed in 1911 and a midwife was appointed in 1916; there was a national focus on mothers and babies during and after the First World War.

These first decades of the new borough saw the passing of major figures of Ealing's late Victorian development. They included absentee landowner Edward Wood in 1904, Dr Oliver Vicar of Ealing, in 1916, and Edward Montague Nelson in 1919, but perhaps the most significant was the death of Charles Jones. Having served fifty years as borough surveyor and architect, the man whose motto was 'moderation in everything except work', declared his retirement. The council offered him to become the mayoralty, the only non-councillor both before and since to have been so honoured. He accepted, but died in 1913 before he could take up office. His monument, though, was all around him in Ealing, as well as the plaque now in Walpole Park.

As ever, as Ealing continued to grow, the majority of residents, particularly the more affluent ones, had not been born in Ealing. Of the prosperous residents of Castlebar Hill in 1911, none had been born in Ealing, though a few of their servants had. Of the seventy-six people living in Creighton Road, a lower middle-class district, only five were Ealing born. However, in the working-class Green Man Lane, half had come from Ealing or an adjoining parish. This 'immigration' into Ealing was mostly from elsewhere in England. The 1921 census noted that 62,382 people had been born in England (over 90 per cent of the population); just over a thousand were born in Scotland, 784 in Wales and 822 in Ireland. Just under 4 per cent had been born overseas, but even then, most (1,374) were born to Britons who had served in the civil service and armed forces stationed in parts of the British Empire, chiefly in India (743). Ealing, like Cheltenham Spa and Kensington, was known as a place where retired Empire builders (former soldiers, civil servants, merchants and their families, who had been born in or had served overseas) settled. A further 990 came from outside the Empire, 181 from France, 124 from the USA, 78 from both Germany and Russia and 46 from Poland. Grace Stevenson, a servant who committed suicide at her employers' house in Ealing in 1919, was a rare example of a black resident born in the West Indies.

Ealing's industries had always been few, but saw a slight growth in these years. Foremost was the old established firm, W. Ottway and Co., who made scientific instruments, and were an important supplier of gunsights and telescopes for the military in the First World War. They had workshops, warehouses and offices in the New Broadway from 1908. Ealing Park Laundry off Darwin Road was another large concern, employing 387 people in 1901 and about 500 ten years later. There were also offices, warehouses and factories numbering seventy-four in 1921, but only two hotels.

Most men worked; in 1921, 19,283 did so, whereas 3,629 were retired or unemployed. Continuing the pattern set in the late nineteenth century, many men worked in the building industry – 1,935 in 1911 and 694 in 1921. Two thousand were employed in transport industries in 1921. At this time, there were 1,607 metal workers and 889 wood workers. Despite the fall in the acreage cultivated, agriculture still employed 421 workers in 1921, though most probably worked outside Ealing. The largest single group of male workers were those employed in commerce and finance (3,300), together with clerks (2,774 in 1921, of which 1,355 were professionals and 1,270 were employed in public administration). There were also 564 male servants.

Less than half of its residents actually worked in Ealing in 1921, a total of 11,317 (36.9 per cent), and Ealing had one of the largest proportions of its population who worked in London (11,479 or 37.4 per cent), while 7,797 of its inhabitants were employed elsewhere. However, 4,414 people travelled to work in Ealing from elsewhere, made possible by Ealing's good transport links. But over half of the population (37,152) did not work, including 15,822 children aged fourteen or under and 4,821 people aged sixty-five or over.

Most women did not work in 1921 (21,507 did not), but 11,176 did. Domestic service was still the most common work for women, but there was a decline from 5,545 in 1911 to 4,893 in 1921. Most worked in the homes of middle-class residents, who employed a housemaid and perhaps a cook. Servants could expect between £14 and £25 per year, depending on age and experience, and would also receive board and lodgings. Adverts often appeared in the local press and there were local agencies for servants. One advert in 1911 read, 'General

Servant wanted – good plain cook, 3 in family, good wages – Apply 36 Colebrook Avenue West Ealing'. But increasingly women were being employed in offices; an advert for office staff read, 'Wanted, a lady clerk, for a builder's office. Apply, stating experience.' Teaching was another growth area, where women could earn between £100 and £200 per year. There were 1,086 Ealing women working in the professions – 1,915 were clerks or typists and 1,089 worked in commerce and finance.

Shops provided much local employment, and by 1921 there was a total of 923. In 1903 many shopkeepers banded together to form the Ealing Chamber of Commerce to promote their interests. In their first year, they met to discuss common concerns, but also raised key issues with the council, such as numbering on the high street, tramways, a smallpox scare council elections and dealt with the post office concerning the delivery of goods.

Unemployment was a regular feature of life for some. The council, from 1904, like many other boroughs, began to provide unemployed men (mostly unskilled) with work during the winter. A labour bureau was founded in November of each year and applicants would register, giving age marital status, length of residence in the borough and so on. Priority was given to family men who had lived in Ealing the longest. Single men, men under twenty-one and those newly arrived in Ealing were rarely assisted. Between 1904 and 1911, 315–466 men were on the books per year, and it was impossible to find work for each one. One relief project in the winter of 1904/05 was the construction of the lake in Walpole Park, and in subsequent years work was given to improve other parks, make roads, dig paths, work on the sewage farms and paint lamp posts.

South Ealing had a reputation for poverty, so much so that it was sometimes referred to as 'Savage South Ealing' in the press, which jars with the better-known 'Queen of the Suburbs' label. It was noted in 1905, 'Of the existence of a good deal of very real material distress there can be no doubt, and unfortunately, the Police Court reports indicate that at time when poverty is less acute, drunkenness and other forms of depravity are only too prevalent. Steven's Town, in West Ealing, continued to be known for its poverty, alleviated to some extent by the energetic work of the clergy of St John's church.

After some misgivings by the county council, Ealing had its own magistrates' court from 1919, located in West Ealing, so criminal cases no longer had to be sent to Brentford. Mrs Travers Humphreys, wife of the judge, was the first female magistrate there. Most criminal cases in these decades in Ealing were relatively minor ones. From 1901–28, there were only three murders in Ealing; Alfred Perry was hanged for killing his mistress, Annie Covell, in 1910; Arthur Benbow shot Sophia Baker, his landlady, dead in 1912 and was found insane and John Ruxton killed Gladys, his wife, before committing suicide in 1915.

The decade 1901–11 saw the greatest level of building that has occurred in Ealing, both before and since; the number of houses increased by 101 per cent from 6,435 to 12,959 By 1921, there was a further increase of 1,975 houses (a rise of merely 15.8 per cent), a the rate of houses being built had slowed to a trickle during 1914–18; men and materia were diverted for war use. In 1921, there were then 13,189 houses, 276 blocks of flats and 858 shops, which also included accommodation, 87 per cent, 8 per cent, and 5 per cent respectively of the total housing stock. Housing density was low, with few houses being in multiple occupancy, as was common in many London districts at the time, there were 1.16 families per dwelling and 1.36 rooms per person on average, as average family sizes fell from 4.35 to 3.92 between 1911 and 1921.

More new building occurred in the south and west of Ealing. Drayton Green and Little Ealing were no longer detached hamlets, but part of the urban expanse of central Ealing. Northfield Lane, for long a country lane, ceased to be so as houses and shops were built on both sides and in streets off it, and was renamed Northfield Avenue. Dr Patten noted in 1910, 'A considerable portion of these new buildings are erected in the south west and west parts of the borough, and adapted for the dwellings of clerks, artisans and members of the working classes.' There was little sign of let up in development until 1914, 'so long as space is open to the speculative builder this increment of population is bound to continue'. In the 1920s, the Rothschilds sold their land in Ealing and detached and semi-detached houses were built on Gunnersbury Crescent and Gunnersbury Drive. Many garages were also built at this time, too, for the increasing number of car owners.

Large old houses, such as Drayton House and Fordhook were demolished; the former was replaced by a school, and the latter and its grounds had Fordhook Avenue and Fielding Road built on them. The Elm Grove estate was also replaced by houses. Spencer Walpole's own home, The Hall, was knocked down and Ealing Grammar School built on the site in 1913. Ashton House, which had once housed Ealing Library, was demolished and Bond Street built on its site to connect the New Broadway with Ealing Green in 1902/03. There was also building in the north of Ealing, too, around St Stephen's church, and another old building, Pitshanger Farm, was a casualty of this era's building boom.

Generally speaking, Ealing's larger houses only survived if other uses could be found for them. Pitshanger Manor became home to Ealing's Library and opened to the public in 1902 and a branch library opened in the following year on Melbourne Avenue in West Ealing. Castlehill Lodge became part of St David's Home for limbless ex-servicemen, opened in 1918. Castlebar House was bought for use as a school by Visitation Nuns from 1901–10 and then by Augustinian Nuns from 1912–15. Place House became a convent of the Sisters of Charity.

Shoddy housing was opposed by the council, as those newly built had to be erected and passed as fit by the borough surveyor's department in accordance with ever stricter by-laws. These standards did not only apply to new buildings, but as the medical officer noted, 'no family is permitted to remain inadequately or unhealthily housed or to be overcrowded'. Much of this housing was smaller than that which had been built previously. So, though there had been an increase in Ealing's roads from 33 miles in 1901 to 52 in 1911, this was a smaller increase than the number of houses, so, as Jones noted, 'It is indicative of the class of property which has been erected in various parts of the Borough.' The preponderance of smaller houses was regarded positively by one writer in 1904:

a number of new estates have been opened up – particularly in the west of the town and on these hundreds of houses of a more modest description, from seventy pounders to pretty semi-detached villas at £30 have been, and are, built in response to a public demand which shows little sign of abating ... electric trams ... have made the borough a pleasant place of residence for those less well endowed with the world's goods. It is possible now for persons with every size of income to find houses suited to their mind and to enjoy the advantages and pleasures of life in the borough. The newly developed estates are in close touch with the heart of the town and within as easy reach of its most popular places of resort as the older parts.

However, the medical officer took a less sanguine view about the availability of housing for the poorer, writing in 1912:

> There is evidence that suitable accommodation, although sufficient to meet the average demand of the better classes of the population, is certainly becoming more difficult to obtain by the labouring portion of our population, and doubtless something requires to be done to increase and improve this class of dwellings. To a great degree the working man is called upon to pay rents out of proportion to his wages and consequently an insufficient amount of his wages is left for procuring the necessaries of living and this is felt more by those having large families. The provision of cheaper and suitable cottages for the labouring classes, however desirable, is, as I know, a very difficult problem.

It was not one that the council were enthusiastic to address; apart from the workmen's dwellings of 1899, there was no public housing built in Ealing until after the First World War, when subsidies were provided by central government as part of a wider policy to improve the lot of the poor. In Ealing, a large council estate was built to the north of Pope's Lane and the south of the railway line, of twenty-two streets, all named after trees, between 1920–22.

Another response to the problem of housing was to adopt a self-build scheme, and this was the origin of the Brentham estate near Pitshanger Lane, operated by Ealing Tenants' Ltd. It began in 1901 when a group of six builders decided to buy land for nine houses in Woodfield Road. They were encouraged by Henry Vivian, a Liberal MP, to form a co-partnership. They then built houses in Woodfield Avenue, Woodfield Crescent and Brunner Road. The layout of this estate followed the principles of the Garden City movement, as promoted by Ebenezer Howard. Architects Barry Parker and Raymond Unwin helped plan the estate and designed Nos. 1-7 Winscombe Crescent. By the time of the outbreak of war in 1914, 700 houses covered 60 acres. The community had an institute for social activities, which was opened in 1911 by the Duke of Connaught. The community became home to middle-class professionals, often with Liberal convictions; one was the Perry family. Following Brentham's example, similar housing schemes appeared in Letchworth and Hampstead.

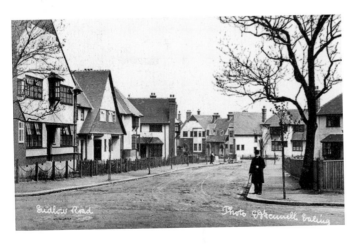

Ludlow Road, Brentham Estate.

Many houses in Ealing had electricity laid on (Ealing Council had been generating its own electricity since 1894 for street lighting and sale to domestic and business customers), and this number grew from 731 in 1901 to 4,569 in 1911. The telephone was also making its presence felt; with many middle-class homes and some public buildings and businesses having one, though by 1911, only about 5 per cent of residences were connected. Public telephone boxes were to be seen in the main thoroughfares and near transport hubs, and on the common. Ealing's first telephone exchange was located on the west side of the Green by 1904. But for most, letters and postcards were an easier form of quick and efficient communication. Wakefield and Sons were Ealing's premier photographers and postcard manufacturers.

By 1914, there was little available building land left in Ealing, except in the north-east, near Hanger Lane, towards the Brent in the north-west, and in the south-east towards Gunnersbury. There was also some land to the west of Little Ealing and the border with Hanwell, in addition to the north and west of Drayton Green near to Hanwell, and the east of South Ealing Road. There were also parcels of land between streets, some of which were occupied by orchards.

There were further developments to Ealing's transport system in these decades. The London United Transport Company's electric trams started running along the Uxbridge Road from Shepherd's Bush via Ealing to Southall in 1901, and the route was extended westwards to Uxbridge by 1904. It provided a frequent service with a tram every three minutes. After all the controversy of the 1890s, trams seem to have gained wide acceptance, as the medical officer noted, 'as a resident of the main road, and after several months experience, that if only the serious noise occasioned by them could be modified, there is little but good to be said of them'. They were not the only form of motorised transport, for motor buses began to be appear in the 1900s and horse omnibuses were phased out by 1914. One of the first bus routes to affect Ealing was that of the London General Omnibus Company, which from 1911 ran from East Ham through London to Ealing.

Tram in West Ealing, 1902.

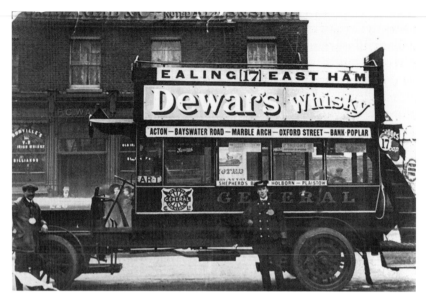

Motor bus on
Ealing Green.

Roads had to be improved due to the 'exigencies of traffic'. The Uxbridge Road benefitted
from wood paving on the coming of the trams in 1901; macadam replaced flint road surface
from 1907 and, by 1911, nearly 5 miles of roads had been improved in this way. Roads
were widened to accommodate the increased traffic, especially along the Uxbridge Road, but
also along other important thoroughfares, such as South Ealing Road and Pope's Lane. The
motor car was still relatively unusual, with only one garage in the whole of Ealing in 1911.
Motoring was too expensive for most people, but in the 1920s it became less so, although it
still remained the exclusive preserve of the middle classes.

Underground services continued to develop. A further station was opened on the
Metropolitan District Railway, between Boston Manor and South Ealing, named Northfield
in 1908 and renamed and Little Ealing three years later. Meanwhile, to the north, the
District Railway opened another branch – their first electrified one – from Ealing Common
towards Harrow, which had a station at North Ealing in 1903. Finally, the Central Line was
authorised in 1905, to extend the Central London Railway from Shepherd's Bush to Ealing
Broadway, but because of the war this was not opened until 1920. District trains ran from
six in the morning to midnight, every half hour. GWR trains were even more frequent, from
5.50 a.m. to twenty minutes after midnight, stopping at Ealing Broadway on average every
nine minutes and taking nine to twelve minutes to reach Paddington. There was also a spur
from West Ealing station to Greenford opened, and Castlebar Park Halt was opened in 1915.

Social and sporting clubs continued to grow and thrive. In 1911, there were fifteen football
clubs, ten cricket clubs, seven tennis clubs, seven bowling clubs, five hockey clubs and five golf
clubs. There were clubs catering for cyclists and rugby players. Not all sport playing involved
a club. Tennis parties were very popular among the middle classes in this period, doubtless
encouraged by the Wimbledon success of Dorothea Chambers, daughter of the vicar of St
Matthew's, Ealing, who won the Ladies' singles at Wimbledon more times than any other Briton
before or since. Christmas Humphreys recalled, 'Tennis parties on Sundays in those days were an

nstitution and had a certain efficient discipline of their own.' The lawn would be cut and rolled, it vould be marked out for the game, then tennis was played with guests in the afternoon, followed ·y tea and supper, with songs at the piano, before a rush for the last train from Ealing Broadway.

There were societies for drama, music, literature, photography and natural history. Rooms n the town hall and the Victoria Hall were often used by groups for balls, lectures and ·erformances. Before the advent of radio as home entertainment, these clubs flourished. ⅤIany national organisations had branches in Ealing, such as the RSPCA, the NSPCC and)ur Dumb Friends' League, as well as political pressure groups such as the Navy League and he Tariff League.

Additionally, there was the arrival of cinema and this had a two-fold effect in Ealing. Firstly, ⅰve cinemas came into being. The first, in 1912, was the West Ealing Theatre Charming on the Jxbridge Road; the theatre on the Broadway became Ealing Hippodrome; a former skating ⅰnk in the newly built Bond Street was converted to become the Walpole Picture Palace in 1912, ⅰnd became at least one resident's choice: 'The Walpole immediately became the leading cinema n Ealing. The programmes were better, the seats were more comfortable, the heating and entilation were more modern … the musical accompaniments were far superior'. Away from he town centre, the Kinema opened on Northfield Avenue, on the site of the former Cottage Ⅰospital, in 1913. Finally, there was Northfields Cinema at the other end of the same road, ·pening in the following year and being renamed The Elite in 1924.

Of more significance was the opening of Will Barker's film studios on Ealing Green, when he ·ought West Lodge in 1908 and 3 acres of adjacent land. Perhaps he chose Ealing because the ⅰght conditions were better than the fogs of London; certainly other film studios were opening

Derelict Walpole Cinema.

to the west of London. This was, in 1912, said to be the largest film studios in England, but was relatively obscure locally, 'for nearly three years past the workshop of this, the largest national business in motion photography, should have been lying hidden among our midst'. Films made by Barker included spectacles such as *Waterloo* and *Jane Shore*, but he also adapted classic novels for the big screen and once shot *Hamlet* in just one day. The studios gave much employment to local craftsmen. In 1920, Barker's company, Barker Motion Picture Photography Ltd, was sold to General Renters, who hired the studios out to numerous other companies. By this time Barker had retired from the business, increased competition from American films led to a downturn in the British film industry by the 1920s. In 1925, it was stated that Ealing 'appears to be finished as a film producing centre'.

Medical services were improved. Ealing Cottage Hospital was demolished and a larger purpose built hospital was opened on the west end of Mattock Lane in 1911 (Lord Rothschild laying the foundation stone in 1910). Named after the recently deceased monarch, it was called the King Edward Memorial Hospital. Initially, it had forty beds, but this rose to seventy in 1915. This hospital was run and financed by residents. The council's isolation hospital also increased its accommodation to fifty-five in 1911. In 1921, it came under the Ealing and Chiswick joint hospital committee and Brentford's isolation hospital was annexed to it.

There were other facilities that benefitted the poor. The almshouses on the Mall were rebuilt near to the parish church in 1902, not far from St Mary's church's own mock-Tudor buildings, known as Church Homes, in Church Gardens. Bequests made by James Tidy in 1911 and Francis Gladstanes in 1912 provided stock from which the interest went towards the upkeep of the almshouses. Other income from Ealing's older charities could also be used for the same purpose from 1904.

There were a number of self-help organisations, slate and benefit clubs, sometimes attached to churches or pubs, by which working people could set money aside in return for a pay-out in times of need. In 1911, there were fifty of these in Ealing. The Three Pigeons on the High Street was the headquarters of one of these. Members came along each Monday and paid their subscriptions to the secretary, Mr W. H. Dickens, a local builder.

After the explosion of the church building, in the late nineteenth century, the rate slowed. All Saints, to the west of the Common and on part of the grounds of Elm Grove House was consecrated in 1905. It was built by money given by the late Frederica Perceval to commemorate her late father, and is known as the Spencer Perceval Memorial church. It was at first a chapel of ease for St Mary's. St Barnabas church on Pitshanger Lane, first erected as an iron mission church of St Stephen's, was built close to the expanding population of Brentham in 1907. It was built in brick to a Gothic style in 1914–16. One event that brought churches together in a common cause was the burning down of St John's church in 1920; the Revd John Summerhayes later wrote of his appreciation to church people of all denominations who assisted in the rebuilding of the church. Other mission churches were built to cater for the rising populations in west and south Ealing, the church of the Good Shepherd in South Ealing in 1905 and St Paul's on Northcroft Road in 1907. In the west was St Luke's on Lynton Avenue, Drayton Green, which has remained an iron church from 1901 to the present day.

Roman Catholicism in Ealing was not wholly harmonious in this period. Father Richard O'Halloran had been operating a church in Mattock Lane since the 1890s, but refused to bend to Cardinal Vaughan's instruction to close his church now that the Benedictines were established

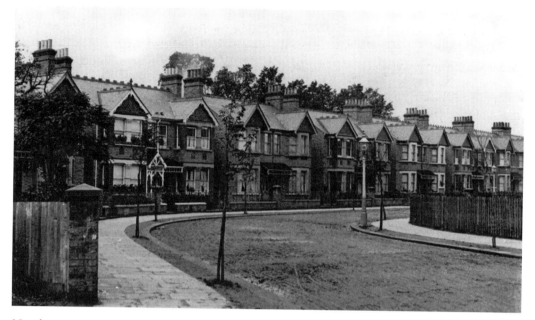

New housing on Lynton Avenue.

in the area. Despite his being excommunicated, a number of local Catholics loyally stood by him, and in 1915, he attempted to register his chapel as being for 'unattached Catholics'. The controversy only died with him in 1925. A separate Catholic parish was assigned to St Peter and St Paul's church at Leyborne Avenue, worship being initially in a hut from 1922.

Nonconformity continued to prosper. Quakers began to meet at the Ealing branch of the YMCA in Bond Street from 1905. Growing attendance at Haven Green Baptist church meant that a Sunday school and hall were added in 1910. Another Baptist church was built on Junction Road in South Ealing by 1921. Additions were made to the Congregationalist chapels in West Ealing and Ealing Green in the 1920s. A new congregation was the Presbyterian Church of Wales, which, as with the Quakers, first used the YMCA buildings and later established a church on Ealing Green in 1909.

Methodism gained a stronger presence in Ealing in these decades. Wesleyan Methodists in north Ealing met in private houses in 1910, but built a temporary church on Pitshanger Lane in 1913. In West Ealing, Wesleyan and Primitive Methodist chapels were built; the first was at the corner of Northfield and Kingsdown Avenues, and opened in 1908 in an old school building. The Primitive Methodists worshipped on a site on the Uxbridge Road. Finally, there was an unusually strong presence of that minority Christian denomination, the Plymouth Brethren. They had three chapels in Ealing. One was located on the Grove, another in Disraeli Road and a third met at Dean Hall on Williams Road from 1912.

The first non-Christian place of religious worship also opened in Ealing in these years. Despite the presence of a notable Jewish family, the Rothschilds, in nearby Gunnersbury Park from 1835, and Dr John Chapman at the Great Ealing School in later years, there had never been a synagogue in Ealing until the Ealing and Acton Hebrew Congregation was formed in

1919. As with other religions, they initially met at the YMCA building in 1919, but in 1921 were registered at a house on the Uxbridge Road and from 1924 in Grange Road.

Ealing was deemed a particularly religious borough. In a survey taken in 1903, it was found that 8,893 people attended a morning Sunday service (5,622 Anglicans, 393 Catholics and 2,878 Nononformists), and 7,122 an afternoon one (4,171 Anglicans, 137 Catholics and 2,815 Nonconformists). Yet it should be recalled that these were minorities of Ealing's population of over 30,000.

It was in 1929 that Ealing Parish finally shrugged off its final connection with the Poor Law, after over three centuries. Up to that year, there were five overseers and two assistant overseers/district rate collectors, though the latter had long been employees of the council. Most of these last overseers were to go on to political careers. At the same time, another ancient link was broken as the manorial system came to an end; the demise of both seems to have gone by almost unnoticed.

Of course, churches did much more than provide a place for the faithful to worship on Sunday morning and afternoons. All churches provided a range of activities and services to help their parishioners. For example, St John's church, which, though at the end of the affluent Mattock Lane, catered for a largely working-class parish, provided a blanket club, soup kitchens, Mothers' meetings, Mothers' Union, Maternity Society, a Band of Hope, the Scripture Union, Young Men's Institute and Men's Club. Yet we should not exaggerate their impact, for it was claimed, in 1905, 'The wealthier Ealing parishes do next to nothing to help the poorer ... that even in Ealing, there is growing up a huge population outside the churches and largely indifferent to their claims.'

Schooling altered in 1903, with the abolition of the Ealing Educational Association. As a consequence of the 1902 Education Act, Ealing Council finally became an educational authority with powers to provide further schools to meet the need of the growing population. There was

Acton and Ealing Synagogue.

increase of children enrolled from 3,167 in 1902 to 6,911 in 1911, and average attendance rose from 2,653 to 6,140. By 1921, the numbers had increased to 7,602 and 6,500 respectively. Ealing now levied an Education rate, which rose from 4½ pence in the pound in 1903/04 to 10 pence in 1911/12. The council invested in five new schools between 1904 and 1911, which cost, excluding land purchase, £79,287. Charles Jones reflected that, 'during the decade the Ealing Education Authority has striven to carry out faithfully the Board of Education's instructions, though at times there may have been serious misgivings at the elaborate demands made and the consequent expense thrown upon the ratepayers', one sore point being that the interest and principal costs on the loans taken to pay for the schools had to be repaid in thirty years, later extended to fifty, instead of the expected sixty.

Jones himself designed several elementary schools for infants, boys and girls throughout the borough: Little Ealing (Little Ealing Lane, 1905), Northfields (Balfour Road, 1905), Drayton Grove (1908), Lammas (Cranmer Avenue, 1911) and North Ealing (Pitshanger Lane, 1911). Each charged pupils a modest fee. In 1925, Grange School was built on Church Place and Walpole School opened in the same year, as a result of a reorganisation of Lammas School on the same site. These years also saw the closure of some of the old church and chapel schools; Ealing Wesleyan School closed in 1921, and the Lancaster Road School closed four years later; in both cases pupils transferred to the new Grange School. St Stephen's closed in 1921, and the boys went to Ealing North (which had been a girls' school up to then). Christ Church, St John's and St Mary's schools survived, however.

These church schools closed because of poor accommodation. An inspector noted of the Joseph Lancaster School in 1921,

> In some of the class rooms, ventilation is so poor that it is hard for the children to attend to their lessons, especially on close afternoons, when the smell of the neighbouring stables became oppressive. Physical exercises are taken under difficult conditions in the public passages surrounding the school.

In the Wesleyan school, there was no playground, so exercise classes took place in the classrooms themselves. The new schools were far more spacious. The best was Drayton School, which charged fees until 1919 and attracted middle-class pupils whose parents took a great interest in the school's progress.

There was also, for the first time (and still only for a few) public provision of secondary schooling (schooling was only compulsory up to twelve years from 1902 and fourteen from 1918). These secondary schools were not provided by Ealing Council, but by Middlesex County Council. Ealing Grammar School for Boys opened on Ealing Green in 1913, and a Girls' Grammar School in The Park in 1926 (it moved to new premises in Queen's Drive in 1965). These were fee paying, but had 25 per cent free places for bright children. The Boys' School was also used in the evenings for further education classes from 1913–29. Lammas School was also expanded in the 1920s to provide education for older children. Special subject centres were also established at Lammas and Drayton schools to teach cookery, laundry and handicrafts.

The fortunes of private schools fluctuated. The oldest, the Great Ealing School, which mostly catered for Jewish boys at this time, finally closed its doors in 1908 and was demolished to be replaced by the inevitable housing. This was not due to any educational defect or lack

of demand, but because Dr Chapman, its proprietor, had speculated unsuccessfully and had to sell the school to cover his debts (Nicholas Gardens and Cairn Avenue were built on the site). Ealing Grammar School, run by Dr Brucesmith, was a more recent boys' boarding school and had 200 pupils in 1912, but it closed in 1917. However, Ealing College and Durston House Schools survived. Heidelberg College moved to Castlebar Road in 1898, and in 1916, inevitably changed its name to Harvington School, in the wake of anti-German feeling in the First World War.

Catholic schools opened in Ealing. St Benedict's School, earlier called Ealing Priory School, was attached to the Priory and located in Montpelier Road from 1906, moving to Eaton Rise in 1924. For girls there were several convent schools: Lourdes Mount School opened in Rochester House, Little Ealing Lane, in 1923, run by the Sisters of the Sacred Heart; a boarding school in Hillcrest Road was founded in 1915 by Augustinians; and finally there was St Anne's Convent school in 1903, partly formed from the house known as Ealing Park in Little Ealing Lane. There were also schools to teach professional skills, aimed at both boys and girls who were increasingly in demand in the growing number of offices. Clark's established a branch of their secretarial college in the Uxbridge Road in 1910, as did Pitman's in 1914. There was a girls' only secretarial college on the Mall in 1912.

So, what was the overall impression of Edwardian Ealing presented to outsiders? Two writers provide contrasting viewpoints. C. G. Harper was generally positive, writing in *Rural Nooks around London*, published in 1907:

> I do not think there can anywhere be a more eminently respectable and residential suburb than Ealing. It impresses me with those two qualities in a superlative degree. You come to it by road past a fine common that is almost park like, or else alight at its various railway stations, that are not as other stations, but particularly roomy, smart and well groomed; and thence you emerge upon busy streets of extremely prosperous shops, and from them come to great areas of villa residences built and maintained in good style, the supporters of those shops.

Yet he had to admit that 'West Ealing is not so select as the other districts – not in short, so 'residential' the houses merge by inadmissible degrees into Hanwell. Walter Jerrold, writing two years later in *Highways and Byways of Middlesex*, finds the changes to Ealing less positive:

> The old place has become renewed, and with its residential byways spreading northwards towards the Brent, and southwards towards Brentford, it has a little left of the old time character when it was a village of large houses and wide stately grounds ... Thanks to the broad bit of common it is in a way cut off from Acton on the east, but expansion to the west has made it merge with Hanwell and where not many years ago used to be a fairly attractive stretch of highway, now humming with electric trams pass through rows of substantial villas and stretches of showy shops.

The two major conflicts of this period had their effect on Ealing. The first was the First World War. Although Ealing men had enlisted in the Boer War of 1899–1902, the number of casualties (including Capt George Wood, son of Edward Wood) had been relatively small.

By contrast, the Ealing Roll of Honour for the First World War lists 1,051 men (including 158 officers from 2nd lieutenant to brigadier general) who died, and this is probably a slight underestimate. Of these, almost all had been soldiers, chiefly joining regional units such as the many battalions of the Royal Fusiliers and the Middlesex Regiment, though officers were in more diverse units. There were also ten airmen and eight sailors among the Ealing fatalities. Eight more of those killed won the Military Cross. Despite this, the majority of those who enlisted came back alive.

The memorial to those who died took the form of a wall and gateway in front of the public library on Ealing Green. It was designed by Leonard Shuffrey, a resident whose son Gilbert had been killed in action, and unveiled in 1921. Money to pay for this had come from the local public, but there was money left for assisting the education of children made fatherless due to the war. The memorial records Ealing's single female casualty, one Miss Alice Maud Harman, who was killed in an accident in an engineering works in Acton in 1916.

German Zeppelins and aeroplanes bombed London from 1915–1918, but in the end Ealing did not suffer directly from an air raid. However, the fear of aerial assault was a source of concern to the population, as one resident recalled:

> Then came night time raids by aeroplanes and, most alarming of all, daylight raids on quite a large scale...During the night raids, as well as the explosions of the bombs one could hear the loud crump of the local anti-aircraft guns which were at Boston manor and on top of Horsenden Hill.

The nearest bomb to fall to Ealing was on the night of 29/30 January 1918, when one fell on a house on Whitestile Road, Brentford, just south of the border. Eight people were killed and people from Ealing, including Reginald Lloyd-Jones, went along to see the damage on the following morning.

Initially, the outbreak of war in August 1914 was met by a wave of panic buying as households stocked up with coal, meat, fish and groceries. Initially, local supplies were running down. Food shortages occurred later in the war, and rationing was finally introduced in 1918. The government encouraged the establishment of communal kitchens and there were four in Ealing by 1918 (the first opened in Rochester House in 1917). Land, including that in Lammas Park, was given over for allotments so more food could be grown locally, as the German submarine blockade reduced food supplies from abroad. In 1917, there were 1,975 plots and by 1918, 3,000.

Men and women unable to fight assisted in the war effort in other ways. In the first few months, 800 men enrolled in Ealing Volunteer Forces, and others as Special Constables. They were given training and weapons, and assigned tedious security roles, guarding reservoirs, bridges, railways and other places that might have been at risk from enemy spies and saboteurs. Even local Boy Scouts were engaged in these tasks. Women were also enthusiastic in helping in hospitals; the King Edward Memorial Hospital was opened up for war casualties, as was the temporary Red Cross Hospital at Montpelier Road. Women were prominent in the Ealing War Dressings Association, which provided comforts for the troops at the Front and also in raising money for the 700 Belgian refugees and wounded Belgian servicemen, some of whom lived in a hostel on Haven Green (the Belgian-born Mrs Humphreys being the president of the Ealing Belgian Society). Others worked in the Perivale

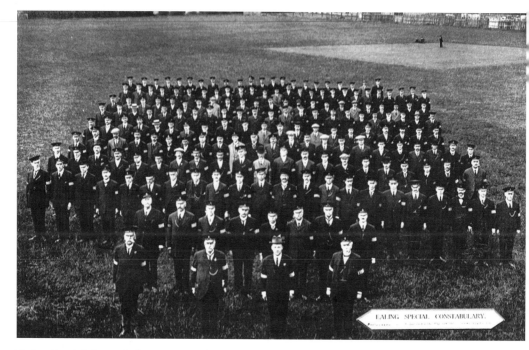

Ealing Special Constabulary, First World War.

munitions factory and lodged locally. Crèches were established so married women could take part in these activities.

War ended in allied victory on 11 November 1918, and the local newspaper noted,

> At eleven, however, the great news burst out. With the crash of maroons and the sounding of hooters, reinforced by an ever growing volume of other noises, which gradually rose to a tremendous roar, the glad tidings were proclaimed. People rushed from the shops and from their houses, joined in the cheers of the gathering multitude, and rushed in again to put out their flags. In a few moments the scene was transformed, and colours flew across from every flag staff.

At seven that evening, crowds gathered outside the town hall, where earlier in the year they had queued to buy war bonds when a tank was parked outside there. Now the town hall was lit up, flags were flying and the Ealing Silver Band played, before the mayor, MP and other dignitaries made speeches. They said that thanks must be given for the end of hostilities and return of the troops, rather than jubilation. Hymns and patriotic songs were sung and the crowds dispersed quietly at nine.

Shorter and less deadly, but nearer home, was the General Strike of May 1926. The origins of this national dispute lay in the quarrel between the National Union of Mineworkers and the coal owners, over pay and conditions. Arbitration by the government had failed. The Trades Union Congress called on all trade union members to back the miners' cause and to withdraw their labour. Heavily unionised workforces included the transport workers. Given that they formed a significant proportion of Ealing's workers, as previously noted, and that

many local residents travelled to work in London, the effect of the strike would be significant in Ealing. It could be expected that with trains, trams and buses not operating, and with a low level of car ownership, the country must grind to a halt and so the government would have to press the coal owners to accept the miners' demands.

In the end, ways were found to overcome the problem. The local newspaper reported that

Ealing is facing the General Strike with its usual calm, determined to make the best of a difficult situation. An attitude of reasonableness has been shown by the strikers and there has been no suggestion of disorder. The general public, greatly inconvenienced, is getting over these difficulties.

One reason for this was that on the first day of the strike, Tuesday 4 May, there was a rush of volunteers to Ealing town hall. People wanted to help drive public transport and to be enrolled as special constables. One Ealing resident, Felix Hookham, Margot Fonteyn's father, realised his boyhood ambition to drive a train. Christmas Humphreys, a young lawyer, later recalled,

I volunteered as a Special Constable. Bearing in mind a splendid oath administered at the Ealing Police Station, I armed myself with a truncheon bearing the arms of the City of London which had been used in the Chartist riots, and paraded for duty … it was light hearted fun, as a crowd of public school boys and others rapidly took over the running of public services.

In all, 1,200 volunteers came forward, including the fifty members of the Ealing British Fascist Party.

Buses ran with barbed wire on the bonnets and a policeman rode with the bus drivers. At first, services were erratic, but after a couple of days and some very rudimentary training, the new bus, train and tram drivers were providing an adequate service. Car owners gave lifts to

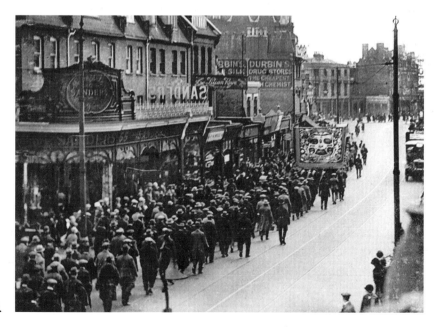

General strikers
in The Broadway.

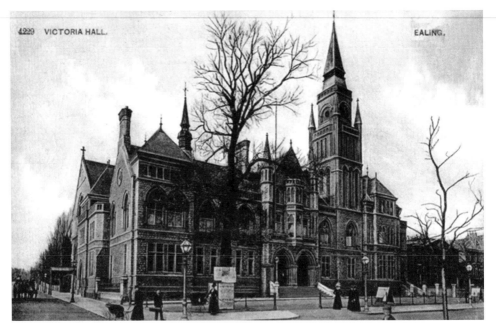

Ealing Town Hall.

those who wanted it to London. Local businesses such as Ottways and the cinemas provided sleeping quarters for employees who lived a distance from work.

Strikers marched in an orderly fashion to Ealing Common in their thousands to listen to speakers urging them to support the miners in their fight for decent conditions. Special constables monitored the crowd. Likewise, there were similar speeches at Ealing Labour Hall, on Dorset Road, by a Labour councillor and a Scottish MP. The audience was told that those who went to work were selfish and should desist. Pickets stood outside railway stations. Generally speaking, both sides acted with restraint. The only known violence was when a Brentford man threw a stone at a bus driver on the High Street. He denied the charge but was given a month's imprisonment.

In any case, on 12 May, the strike was called off. This surprised and angered many transport workers, who remained on strike for three more days, as the volunteers continued in their work. Most of those who had gone on strike lost a few days' pay, but were given their old jobs back. Two council employees who struck were reinstated by a narrow vote, but a railwayman who had played a prominent part in the strike was not re-engaged.

The year 1926 was important in Ealing for another reason. Two years previously, there had been a recommendation by the county council that Ealing should incorporate its smaller neighbours, the urban districts of Hanwell (population 20,850, acreage 1,086) and Greenford (1,458, 3,042). This was part of a more general move to encourage local government units to merge, and as larger but fewer units, they could be more efficient and economical in the provision of local services. Hanwell, for instance, lacked an isolation hospital and swimming baths, both of which Ealing possessed. Greenford Council was allegedly not pursuing an efficient housing policy. The Borough of Ealing argued that 'an alteration of the

boundaries of the said borough is desirable'. Hanwell councillors were happy to have their district incorporated with Ealing, but here was no such unanimity among their Greenford counterparts, so the Ministry of Health (which also dealt with local government) sanctioned a three day conference in early 1926 to explore the issues. The end result was that in October 1926, the two districts merged with Ealing, adding additional numbers of councillors. The new borough had an acreage of 7,056 and a population, in 1921, of 89,700 people. Northolt Parish petitioned to be added in 1928; it had been part of the rural district of Uxbridge. There was little controversy and after a mere morning's discussion, it was sanctioned, adding a further 2,180 acres to the already enlarged borough.

Was Ealing the Queen of the Suburbs as its promoters stated? One difficulty is that there is no surviving correspondence or diaries to give private opinions. It was certainly a period of almost unprecedented change, as regards to an explosion of both building and population in the years preceding the First World War, and the latter itself was a major upheaval. Certainly for some of the population, life was hard. Ultimately, the reader will have to decide for themselves, but it was a tag that was to remain remarkably durable, as we shall see.

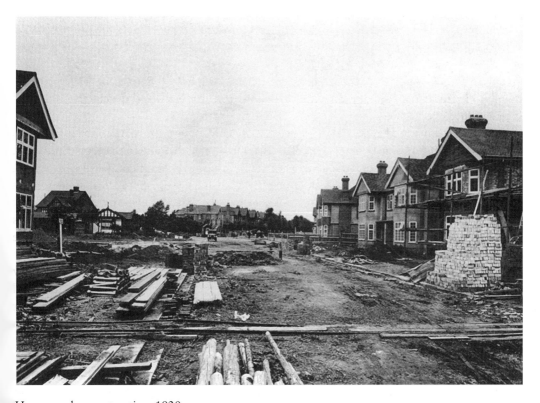

Houses under construction, 1920s.

6

GREATER EALING, 1928-65

Ealing would not alter as radically in the next decades as it had in the previous half century, at least in terms of its population and the building of new housing. This is not to say it was preserved in aspic; it was not, as we shall see. With the addition of Greenford, Hanwell and Northolt, Ealing was no longer the same district that it had been from 1863–1926, and statistics reflected the new reality of the vastly enlarged borough, making some comparisons with former decades largely meaningless. From now on it would always be necessary to distinguish Ealing as a borough from the smaller Ealing represented by the postal districts of W5 and W13.

Commentators in the 1930s tended to find Ealing still an attractive place. *The County Handbook* of 1939 thought that it was 'one of London's most popular western suburbs on the main Uxbridge Road … largely residential in character, Ealing is pleasantly enhanced by many tree lined avenues and a beautiful Common', and Arthur Mee, a popular historian, similarly described it as

> the most populous of Greater London's western suburbs … Through it runs one of the highways out of London, busy day and night. Those who take that way will see the many and some shops; and those who look beyond that imposing façade will find another Ealing, a garden city with tree lined roads, lawns and gardens.

Martin Briggs, writing in the same decade in *Middlesex: Old and New*, was less flattering, suggesting that Ealing was 'certainly an attractive suburb as suburbs go, but not altogether different from several already described in this book.

We have already seen how the phrase 'The Queen of the Suburbs' was widely used in the early twentieth century. It was a phrase that had a long lease of life, but Ealing's claim to pre-eminence was beginning to fade in the middle of the century. In 1936, W. A. Berians of Carshalton wrote that Ealing was 'no longer the favourite suburb' and a year later, Mr Forty, the Borough Surveyor, referred in a speech to Ealing being 'regrettably labelled the Queen of the Suburbs'. Yet the Borough Guide of 1946 had the title emblazoned on the front cover and the text could proclaim:

> Nothing is more satisfactory to those who are proud of Ealing's claim to be 'Queen of the suburbs' than the way in which the place is adapting itself to changing conditions. It is true that some of the bigger houses with an acre or two of ground have gone and that others are going, but they are being replaced either by blocks of luxury flats that are the last word in design and construction, or by smaller property of a type that appeals to the fairly well to do businessman with a small family.

By the 1950s, the borough guides had ceased to use the phrase, and though the Kemps' directories of Ealing did, they desisted by the 1960s. Montague Jones, writing in 1959, noted,

> Ealing was, at one time, a very pleasant place in which to reside, and whatever claim it may have been had to the title Queen of the Suburbs, it has of later years declined as a quiet residential neighbourhood. It has become over populated. It is also noisy due to the racket of the infernal combustion engine.

At the same time, some correspondents to the letters pages of the local press continued to rely on a shared acceptance of Ealing's suburban royalty, though at the same time others complained about vandalism and local hooligans wrecking their allotments. The life of this epithet was not quite over, as we shall see in the concluding chapter.

There were a number of housing developments, where builders could still find space. These included the Hanger Hill Garden Estate, built from 1928–32, with its four- and five-bedroom houses, in the mock Tudor style, costing between £1,475 and £1,975 in the 1930s. Mee wrote that it 'well deserves its flowery name. The roads are planted with gardens so gay that as we walk along them we might almost imagine ourselves in St James' Park. As a Borough Guide noted, 'the type of house that is being erected there is likely to appeal to the well-to-do.' Just north of the estate was the Hanger Hill estate, built by Haymills, with many houses built in a modernist style. Another development for the more affluent was Ealing Village, built between Madeley Road and the District line. This development was made up of five blocks in a Dutch colonial style, containing 128 flats, designed by R. Toms for the Bell Property Company in 1934–36. When local diarist Alexander Kay Goodlet saw these, he wrote that he was 'horrified to find large blocks of flats erected close to the District Railway', although they seem modest by later standards.

In south-east Ealing, the sale of the Rothschild land in 1925 led to building up to the borders of Gunnersbury Park, along Pope's Lane and northwards towards the south side of the common. Restrictive covenants were placed on the development here, preventing cheap houses, garages, pubs and cinemas being built. Houses were built to the north-west of the borough; the Argyle Park estate advertised houses from £975 to £2,250. There was also building on other spare land, especially towards the borders of the parish. Cavendish Avenue was built up along the border with Hanwell by 1934.

Blocks of flats were increasingly popular. In 1936, Mount View was a development of flats on Mount View Road, each with two to four bedrooms, a bathroom, toilet, kitchen, dining room and large entrance hall, with a rent of £140–220 per year. Elsewhere, large Victorian properties were demolished and replaced by blocks of flats, which, in the case of Oakland and Edmonscote at the junction of Argyle and Cleveland Roads, retained their earlier names. This pattern would continue during the next few decades. Over time these blocks of flats became taller, so that two ten-storey towers were built on the north side of St Stephen's Road in 1962.

More detached houses of the Victorian period were lost in these decades. The semi-detached houses of Sandringham Gardens to the west of the junction with Bond Street were demolished and shops built; likewise, the vicarage for Christ Church on the opposite side of the road also made way for shops. Niagara House, once home to Charles Blondin,

made way for shops on Northfield Avenue. Elsewhere, new residential property replaced them. On Haven Green, The Haven, once home to Admiral Collinson, who was chairman of Ealing Local Board, was replaced by a five storey block of 160 flats, Haven Court, in the 1930s (though it could have been worse; a coach station was mooted and then a seven-storey block of flats).

At Brentham, the original spirit of co-partnership was lessening. Ealing Tenants had been absorbed into the Co-Partnership Tenants, then Liverpool Trust Ltd in 1930 and finally to Bradford Property Trust Houses began to be treated as private property and began to be sold. By 1964, only a third were still rented.

Many of Ealing's Victorian houses were now too large for smaller families and fewer servants, and some were demolished and others converted into multi-occupation. This trend was already marked by the 1930s, as the borough surveyor wrote in 1937:

> Many of these self-same houses today are in outward appearance rather dreary, in some cases rather derelict. They have been converted into flats, and the different hues of the curtains in the many windows indicate at once the separate habitations of the occupier. This is, of course, a state of affairs which is obtaining not only in Ealing but all over London and the suburbs of London ... what were once delightful rather spacious residential suburbs, act as fully loaded dormitories for London's workers, what were once well kept houses have given place either to conversion of the original structures as flats or to demolition, for the purpose of erecting large blocks of residential flats.

It was not only large houses that came tumbling down, but small old houses in Church Lane, deemed uninhabitable, were compulsorily purchased by the council and demolished in the 1930s and 1950s. The single household large houses in their own grounds, such as those in north Ealing, were beginning to be too expensive to maintain, given heating, furnishing and cleaning costs, as well as the cost of maintaining the grounds. Many were four-storey with twelve main rooms. In some cases, they were lived in by a single resident with a daily help, and when they died, the houses were often sub-divided. Younger owners sold out and bought houses in the countryside.

Each of Ealing's districts had a character of its own. In the 1950s, Hanger Hill had 'its share of Ealing's stately homes, and a great deal of open spaces'. Likewise,

> some of the finest property in Ealing is to be found in Castlebar, though few of the big houses remain in the sole occupancy of the families who resided there at the beginning of the century... some are used as offices or nursing homes.

Northfield was lower down the scale, 'mainly of middle class residential property'. These contrasted with the area immediately south of the shops in the Broadway, where there was some poor housing as there had been for decades. 'Some of the streets, particularly those bordering on the Uxbridge Road, contain cramped and dingy cottages built in the worst traditions of Victorian working class dwellings.' Houses in the Grove and Baker's Lane were knocked down at this time, but the area remained unkempt and derelict throughout the 1960s and 1970s, as plans for development were delayed. One resident complained in 1962 'I have lived in these streets all my 38 years. I played in the same filth as my kid has to today'

and when I was a kid it was the same old story – our houses were condemned and we were told we would live in nice new houses.' Yet some residents liked it, claiming that there was 'a very close knit community which is the last vestige of the village atmosphere in this rapidly expanding borough'.

Back in 1928, the Borough Guide could truthfully state that 'between Greenford Green and Perivale the country is still unspoiled' and the houses in north Ealing still looked over an unspoilt Brent valley. This condition did not remain for long. Housing estates grew up in the neighbouring parishes, now part of the borough, of course. Greenford and Perivale were transformed from small rural villages to heavily urbanised factory land, as the Western Avenue became a major transport route from west London to Buckinghamshire. Goodlet 'sorrowed over the awful spate of building over that once charming locality' that was Perivale in 1935; as to Greenford, 'it breaks my heart … to traverse country that only ten years ago was absolute countryside and see it completely urbanised'. Ealing was no longer the country town near London, but part of a wider suburban sprawl. There were attempts, however, to retain open space on the borders of central Ealing and Gunnersbury Park was bought by several councils, including Ealing, and so 186 acres to the south east of the borough was saved from building for recreation.

Ealing's population was changing in character. Briggs wrote in 1934,

> There was a time, not long ago, when Ealing claimed to be par excellence the suburban home of the retired colonial servant … One still sees them strolling aimlessly along the Broadway, twirling cheroots … [but] … The days when Ealing could regard itself as the refined home of retired Indian civil servants has gone forever.

However, George Orwell, writing in 1939, still felt that some of this tradition lingered on.

Ealing's population waxed and waned over these decades. In 1931, it was 80,323, showing a rather larger rise than there had been between 1911 and 1921 – clearly the impact of war had been significant. Population density was greatest in the southern part of the borough, with 49.2 people per acre in the terraced houses of Lammas Ward, compared with the 19.5 in the detached houses in Castlebar ward.

The range of Ealing's public transport changed little in the 1930s and 1940s, but one important development was the replacement of trams along the Uxbridge Road with trolleybuses in November 1936. The London United Tramways Company and other transport firms in and around London had been taken over by the London Passenger Transport Board, who wished to phase out trams despite the arrival of new fleets of the superior Feltham class of vehicle. The switch seems to have passed off without controversy. Goodlet wrote, on 15 November 1936, of the new trolleybuses finding that 'they are splendid vehicles of course and uncannily quiet, but one regrets the passing of the old trams'. Trolleybus number 607 ran along the same route as the trams from Shepherd's Bush to Uxbridge. In 1950, there were 1,616 vehicles in the fleet and there was one every two minutes on weekdays, with more on Saturdays and less on Sundays. However, the trolleybuses in their turn would be phased out, to be replaced by Routemaster buses; they last ran along the Uxbridge Road on 8 November 1960. Apart from the 607 route, there was the 207 route from Chelsea to Hayes.

In 1950, there were five bus routes through Ealing, with destinations at Kingston, Golders' Green, Brentford, Ruislip, Willesden and Hampton Court. At night times, there were buses

travelling to and from London Bridge. A decade later there were thirteen bus routes in all, including buses to Uxbridge and Shepherd's Bush. There were also Green Line coaches taking passengers to places in Surrey and Buckinghamshire.

Railway services changed little, though the GWR was replaced by British Rail when the railways were nationalised in 1948. In 1938, the first train to Paddington left at 4.12 a.m. and the last was at 1.55 a.m., and from Paddington ran from 3.30 a.m. to 1.33 a.m.

The major change for Ealing was the amalgamation of Ealing Broadway overline station with the underground stations, which had been immediately north of it on Haven Green. Work was announced in 1961 and the old GWR station was demolished in 1962. Yet delays in planning and buck passing between British Rail, Ealing council and the county council resulted in further delays and rapidly increasing expenditure. Work on the new station only began in 1964 and was not completed until 1966, much to the frustration of commuters. It eventually resulted in a single booking hall for all three lines, although the District Line station was retained and converted into shops.

From 1932–64, District Line stations were also served by the Piccadilly line trains to Hounslow and Uxbridge. This resulted in the existing stations being rebuilt, with the exception of North Ealing and South Ealing. Charles Holden designed the station at Ealing Common in 1930 and worked with S. A. Heaps to redesign that at Northfield two years later. Park Royal, unusually was designed by Welch and Lander, the architects of the adjacent Haymills estate, but in a similar style to Holden's and included a parade of shops. The Central line extension from north Acton to Ruislip, delayed by the Second World War, opened in 1947 and Hanger Lane station was built in 1949. The nearby GWR Brentham Halt closed in 1947. In 1938, the first train left Ealing Broadway from the Central line at 5.59 a.m. and the District line from 5.32 a.m.; the last times were, respectively, 11.59 p.m. and 11.55 p.m.

The number of cars soared during the 1930s, though, with prices at £100 or more, they remained the preserve of the middle class, who, of course, were well represented in Ealing. Economic restrictions in the Second World War and petrol rationing, which lasted through the 1940s, caused a brief brake on the rise in car ownership. Many garages were built in Ealing in the 1930s. In 1951, there were twenty-six commercial garages, fourteen motor dealers and twenty-five car hire firms, with numbers rising by the next decade to 30, 19 and 14 respectively.

Given the lack of space for factories, Ealing never developed into an industrial hub, though Wolf Electric Tools opened the Pioneer Works off Hanger Lane in 1935 to manufacture portable electric tools. Ottway's continued, but moved from the Uxbridge Road to Northfield Avenue in 1954. Another industry was Cooper's Peroxide Cleaner's Coronation Works on Craven Avenue. They made products for domestic cleaning on a national scale and established their headquarters in Ealing in 1935.

In the 1940s and 1950s, a number of other industrial premises opened in Ealing. There was an engineering works and an electrical engineering works on Ealing Green. Among the former was the Flextol Works, who, in the 1940s negotiated over a possible invention with John George Haigh, later revealed as the acid bath murderer. Light industry was located by the railway line to the west of Longfield Road; two engineering works, a plastic works and a carpet works. West Ealing also had its share of small factories and workshops. North of the Uxbridge Road was a printing works, a scrap metal dealers, a coach station, an

electro-plating works and a warehouse. To the south was a metal pressings works, a laundry, a plating works and a timber yard. Gone were the days that Ealing could boast of having no industrial premises within its borders.

The stretch of the Uxbridge Road between Ealing Broadway and West Ealing reflected the changes in Ealing's character. Many of the large houses that had lined the road were converted in business premises, often with an extension to the front, in the 1920s and 1930s, but these in their turn gave way to purpose built office block. The 1962 Borough Guide stated, 'At the present time there is a tendency towards the erection of multi-storey blocks of offices, which may foreshadow further transfers of administrative centres from the business areas of London'. One very grandiose vision was to build a sixteen-storey block with a bridge (with the possibility of housing a restaurant and/or staff canteen there) across the main road, connecting it to another similar tower to provide ¾ million square feet of office space, and was hailed as the 'golden gateway' to Ealing. Although this was never built, others were, and one glass and concrete block was the new police station, transferred from the old site in the High Street in 1965. Curry's built their headquarters in 1964. For one such application, for blocks on Nos. 97–107 Uxbridge Road in 1963, an official inquiry was held, and the inspector claimed the proposed developments were 'in themselves architecturally acceptable and not un-neighbourly ... The 11 storey block ... would not be seriously out of keeping in the mass or emphasis with the existing or approved new building in its vicinity.'

The most famous Ealing industry was its film making, of course, which had mixed fortunes in this era. Associated Ealing Pictures acquired the site in 1931 and turned a house on Ealing Green into offices and the main entrance, while building sound studios behind it. It made a number of popular films in the 1930s, under the supervision of Basil Dean, but the studios shot to national prominence after 1938 when Michael Balcon became head of production for Ealing Studios Ltd. Balcon made a number of war films such as *Went the Day Well* and *Nine Men*, followed by the famous Ealing comedies, from *Hue and Cry* in 1947 to *The Ladykillers* of 1955 (the last film made at the studios for four decades). Scouse, reflecting on the first fifty years of Ealing's existence as a borough in 1951, observed that

the industry which has taken Ealing's name to every corner of the civilised world – indeed, it has shown Ealing itself to countless thousands, for the Ealing Film Studios have used the streets and open spaces of the borough as sets in many of their films ... and today are among the most up-to-date in the country, with a fine record of quality productions.

The studios were sold to the BBC in 1955, but Balcon produced films for another three years in Ealing, with Nile Lodge in Queen's Walk as his headquarters. By 1957, Ealing studios had four acres, three studios, five stages and made between 8 and 10 miles of film per year for inclusion in an average of 120 BBC programmes. The infamous spaghetti tree hoax on *Panorama* of the 1950s was shot at Ealing Studios, as was the popular long running police drama, *Dixon of Dock Green*.

There were a number of changes for the churches. St Mary's underwent a restoration in 1955 and added a lounge to the south in 1959. One new church was the Ascension church on Beaufort Road, Hanger Hill, to serve the increased population of the north-east part of the parish. An iron church was first used, as ever, in 1937–39, but a brick building in

the Georgian style was built by Seely and Paget on the eve of war. Ealing also acquired an abbey. St Benedict's was finally completed in 1935 and became an independent priory in 1947, before achieving abbey status in 1955. The building was badly damaged by bombing in 1940, and was not rebuilt until 1962. Some of the money towards the rebuilding came from the West German government.

Some churches were permanently lost, however. St Saviour's was destroyed by bombing in 1940 and despite post-war suggestions to rebuild it, this was not undertaken and so the parish merged with Christ Church's to become Christ the Saviour in 1952. Similarly, the two Methodist chapels in West Ealing merged at Kingsdown Methodist church in 1959. St Luke's, always apparently a temporary structure, closed in 1952. South Ealing Baptist church was closed by 1968.

A number of other denominations put down roots. The Elim Foursquare Gospel Alliance worshipped at Cranmer Hall Social Building from the 1930s. The Crusaders, Christian Scientists, the Sutcliffe School of Radiant Living, the Seventh Day Adventists and the Jehovah's Witnesses also established themselves in Ealing in the 1930s. The only non-Christian religion with a building in Ealing remained Judaism, and the synagogue at Grange Road was enlarged in 1931, with a new hall being added in 1938, which was extended in 1962. A Liberal Synagogue was established in 1943 and acquired the former St Luke's church in 1952.

Two moral issues that led to much controversy among many residents in the 1930s were birth control and Sunday observance. Packed meetings were held in the town hall and luminaries invited to give opposing views; Mrs Marie Stopes spoke in favour of birth control and G. K. Chesterton spoke against. Eventually these causes prevailed and, in 1933, a birth control centre was controversially opened in Mattock Lane; Sunday observance was relaxed so that cinemas could open on Sundays after a local referendum in 1940 when 13,293 voted for and 5,814 against. In the same year, games could be legitimately played in parks on Sundays, due to the need for leisure during the war. Ealing's claim to religious respectability was clearly on the wane.

Ealing had, in 1928, become part of a larger new borough, but its administrative headquarters remained at the town hall in the Broadway. In order to accommodate the additional staff needed to administer this more populous borough and to administer new burdens imposed by government legislation, the town hall had to be expanded. This was sensitively achieved in 1930 by adding an east wing to the building, using the same materials and in the same style as Jones had used in 1888. Certainly, the number of committees increased compared to the number that had been in existence in 1901, and there were now housing, Victoria Hall and public buildings, finance, general purposes and establishment, public libraries, education, town planning, recreation grounds, works, highways, public health, rating and valuation, maternity and child welfare and electricity.

Ealing's own additional population resulted in an extra wards being added to the six created in 1901; Grosvenor ward, in south Ealing, in 1926, and then Hanger Hill ward in 1946, both to reflect the increases in building and population within its old boundaries.

Some new schools were built, but in most cases schools were reorganised or had extensions built to cater for changing numbers and age groups. Two new schools were Fielding First School, opening on Wyndham Road in 1953 and Montpelier primary school, which opened on the site of the former Princess Helena College, on Helena Road in 1957, despite

pposition from those who claimed it was unnecessary. Nursery classes were established
: No. 26 Barnsfield Road in 1925 and at No. 77 Uxbridge Road in West Ealing in 1936.
here were some closures; St Mary's Boys' school, established around 1714, was closed
1 1939.

Numbers attending grammar schools increased. Ealing County School's numbers rose from
34 in 1926 to 503 in 1938; Ealing Girls' from 225 to 471 in the same period. These schools
1arged fees; 15 guineas per term in 1935, but each offered 25 per cent free places. In order
) meet the three tier approach of the 1944 Education Act, the Central School on Cranmer
venue was designated a Grammar school, Walpole Grammar, in 1945 when its premises
ere extended, taking over buildings of now redundant schools in the subsequent decades.

Most of Ealing's private schools survived, but often with name changes and new addresses.
osses included Girton House School, which closed, and Princess Helena College, which
1oved to Hertfordshire in 1936. However, Notting Hill and Ealing High School for Girls
1me to Ealing in 1931 and occupied the site of the former Girton School on Cleveland
oad. It also had a junior school from 1935 on the nearby St Stephen's Road.

Adult and technical education finally established themselves on their own site in
929, at the corner of St Mary's and Warwick Road, and was funded by the county
)uncil. By 1937, it was named Ealing Technical Institute and School of Art. There
ere about 220 full-time students in 1946, and this number had doubled a decade
1ter, with 700 part-time and 7,000 evening students. New buildings were added to
:commodate this expansion in numbers, when the former girls' county school buildings
1 the park were taken over. Subjects taught included art, commerce, retail and languages.
tudents from all over the county attended. Ealing students wanting to learn engineering
'ould attend the technical college in Acton.

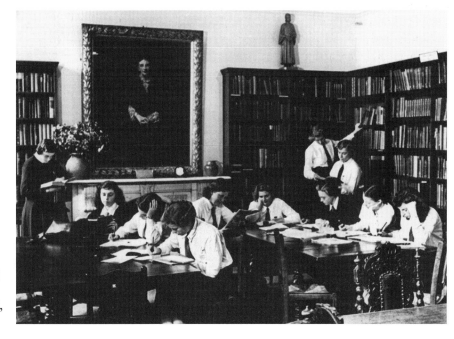

ibrary of
otting Hill
1d Ealing
igh School,
930s.

Ealing Technical College.

There were three notable murders in the borough in these decades. One was a very 'typical' Ealing murder. In 1936, Arthur Wheeler (an insurance clerk living with his family in Brentham) was killed by a 'friend', Linford Derrick (a tennis coach), allegedly in self-defence. Derrick was fortunate to be found not guilty of murder, but guilty of manslaughter. Another was eminently middle class, too. At No. 22 Montpelier Road in February 1954, Mrs Chesney and her mother, 'Lady Mary Menzies', were killed by the former's estranged husband, former naval officer, Ronald Chesney, who wanted his wife's money. He committed suicide near Cologne. Finally, there was the discovery in April 1964 of the corpse of Helen Barthelemy in Swyncombe Avenue by a Northfields man; the murderer was an unknown serial killer named Jack the Stripper, who killed at least another five women in 1964/65. A number of the inquests of his victims were carried out in Ealing town hall.

In terms of national politics, Ealing in the 1930s and early 1940s continued much as it had previously. Herbert Nield was taken ill and in 1929 retired from politics, to be succeeded by Frank Sanderson who was its MP for the next decade (interestingly, in light of subsequent developments, his daughter-in-law was Polish). Like Nield he was a Conservative. However, there were changes in 1945 when Ealing was reorganised into two constituencies, due to its increased population and size, as Ealing North and Ealing South. The first consisted of Greenford, Perivale and Northolt, while the south was primarily the pre-1926 constituency

James Hudson was Ealing's first ever Labour MP (for Ealing North, of course), elected in the year of the Labour landslide in 1945, though his constituents were chiefly the working-class residents of the new suburbs. 'Old' Ealing remained resolutely Conservative, with Sanderson being returned for a final time. Angus Maude then held the seat for the Conservatives until he was replaced by Brian Batsford, a publisher, in 1955, and he too maintained Conservative dominance in Ealing for the next two decades.

Party political labels were not used for some time in local politics. In 1927, candidates described themselves as 'Labour' and 'Anti-Socialist'. Many councillors in the following decade were businessmen, as they had been for several decades; nine out of eighteen Ealing councillors were in business, there were four professional men, four men from public service backgrounds and one woman. This tended to give them a fairly conservative (and Conservative) outlook. There was a Labour mayor in 1941 for the first time, but he was a Greenford councillor and the local newspaper reassured readers, 'We know that old Conservative Ealing has not yet changed its character very much.' The first female councillor from an Ealing ward (Drayton) was Mrs Brooks, the wife of an existing councillor, in the 1930s.

Political extremism was another force in Ealing during the 1930s. Sir Oswald Mosley had formed the anti-Semitic and anti-Communist British Union of Fascists in 1933, and a branch was established in Ealing by the following year. Mosley spoke to supporters at Ealing town hall on two occasions and once in the open, provoking the opposition of trades unionists, Labour supporters and Jews. Goodlet was invited to one of their meetings in 1934 and noted,

> I must say that I feel it, instinctively, to be a pity to see so many charming people, the majority of them young, engaged in a movement so utterly un-English and subversive of all that English political genius has accomplished and stands for. The movement, is, of course, quite definitely anti-Communist, and has the sole advantage, that it may counterbalance the latter. But really their mutual aims are so alike and their methods both so objectionable that I think the present a grave danger.

Goodlet once noted a Communist speaker holding forth in the Common (where Fascists and Communists occasionally clashed) and that the police were taking an interest in him. There were other political groups, such as the Ealing branch of the League of Nations and Peace Council, as well as junior branches of mainstream political parties, such as the Conservative Junior Imps.

Two amateur theatre groups established themselves in Ealing in these decades. In 1929, the Questors Theatre was established, and used the former Catholic chapel on Mattock Lane by 1933. They formed a limited company in 1949 and opened a purpose built, fully adaptable theatre, the first in the country, in 1964, when Sir Michael Redgrave was the group's active president. The theatre had an impressive record; from 1929–62, it put on 177 full-length plays, thirty-six of them new plays, as well as maintaining a student group and teenagers' club, Young Questors. Another amateur theatre group was the Bankside Theatre at Tring Avenue, which existed from 1931–61.

There were changes in the town's cinemas. The Kinema was rebuilt in 1928 and renamed The Lido. The Avenue theatre, built in 1932 on the opposite side of Northfield Avenue to the Elite was known as the Spanish Cinema because of its interior design. In 1938, it was

an Odeon cinema. A Forum opened on the New Broadway in 1934 in a quasi-Egyptian style. The Ritz opened at the junction of Hanger Lane and the Western Avenue in 1938. Some Ealing residents travelled outside the borough to visit the cinema; Goodlet frequently recorded travelling to The Globe in Acton to watch films in the 1930s.

Throughout the 1930s, there were concerns that the rise of Nazi Germany would plunge the world into conflict and this would mean mass bombing on a scale hitherto unknown. Letters in the local press encompassed a range of opinions from those of socialists who called for collective security through alliances, but argued against rearmament, to fascists who preached peace with Germany and Italy. Air raid precautions were seen as vital and preparations were made in the 1930s, though this was initially on a purely voluntary basis.

When Neville Chamberlain returned from Munich with promises of 'peace in our time', he was understandably lauded. The Mayor of Ealing doubtless spoke for many when he congratulated the premier: 'The inhabitants of Ealing thank you for saving the peace of Europe. Their hearts are full of the deepest gratitude. Their admiration of your diplomacy, courage and perseverance is intense.' Not all agreed, and the dissenting voice of Alexander Goodlet wrote, 'To me it seems a complete surrender to Hitler and a humiliating final desertion of the Czechs and for the principles for which we have been standing out … What a humiliation! But I suppose it means peace – for how long?'

The answer was for little over a year and this did give time for additional precautions to be taken. But as war was declared in September 1939, Ealing's ARP preparations were still unfinished. Air raid shelters had not been prepared or distributed, gas masks were often found to be faulty and there were insufficient people enrolled in civil defence. Many of them problems were rectified in the following year. Roy Bartlett recalls the announcement of war: 'Mum sat with her arm around my shoulders during the broadcast and I felt her stiffen as the family sat, stunned by the news, however much this was expected. Dad finally broke the tension as he quietly said, "Oh well, that's it. Better get on with it now, I suppose".'

Unlike in the First World War, Ealing was subject to bombing. The heaviest phase took place in September 1940 and a letter of 15 September gives a graphic portrayal of this:

> From Ealing Broadway down on both sides, every house or shop either all the windows out or some were burnt. We were all petrified … you can't imagine what is going on. It was 5 a.m. this morning before we could go to bed, and at 7.45 a.m. we heard the siren again… It wasn't a raid it was a bombardment. Ealing was alight. A basket of bombs, right through Sanders furniture shop, and storage all alight, Sayers, all the back on fire. Shelter back of Christ Church bomb dropped on … Madeley Road bomb on houses all to the ground… An oil bomb on a house in Eccleston Road, burnt several people and three houses. Westfield Avenue, eight houses down, Rowse's shop windows not one escaped.

Many prominent buildings were damaged or destroyed outright; the latter included the Railway Hotel and St Saviour's church. Ealing Studios and St Benedict's were damaged, and so was part of Christ Church. Bombing subsided as the months progressed. There were no bombs in 1942 and very few in 1943. However, the V1s caused suffering in the summer of 1944; on 3 July, one fell on central Ealing with heavy damage to property, but no lives were lost. On 21 July, there was a more deadly attack from a V1 that fell in West Ealing, killing

twenty-three people and injuring many more, as well as destroying shops and blocking the Uxbridge Road. A V2 rocket burst over Ealing on 6 November, fragments falling on Mount Park Road and South Ealing. About 170 civilians were killed in Ealing by bombing and it is probable that a similar number were badly hurt and perhaps three times the number sustained lesser injuries.

To an even greater extent than the First World War, most of Ealing's adults had a part to play in the war on the Home Front. Many were employed in civil defence, whether as ARP wardens, ambulance drivers, war reserve constables, clerks and typists in the civil defence headquarters or assisting the Fire Service. Their stoic service was recalled by a local journalist, Mr C. R. Wallis:

Such was life in Ealing. Some of our landmarks went up in flames, or came tumbling down. Before long we had become so adept in dealing with these incidents … The trapped were freed, the dead removed to the mortuary, the injured were taken to mobile units and first Aid posts or hospital, what remained of a household was salvaged, and, so far as could be arranged, the area was 'restored to normality'.

Family life was disrupted in an unprecedented manner. It was suggested that children living south of the GWR line should be evacuated in September 1939 to various locations in Buckinghamshire and Berkshire. There was no compulsion, but over 2,000 went. For many children, who remained in Ealing, schoolwork was disrupted by air raid warnings (most schools had air raid shelters). Most evacuees returned from the countryside by early 1940, only to be re-evacuated as the Blitz began in the autumn.

Erica Ford, who worked in the canteen of the fire service, recorded the end of the war in Europe on 8 May 1945 in her journal:

Victory Day: At last. Cycled to 'Z' via Broadway – houses and shops gay with bunting and flag & church bells ringing. Sunday routine – rather quiet at C1. Went to Hanger Lane for while. Back for tea. Bacon roll for supper. We watched band go out and play outside Town Hall from 8.00 – 9.00 … We all cheered it & rushed to side entrance to watch & cheer. When band came marching back, half of Ealing was marching behind & came right in the yard through the gates – wonderful sight. Band played some more, then dismissed … Houses floodlit & bonfires scenting the air … Couldn't get down Haven Lane because of crowd dancing outside pubs. Big crowd on the Green singing & dancing … Bed 1.45.

Celebrations were more muted when victory over Japan was declared in August, finally bringing the war to an end. Erica Ford wrote that this was a two-day event, covering 15 and 16 August:

Today VJ Day … Hundreds of people going home after starting for work not knowing … Crowds dancing on the Green. Floodlighting in Great West Road. Bonfires down every side street. Fire engines turned out … [next day] … They had dancing under covered way & it became quite crowded & jolly … Crowd from outside joined & when rain stopped were able to go right out into yard.

Erica Ford.

Of course, many of Ealing's men were employed in the armed services at home and abroad. Many paid the ultimate price for victory, and 508 were killed in action. This number was less than it had been in the First World War, primarily because the USSR had borne the brunt of the fighting against Germany. Ealing's two Victoria Cross holders were Ian Fraser, a lieutenant in the RNR, who won it while serving on a submarine in the Jahore Straits in 1945, and Norman Jackson, an RAF sergeant, who won it flying over Germany in 1944. In addition, two received the Military Cross, one the Military Medal, five received the DFC and one the DSO.

By 1951, the population had fallen to 74,871. This fall was only partially due to wartime casualties, which were relatively light, but also due to people moving out of town, a trend that affected London as a whole. However, by 1961 the population had risen again to a record 83,792 residents.

One of the reasons for this rise was a relatively high level of immigration from overseas, especially in the 1950s and 1960s. In 1960, George Brown wrote, 'A Polish community commenced during World War Two, has flourished, bringing Continental ways of living into the district.' Polish grocery shops began to appear in the 1950s, with a fairly short-lived one on Northfield Avenue and another, and long-lasting one, opposite Ealing Broadway station The Parade Delicatessen. P. Kirkman, writing around 1960, noted that

> The foreign population includes people from all over Europe, but particularly Poland, evidence of this is found in the several Polish grocery shops, to be found in the vicinity of Ealing Broadway, where the majority of them have settled. There is a noticeable lack of a coloured community, this is possibly because the rates are comparably high, West Indians and Africans are frequently seen. There is a small Indian population, that, although not clustered in one quarter, live on the Oxford Road and Windsor Road areas and generally south of the railway line.

he appearance of Indian and Chinese restaurants reflected this increasing multiculturalism: n Indian restaurant, Shillong's, opened on Northfield Avenue and The Five Happinesses, a Chinese restaurant on Bond Street around 1962.

The numbers of immigrants arriving in Ealing are difficult to ascertain from the 1951 ensus, and 1961 census statistics are only for the whole of the Greater Ealing borough. s accommodation was generally cheaper in Greenford and Perivale, and there were more ndustrial jobs on offer, it is possible that many immigrants settled there. In 1951, there were ,174 people who had been born in the Commonwealth (which included India), 427 from he colonies (which were still part of the British Empire), such as Africa and the West Indies, nd 5,059 from other countries, mostly from Europe. There were also 4,062 people born 1 Ireland, reminding us that the Irish were Britain's largest but least noticeable group of nmigrants. The 1961 census is a little more specific, showing that the number of Irish had allen to 2,900, and there were now 205 Africans and 680 people from the Caribbean, as ell as 1,487 from India. Many of those born in the Empire and Commonwealth, especially ndia, would have been expatriate British. The largest groups from Europe were the Poles, at 44, and the Germans, numbering 542.

Many of these newcomers were not particularly wealthy and so lived in parts of Ealing hich were cheap, such as around the fringes of the Mall and south of the main shopping treets in central and West Ealing. Some of the housing was in multiple occupancy, in a poor tate of repair and lacking amenities. Very few lived in high-value owner occupier housing ear Ealing Common, Pope's Lane and north Ealing and Hanger Hill. For Indian and African nmigrants, economic motivation probably provided the incentive and there was a rush in 960–62 to beat the restrictions of the Commonwealth Immigration Act of 1962. Polish nmigrants were primarily political refugees, resulting from the German, and then Soviet, ccupation of their homeland from 1939. Polish pupils had been at school in Castlebar Court in the 1940s, Polish fighter squadrons had been based at the nearby Northolt RAF ase, and the Polish government in exile was based in South Kensington (on the District ine, of course). These may be pointers to why some Polish people decided to settle in Ealing.

The post-war Labour Government's pursuit of nationalisation led to the council and its itizens having less control over some local amenities. Ealing's electricity works closed down 1 1950 as the Southern Electricity Board took over. The greatly extended King Edward Memorial Hospital (which had 160 beds by 1945) began to be managed by the North West Metropolitan Regional Board in 1950, following the creation of the NHS in 1948. Another ospital that came under NHS control was the more recently established (1932) Royal Jational Throat, Nose and Ear Hospital on Castlebar Hill.

In other spheres, however, the council expanded its activities, for example with the brary service. Branch libraries were opened on Pitshanger Lane in 1948 in a disused shop, Jorthfield Library opened on Northfield Lane in 1960 and Hanger Hill Library opened at Jo. 11 Abbey Parade in 1955 before moving in 1963 to Fernlea House.

The kinds of leisure pursuits changed over time. Sports clubs tended to decline in number; 1 1938 there were twelve badminton clubs, eleven bowling clubs, sixteen football clubs nd twenty-one tennis clubs (Fred Perry, who won the Wimbledon Men's Single three times 1 the 1930s, came from Ealing); but in 1950 there were seven of each of these, and this is artly due to the disruption of the world war. This was a trend that affected other activities

as well. The number of amateur theatre groups fell from fifteen in 1938 to eight in 1950. Cinema-going was also on the decline. The Palladium was closed in 1957, due to its small size and the commercial possibilities the site offered, and a branch of W. H. Smith occupied the site. The Lido became a bingo hall and audiences at the Walpole were declining.

On the other hand, allotment societies grew in number, again partly due to the war, as increasing numbers had grown their own food in that period. After the war they were, understandably, far more ex-servicemen's organisations and a number of old people's groups as well as numerous women's co-operative groups. More diverse hobby groups began to appear in the 1950s, including a Zodiac Magic Society, a scooter club, Scottish Country Dancing and whist clubs. The council established community centres and these and church halls were used for a range of activities, often throughout each day. One was Northfield Community Centre, built on Northcroft Road, in a converted sports pavilion.

Other post-war interests included gambling. The legalisation of betting shops in 196 resulted in two shops opening very quickly and, by 1964, there were sixty-eight in Ealing. The Lido cinema was converted into a bingo hall, attracting housewives and working-class couples (it had 29,900 members in the 1960s). Popular music was another new development. In the 1950s there were seven venues in Ealing, mostly basements in the town centre and in rooms above pubs or in outbuildings, where teenagers and young people went for beat and jazz music. Other forms of entertainment were provided by the council in the 1950s. Firstly

W. H. Smith, Ealing, Broadway.

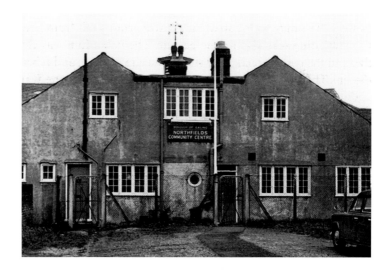

Northfields Community
Centre.

ney put on a Summer Arts and Crafts Exhibition, swimming galas in the Baths and a Spring
ance contest.

Illegal drinking and gambling clubs also existed in the Ealing of the 1950s. In 1952, the
ilencairn Club in Hanger Lane was charged with out of hours drinking. The Ealing Club on
Ielena Chambers was similarly charged, as well as being a gambling club. The proprietors of
oth were fined. However, the Ealing Club had a more prominent role in the early 1960s as a
iusic venue and has a distinguished place in the development of British blues and jazz. It was
pened in 1962 by Alex Korner and Cyril Davies. A young Mick Jagger was a performer, and
e met Brian Jones there, leading to the founding of the Rolling Stones. Many other famous
ames of the period played here, too, in the less than salubrious surroundings.

There were a number of young people in Ealing who were involved in more serious
astimes. The Ealing Young Conservatives were a vibrant social and political youth group
1 the 1950s and later. Other young people took part in the anti-nuclear protests of the
950s and 1960s, and the Aldermaston marchers passed through Ealing. Henry St John, a
iisanthropic civil servant, said of them in 1958,

I saw a few of the marchers in the Aldermaston to London march organised by the Campaign for
Nuclear Disarmament. They were young people, some with heavy boots ... There were women
pushing children in prams ... There were several hundred of them, average age about 20, of the
intellectual type, hardly a hat among them.

.nother form of activism came from Residents' Associations, groups of people from particular
arts of the borough who campaigned on very local issues. They acted as pressure groups for
ction on the part of the council. These sprung up in Ealing as a result of the Second World War
nd, by 1955, there were three, as well as two Townswomen's Guilds.

The people of Ealing began to take an interest in their own history. Cyril Neaves, a
Ianwell headmaster, wrote *The History of Greater Ealing*, as it had become in 1928, in
931. In 1958, the Greater Ealing Local History Society was formed out of the Greenford

History Society, which had been formed in 1942. It was stated, 'Interest in local history i becoming far more popular in the relics of the past are being swept away to make way fo the history of tomorrow and we must accept a certain responsibility for preserving som record of those things before they are forgotten.' From 1962, the society produced a regula journal with articles about the borough's history. Gunnersbury Park Museum, established i 1928, catered for Ealing, Brentford and Chiswick and Acton's history, for it had been bough by all these local authorities from the Rothschilds.

Ealing had become the largest non-county borough in Great Britain and larger than mos county boroughs in the country. The distinction was that a non-country borough council' powers were limited as the provision of public services was shared with the county council, a were the other boroughs and districts in Middlesex. Therefore, there was a movement to achiev county borough status by means of a Private Member's Bill in Parliament, sponsored by Angu Maude, MP for Ealing South. It had its second reading in the Commons on 25 March 1952.

Maude argued that Ealing 'is a viable authority in size and an efficient authority, and tha the existing duplication of powers results in inefficiency and in suffering to the inhabitants c Ealing'. He asserted that Ealing could run its services better than the remote county counci which was often slow and insensitive to local needs. Ealing paid 8.4 per cent of the count council's income and had 8.3 per cent of its people, so Maude argued that a change woul not cause the county council much distress.

There was much opposition to the bill, principally by George Pargiter, MP for Southall an defender of the county council. He said that if Ealing were granted county borough statu all the other boroughs in the county would call for it and, following Ealing's precedent, coul hardly be refused. He thought the current system worked well and pointed out that onl thirty-four out of sixty Ealing councillors positively supported the plan. Others said tha the scheme was unworkable and that piecemeal reform of local government should not b pursued. Eventually there was a vote and ninety-four supported another reading and 16 opposed (including Ealing North's Labour MP). The scheme died.

Yet changes in local government, though of a different nature, were in the air. A Roya Commission on Greater London's local government, which met between 1957 and 196(reported that the current two-tier system of administration was wasteful because it led t duplication. It also suggested that more powers be given to the borough councils, and tha the proposed Greater London Council should be reduced to a strategic role, especially wit regards to education, transport and environmental issues. The government adopted many c these proposals and, with the Government of London Act of 1963, sought to amalgamat local government bodies in order to have fewer, but more efficient bodies. The Middlese and London county councils were abolished and replaced with the Greater London Counci the urban district councils and boroughs were abolished and neighbouring boroughs wer merged together and often given new names.

The Royal Commission did not initially recommend that Ealing merge with a neighbourin borough because, with a population of 182,000, it was large enough to stand alone However, Ealing merged eventually with its smaller eastern and western neighbours, Acto and Southall, and gave its name to the new London Borough of Ealing, undoubtedly becaus it was far larger and more populous than the neighbours. It had a new coat of arms and new motto, 'Forward with Progress'.

Ealing was now a de facto part of Greater London. This had been acknowledged by younger people already. G. Brown, writing in 1965, recorded, 'Ealing is now irrevocably a part of London.' P. Kirkman wrote in 1960, 'I consider myself a Londoner rather than a native of Ealing.' The growth in housing had, by the 1930s, made boundaries between boroughs undiscernible to any who did not have a map with these delineated. It was now, with the abolition of the County of Middlesex, explicitly part of the greater London sprawl.

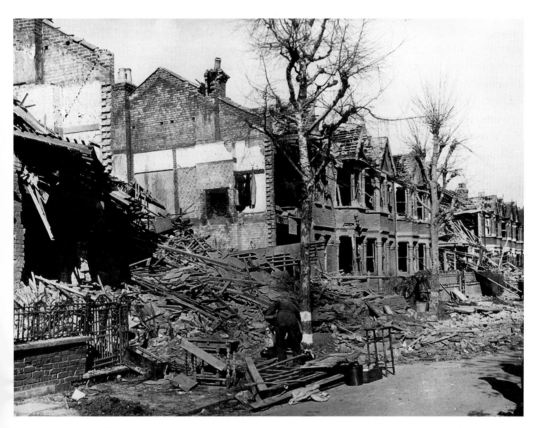

Bomb damage in Westfield Road.

7

LONDON BOROUGH, 1965–2014

The last half century feels too recent to be able to give an easy account of its history as a time lived through does not feel like history. This chapter will provide an impressionistic account of some of the major changes and incidents of that time, but cannot pretend to be definitive.

The new Ealing Council, established in 1965, had sixty councillors, each ward still returning three members, and ten aldermen. Politically, it was marginal; the old borough was always Conservative-controlled, but the former boroughs of Acton and Southall tended to return Labour majorities since 1945, so the new council swung between Labour and Conservative control. In 1965, it was Labour; Conservative in 1968 and 1971, Labour in 1974 and Conservatives again in 1978, and this pattern continued in subsequent decades. Yet the wards of Ealing proper (which fluctuated from five or six and were renamed with each reorganisation) almost always returned Conservative members, except in the early 2000s when Walpole and Northfields returned Labour ones.

In the 1970s, council departments were widely geographically distributed. Many were housed in the town hall, but the rent office was at Paramount House on the Uxbridge Road; the legal department and the computer were at the town hall annexe behind the town hall; the schools special needs division, engineering and town planning were at No. 24 Uxbridge Road, with library administration at Pitzhanger Manor, and other education offices at Hadley House on the Uxbridge Road.

Changes occurred in the following decades. In 1978, the aldermen were abolished in the London boroughs. More significant was that in 1999, the Local Government Bill required that councils adopt new administrative and management structures. In 2001, Ealing Council opted for a leader and a cabinet, made up of councillors from the majority party of the council (the committees had contained councillors from different parties). There were also scrutiny, regulatory and ward committees, to which the public could attend, as they could the meetings of full council.

The cabinet was made up of the leader, his/her deputy, and six members; one for community services, one for children and young people, one for finance and performance, one for transport and environment, one for health and adult service and finally the chief whip and member without portfolio. Their meetings were held once every three weeks behind closed doors, but agendas and minutes were open to inspection. Later, shadow members were allowed to attend and to speak, and finally they were made open to the public, too. There were also ward forums made up of councillors and residents, which were chiefly advisory.

The new status quo was challenged in 2001 by a grass-roots campaign of local activists, who thought that a better system of local government would be to have a directly elected mayor, as

opposed to an apolitical mayor and an executive leader chosen by the ruling party. They believed that their scheme would lead to better leadership, accountability and greater engagement with the electorate, especially since the council's rating was then deemed to be poor, following recent difficulties facing the social services department. Unsurprisingly, councillors from all parties and local MPs were unanimously opposed to the idea of a 'Political Mayor', who would, allegedly, cost the tax payers more money and would result in less power for themselves. The campaign needed enough signatures for a petition for a referendum. This was achieved and the referendum was held at the end of 2002. It resulted, after a 9.8 per cent turnout, in a no vote of 11,655 (55.2 per cent) to 9,654 (44.8 per cent), and the new status quo was preserved.

The shape of Ealing's Parliamentary boundaries has altered too. In 1972, due to falling populations, the Ealing–Acton constituency was created out of Ealing South and Acton, and from 1997–2010, this also incorporated Shepherd's Bush. From 1974–97, the MP was Sir George Young, the 'Bicycling Baronet', but following the Labour landslide of 1997, Clive Soley became Labour MP until 2005 and was then succeeded by fellow socialist Andrew Slaughter. In 2010, this marginal seat no longer included Shepherd's Bush and was won by the Conservatives and Angela Bray became Ealing's first female MP. Ealing North swung from Labour to the Conservatives (Harry Greenaway MP) in 1979 and back to Labour in 1997 (Stephen Pound MP). Since the inception of the Greater London Assembly, Ealing and Hillingdon have formed one constituency, and from 2000–12, Richard Barnes was the Conservative member, but in 2012, Dr Onkar Sahoto became the Labour member.

Ealing continued to promote itself as an attractive place to live, as always. The Official Guide of 1973/74 proudly stated, 'With good schools, several excellent shopping centres and a wealth of open spaces and sporting amenities, Ealing seems set fair to continue as one of London's most attractive and progressive residential boroughs'. While this may be dismissed as commonplace hyperbole, some contemporary opinion supported it. A housing guide to London noted that Ealing

isn't really trendy ['Ealing nightlife is dead'] but is certainly better than average suburbia. Gathering ground for young executives … Transport facilities are good … Plus plenty of open space, good schools and shops.

The 1974 borough guide stated that central Ealing was 'popular with young people, who share flats, often in converted houses and can combine to pay the rather high rents which convenience commands'.

Although Ealing Council seemed to have abandoned the district's Edwardian 'Queen of the Suburbs' epithet, it was resurrected in 1965 and the term gained a further lease of life. Regardless of the council's use of it, estate agents and outside commentators still found it a useful term in their adverts in newspapers and it can still be found in use now. In a less positive way, disgruntled residents employ the term, usually as a stick to beat the council as contemporary Ealing is compared unfavourably to the supposed Golden Age that the phrase suggests. The Revd Michael Saward used the phrase to describe his chapter of his life in Ealing, but it was no longer in universal use, although many residents would have been aware of its onetime popularity. It does not feature in the council's website as a contemporary term, only in reference to borough's history.

Public services also underwent alterations. In 1978, King Edward Memorial Hospital closed as NHS hospitals in the various districts of the new borough were merged into a new one, in Southall, termed Ealing Hospital, which had taken almost a decade to build. Elsewhere, Hanger Lane Library closed in 1980, but a new West Ealing Library was built in the 1980s, and a new central library was established in the Ealing Broadway shopping centre in 1984 as a planning gain. The library was refurbished in 2008, with more computers but fewer books. Pitshanger Manor, now no longer used as a library, was renamed Pitzhanger Manor, reverting to Soane's name for it (which was not that of the house for most of the nineteenth century) and, after it had been refurbished in 1985–87, became a visitor attraction and a venue for modern art exhibitions. The Fox Reservoir, long out of use, was covered over and part of the area became a new open space in the 1970s.

Ealing's population fell between 1961 and 1991, as did that of London more generally in these years. In 1961, it had stood at just over 80,000, but in 1971 it had dropped to 76,982, in 1981 it was 72,052 and it was 70,363 in 1991. This was despite the increase in immigration in these decades, and it was roughly in line with the overall decline in Greater London's population at the time as people moved away from the capital and its environs, and birth rates fell. Household sizes were also falling; from an average of 2.6 per household in both 1971 and 1981, to just 2.2 in 1991, reflecting an increase in single households due to old age or divorce/separation. However, there was a revival in numbers by the twenty-first century, with 78,792 inhabitants in 2001 and an all time high of 85,004 in 2011, chiefly the product of overseas immigration. At time of writing, the complete ward figures for the 2011 census are not available, but it appears that 10 per cent of Ealing's residents in 2011 arrived in the UK in the 1990s, and 25 per cent since 2000, largely due to the relaxations on immigration, and the entry of Poland into the EU in 2004.

In 2011, Ealing's white population stood at 57,492 (67 per cent), with 4,218 people of mixed descent (5 per cent), 13,678 Asians (16 per cent), 5,219 black people (6 per cent) and 4,487 'other' (5 per cent). Of these people, 48,687 had been born in the UK (57 per cent), 2,410 in Ireland (3 per cent), 11,807 in Europe (12 per cent) and 21,648 elsewhere (26 per cent). The second most common language in Ealing was now Polish; 75 per cent had English as their main language and in second place was Polish (6 per cent), with French (1 per cent). Three per cent spoke Middle Eastern languages, 2 per cent Asian and 1 per cent African, with a large group of 'other' making up the remaining 13 per cent.

As said, the population fall from 1961–91 would have been more dramatic had it not been for the modest rise in immigration. In 1971, there were 4,846 people from Ireland, 2,217 from India, 419 from Pakistan, 813 Africans, 795 from the Caribbean and 4,169 from Europe. By 1981, numbers from Eire had declined to 3,449, but numbers from other countries had risen. There were now 6,702 whose origin was in Asia, Africa and the Caribbean and 4,565 from Europe. In 1991, 3,270 residents were described as black and 4,551 were from Asia (European residents were not recorded but lumped under the generic racial term 'White' unless they were Irish).

Slum clearance continued in the 1960s. Many of the small terraced houses in Stevens' Town in streets such as St John's Road, Singapore Road, Williams Road and Williams Passage were demolished between 1967 and 1971. In their stead were built blocks of flats: Tintern Court Melrose Court and Buckfast Court in what is known as the Green Man Lane estate.

Some of these flats did not have a long existence, for in the early twenty-first century, there was new housing at Green Man Lane. This followed the demolition of flats at Wigmore Court and a multi-storey car park. Some of the new flats would be 'affordable', some would be shared ownership and some would be sold outright (706 accommodation units in all). The developer was Rydon A2Dominion and the cost was £141 million, with Conran and Partners as the architects. There would also be leisure facilities; a café, gym, community centre and children's play areas. There would also be enterprise units.

In the 1970s, the council aimed to build more housing, chiefly flats, when land became available elsewhere. This was mostly when a large building, perhaps with grounds, became redundant and thus came on the market. So the council bought Greystoke House on Hanger Lane to build 112 dwellings. They also bought Castlebar Court, once a nurses' home, on Queens' Walk to provide 97 accommodation units as part of a set of low-rise flats. The former Northfields Laundry in Belsize Avenue was bought for a smaller housing development of eighteen dwellings. No housing was built by the council from the 1980s until the second decade of the twenty-first century, due to government legislation to encourage home ownership.

The trend of demolishing large Victorian houses also affected private housing developments. Housebuilders Wates created Lakeside in 1966, a small enclosed development, comprising three storey town houses and a tall block of flats, set in a landscape with a pool inherited from the gardens of the house it replaced (the Grange). The houses on the west side of Kent Gardens went in 1963 and were replaced by flats too. There were two major private sector developments in Ealing in the 2010s. One was the Dickens Yard development by St George,

Above left: Flats in West Ealing, 1977.

Above right: Demolition on Kent Gardens, 1964.

West London Ltd, to build 698 new apartments and private houses on a site behind the town hall, each with one to three bedrooms, which 'aims to create a vibrant new urban quarter' with private gardens, landscaped boulevards and three public piazzas. There were to be cafés and boutiques, and the residents would enjoy hotel style living with a concierge, pool, gym and spa, and underground parking spaces. The first phase of building was the Belgravia Apartments of 130 flats.

Many of Ealing's older buildings had been demolished in the mid-twentieth century. Greater awareness of conservation led to legislation and then a number of conservation zones were established in three Ealing districts in 1969, chosen for their architectural and historical importance. These were the Brentham Garden Suburb, Ealing Green (from St Mary's church to the High Street) and the Hanger Hill Garden Estate. These gave additional protection to the built environment by restricting external alterations, often much to the annoyance of some homeowners. Another was established in 1980, ranging from Pitzhanger Manor House to St Mary's church, which included a number of eighteenth- and nineteenth-century properties. In the 1980s and 1990s, Ealing Common, Haven Green and Montpelier Park were added to this number.

Ealing's housing stock remains mixed. In 1971, it was stated, 'Flats, town houses and early Victoriana stand uneasily side by side off Castlebar and Castlebar Hill, while generally things get worse south and west of the Uxbridge Road ... Best area – if you can afford it – is Hanger Hill'. Some late eighteenth-century properties were demolished in Castlebar Road in the 1960s and 1970s, and flats built on the sites. Commercial premises have been converted into flats, e.g. Curry's former HQ became Cavalier House, and there has been an increase in the number of hotels in the borough.

Household tenure varied considerably by ward. In 1971, 61 per cent in Northfields were owner occupied, rising to 67 per cent in 1976 and in Hanger Hill the proportion rose from 57 per cent to 62 per cent. Council tenants were relatively few in 1971 – 6 per cent in both Northfields and Cleveland, though both wards saw a slight rise by 1976. Many rented privately in other wards; in Walpole it was 49 per cent and in Central 59 per cent in 1971,

Castlebar Road, 1900.

though by 1976, both rates had fallen and more were living in public sector housing. Some houses were in multiple occupation; in Walpole, Central and Cleveland, these accounted for about a quarter of all homes, but in Hanger Hill and Northfield it was only about a tenth.

One of the major issues in Ealing from the 1960s to 1980s was what to do about its town centre. Ealing Broadway, together with the Uxbridge Road in West Ealing, had been declared by both the council and the GLC as 'a major strategic centre' for shopping and 'preferred office location'. The Labour Council produced a detailed plan to connect the two by a four lane highway bypassing the Uxbridge Road, which was to be pedestrianised, while the new road would run through the Grove area south of the Ealing Broadway and then along Mattock Lane, destroying about 1,000 homes in the process. There would be a seventeen-storey office block, a shopping mall and a ten-storey block of flats for childless couples. Grosvenor-EMI was the developer chosen by the council.

This plan met with great hostility from both residents' associations and the newly established Civic Society, concerned with protection of property values and the local environment. They joined forces with the Architects' Revolutionary Council to fight the scheme. Public meetings were held and alternative proposals were put forward. In 1976, there was a public enquiry and the Grosvenor-EMI scheme, which no one but the council supported, was refused permission.

In 1978, the new Conservative council came up with alternative proposals. It agreed that there would be no new road and that the council would make no more compulsory purchase orders. The council drew up a new brief to deal with the blighted site that was the Grove area, which did not entail high rise flats. The architectural practice selected was the Building Design Partnership, and its proposals were closer to the residents' associations views. The new Ealing Broadway Centre cost £25 million.

Much of the original plan for what would be built on the Grove area went ahead; the new site would include offices, chain stores and a multi-story car park, and, initially, a hotel, but the latter was dropped. There would be no public sector housing and no cinemas. The whole structure would be faced with brick, deemed far more aesthetically pleasing. The Alliance of Residents' Associations deemed this a success, proclaiming, 'Life is flowing back … Ealing not only has a heart. It has a body and soul.' The council liked the scheme because it meant it had a new source of revenue, the developers had a 125-year lease on a profitable part of Ealing, and the shoppers seemed to like it. The opinions of those former residents of the Grove may well have been less favourable.

Bentalls, which had occupied the buildings on Ealing Broadway (on the corner with Springbridge Road, once the Eldred Sayers store), relocated to the new Ealing Broadway Centre. The site was redeveloped as a smaller shopping experience initially called the Waterglades in 1985, and renamed The Arcadia Centre in 1997. It is very much the poor relation of its larger neighbour.

There were a few alterations in the centres for religious worship in Ealing. St Mary's built a parish centre in 1977/78 and the church had a major overhaul in 2004, in an attempt to rediscover its late Victorian grandeur, winning an award for it in the process. St Stephen's church was found to be unsafe in 1978 and so closed for worship in the following year. It was sold to a builder, and converted into flats, while the income raised was used to build a new low rise church, nearby. At least it survived, other churches were less lucky. The Church

of the Good Shepherd closed in 1978. Other churches dealt with falling congregations by reducing their number of pews, as St Paul's and St Peter's did in the 1970s. St Matthew's welcomed Polish Catholics to conduct their worship there in 1967. Similarly, Ealing Green Congregational church was used by United Reformed and Methodist congregations by 1972. The Methodist church on Windsor Road was abandoned by the Methodists and remained vacant for over a decade, until it was bought for use by Ealing's Polish Catholic community, who remodelled it as a community centre as well as a church, and whose parish had been run by the Marian Fathers since 1965. There was further building at St Benedict's, to establish a Benedictine Study and Arts Centre in 1992, for adults to understand Benedictine teaching.

Churches continued to run a range of activities. St Stephen's, in 1968, had a youth club, a Mothers' Union, a ladies' sewing guild, Girl Guides, Boy Scouts, an Overseas Working Party, Bible Reading Fellowship, a '20s club, a horticultural society and a Dramatic Society. In 2011, the focus was different and there was more of an emphasis on reaching non-church members, with Messy Church, which is craft and fellowship for young children and mothers, the Alpha Course, teaching people about Christ, a Daytimers' lunch club for the elderly as well as youth and drama groups. There was also more emphasis on churches working together for the common good, with St Stephen's joining with other local churches to provide shelter to the homeless in winter time, though churches pooling resources was not new; in 1978, St Peter's shared St Andrew's Presbyterian church hall for youth activities. Churches also responded to the needs of new parishioners and St Andrew's holds Ghanaian services once a month.

One of the best known Ealing clergymen of this period was the Revd Michael Saward, Vicar of Ealing from 1978 to 1991. He stated, 'Eric Vevers, my predecessor … had done a good job at St Mary's, but the church hadn't made much impact on the town itself.' No shrinking violet, Saward tried to change all that. He forged links with the council, local groups, the MP and deputy lieutenant. He enthusiastically presided over the annual civic service and took a lead in important campaigns. These ranged from helping to raise £400,000 for roof repairs to chairing the Borough Committee for the Mission '89 of the American evangelist Billy Graham. To make his vicarage study more welcoming to visitors, he had it redecorated as a Caribbean beach scene.

The recent censuses record the religions of Ealing's people for the first time. In 2001, the majority professed to be Christian of various denominations: 45,735 (58 per cent) in all, followed by Islam, with 5,054 (6 per cent) worshippers; then were Hindus, 2,414 (3 per cent), and Sikhs, 1,394 (2 per cent). However, 24,155 (31 per cent) professed to have no religion or chose not to state it. In 2011, census data indicates a fall in the number of Christians and a rise in the number of Muslims, with Christians totalling 42,195 (48 per cent), 8,301 Muslims (10 per cent), 1,634 Sikhs (2 per cent), 3,453 Hindus (4 per cent), 1,392 Buddhists, (2 per cent), 562 Jews (1 per cent), and other/unknown at 27,921 (32 per cent). Unlike other parts of the modern borough, Ealing itself has few buildings catering for non-Christian religions. The closure of the West Ealing Baptist church led to the building being purchased by Hindus and, in 1991, it became the Shri Kanaga Thurkkai Amman Kovil, making the locality more colourful, noisy and congested. There is also an Islamic Centre and Jamia Masjid in West Ealing. This was established in 1984 in Oaklands Road, but moved to a new site in Brownlow Road in 1996. The building also houses a nursery, a library, gym and canteen.

Revd Michael Saward

There were major changes in Ealing's educational system in the later 1960s and 1970s, as there was nationally, due to new legislation. After much protest from parents' groups wishing to retain the grammar schools, in 1974, Ealing adopted the comprehensive system, with primary, middle and upper schools, abolishing selective education in the state sector. Grammar schools became upper schools: the Boys' Grammar School became Ealing Green School from 1974 until its closure in 1992, and the Girls' Grammar School was renamed the Ellen Wilkinson School (after a former Minister of Education). Ealing Green school became the Ealing Tertiary College in 1993, teaching courses to the over sixteens, and in 2002 became a branch of Hammersmith & West London College. Other secondary schools, such as Ealing Mead and Grange School, closed in 1974, as did Northfields, which had become a secondary modern school by 1965. Walpole Grammar merged with Bordeston Secondary School in Hanwell to become Elthorne High School, but closed in 1993. By this time, Ealing children went to state schools elsewhere in the borough, such as Drayton Manor in Hanwell and Twyford High School in Acton.

Primary schools merged, with the infants and junior mixed. So, instead of the thirteen in 1965, there were eight, as well as the new Hathaway Primary and two Catholic schools. In the major shake-up of 1974, middle schools emerged, taking the older children from junior schools and the younger ones from upper schools, only to disappear two decades later. In 2010, the best of the Ealing primary schools were Hathaway, North Ealing, Little Ealing and Fielding schools, all rated 'good' by Oftsed.

The private schools, unaffected by such changes in educational fashion, continued to flourish. Notting Hill & Ealing High School expanded in the 1970s, adding a library and a science block. In 1978, there were 643 girls aged five to eighteen there. Durston School

expanded and had 200 boys in 1978, and since 1986 has been run by an educational trust. At this time, St Benedict's took girls into the sixth form, and the school became co-educational in 2000. Against this trend, in 2010, Harvington School contracted and now teaches three to eleven year olds only, and is also a prep school for young boys. Private schools varied in size from the small, such as La Chovette School on the Mall with thirty pupils in 2013, and the Insights School on Alexandria Road with forty-five, to the larger ones such as St Benedict's with 1090 and St Augustine's with 450. In 2013, there were a dozen independent schools in Ealing. Some schools were short lived, such as the Ealing Dean Anglo-French School, which existed on Mattock Lane in the 1990s.

Ealing also had a number of schools specifically for what were then known as mentally and physically handicapped children. In 1971, there was Springhallow School on Aston Road for autistic boys and girls aged three to sixteen, Castlebar School on Hathaway Gardens, for children aged four to thirteen, established in 1972, and Cavendish School on Cavendish Avenue from 1971. By 2011, the latter had closed.

Ealing's Technical College underwent a number of changes. In 1977, it was renamed Ealing College of Higher Education, and had 1,800 full-time and 3,400 part-time students. In 1990, it merged with Thames Valley College of Higher Education in Slough and two other colleges to become the Polytechnic of West London. It achieved university status as Thames Valley University in 1992, and merged with Reading College and School of Arts and Design in 2004. It was rebranded in 2011 as University of West London. As ever, it offered practical degree courses, such as catering and tourism.

A new form of education has taken place, which caters to the needs of immigrant populations, termed supplementary learning. Often using existing school buildings, there are Saturday schools, where parents can pay to send their children for a few hours on a Saturday. Here they will be taught the language, history and culture of their family's country of origin, which would not otherwise be taught in mainstream schools. For example, there is the Polish Saturday school based at St Benedict's, the Ealing Arabic School at Ellen Wilkinson School and the Kurdish Association for New Generations Abroad, based in the West Ealing Youth and Connexions Centre in Churchfield Road.

Overall, the pattern of transport that existed in 1965 remained the same for the next five decades. Ealing was well placed geographically, with two major roads nearby (the Western Avenue and the M4) and was midway between the West End and Heathrow Airport. A few changes have occurred. South Ealing station, which had long operated in a temporary structure, was finally rebuilt in 1988. From 2000, Heathrow Connect trains (from Paddington to Heathrow and vice versa) have stopped at Ealing Broadway and West Ealing twice every hour.

Ealing Broadway station, as the rail nexus for three routes, was inevitably the busiest station in Ealing, with an annual usage of 7.7 million in 1978, almost the same as all the other stations put together. However, despite criticisms that it is not easily accessible by the elderly, the disabled or mothers with buggies and prams, little has been accomplished in this direction, although the booking hall has been redesigned. Rail was the most favoured method of getting to work in 2011; of the census figures, 20,817 used it, or 32 per cent of those travelling from Ealing to work, suggesting that most worked outside the borough.

Cycling was promoted by the council as a healthier form of transport, yet in 2011 only about 2.6 per cent of residents cycled to work (1,674). It entered a partnership with

Brompton Bicycles, and from 2012, twenty of the firm's bicycles were to be made available for hire from Haven Green, and the council provided an additional 150 new cycling spaces there (to the criticism of those who thought that this was eroding part of the public open space).

There could have been a major overhaul of public road transport in the first decade of the twenty-first century. The West London Tram Scheme was announced by Transport for London, and the proposal was essentially to resurrect the trams line along the Uxbridge Road from Shepherd's Bush to Uxbridge that had been abandoned in 1936. It was argued that this would be environmentally friendly and would lead to motorists switching from car to tram for their journey, as had happened in Croydon. It was scheduled to cost £50 million, rising to £1 billion, and would open in 2009, with 40-m-long trams each seating 300 passengers.

Most agreed that additional road users were clogging the Uxbridge Road, yet not all agreed that trams were the answer. Opponents of the scheme said that the trams would clog up already congested roads and lead to side roads being used as rat runs by motorists. 'Pinch points' along the road were identified – these being places where two vehicles would not be able to pass at the same time. It was also claimed that the likely switch of motorists to tram passengers was exaggerated.

Initially, the Labour council were in favour of the scheme, advocated as it was by the then Labour Mayor of London. There were a number of opinion polls carried out between 2004 and 2006, most showing a decisive majority against, though proponents of the trams dismissed the ones that were not in their favour. Opposition came from a grass roots pressure group, Save Ealing Streets, which was remarkably successful. The council's stance on this controversial issue may have helped lead to its being punished in the local elections of 2006 and being replaced by a Conservative led council, who opposed the tram route. The scheme was eventually abandoned in 2007 because the government announced the long awaited Crossrail scheme.

Crossrail was an ambitious plan to build a 73-mile railway route from Maidenhead, across part of Buckinghamshire, into London and under the centre, before splitting towards Kent and south-east London. New tunnels would be required under central London, but existing railway lines would be incorporated on the western approaches and existing railway stations would be used. The proposed new services meant that Ealing Broadway would have an additional ten trains per hour at peak times, and six more on off peak times, and West Ealing station would have another four trains per hour. Plans were developed to rebuild both stations. Work began in 2009 and the route was planned to be completed by 2019, arriving at Ealing Broadway in 2016.

There were other proposals to increase capacity on Ealing's roads. A proposal was first mooted in 1973 to widen the North Circular Road, which ran through Ealing Common and northwards to Hanger Hill. This was a busy through road, but was only single carriageway and with the increasing volume of road transport, its expansion was seen as logical. The difficulty was that this would entail losing parts of the common, that valuable green lung managed by the council since the nineteenth century. The suggestion that the road could be routed through a tunnel under the common (suggested by the council in 1994/95) was deemed far too expensive. The scheme resurfaced in 1983 and was brought to a conclusion

during a major public inquiry in 1990. This led to the preservation of the status quo and the saving of the common.

Bus travel was still an important mode of transport, but as a means of going to work, only about 8 per cent used buses (2756). In 1970, there were nine major bus routes passing through Ealing, with the majority terminating by Ealing Broadway station. Bus routes included the 65 to Kingston, the 207 along the Uxbridge Road, the 83 and 112 to north London, the 273 to Ruislip and the E2 to Brentford. The latter, and the other two E bus routes, were flat rate fares, but the numbered ones were graduated depending on length of journey. Three decades later all bus journeys were paid by a flat fare.

Car ownership has continued to rise. In 1971, out of 29,588 households, 2,629 (9 per cent) had two or more cars and 11,415 (39 per cent) had one. There was a modest increase in the ensuing decade. In 1981, out of the 26,982 households, 4,310 (16 per cent) had two or more cars and 11,796 (44 per cent) had one. In 1991, 13,217 households did not own a car (41 per cent), compared to 40 per cent in 1981, indicating that car ownership in the 1980s had been relatively stable. In 2001, there were 16,102 households with one car and 7,519 with two or more, indicating a significant increase, and only 10,197 without (30 per cent). Figures for 2011 give 10,381 (36 per cent) no car households, 13,240 (46 per cent) single-car households and 5,304 (18 per cent) with multiple cars. This fall in car ownership could be due to the economic downturn and/or a preference for public transport.

Greater car ownership led to increasing difficulties for parking, for both residents and visitors. In the 1960s, a correspondent in the local press had complained that those without garages should not possess cars, but many front gardens are now paved to provide off street parking. For those visiting Ealing Broadway, two major car parks were built – one off Springbridge Road in 1976, and the other incorporated into the new shopping centre in 1984. But this was not enough; supply was limited and demand rising, and on street parking was a serious problem. Starting in 1998 with the streets near Thames Valley University, the council introduced new parking restrictions for many areas requiring residents to purchase permits, and the number of these Controlled Parking Zones has spread, particularly in areas close to railway stations. This has proved controversial. Nevertheless, after rail transport, driving was the most favoured way of getting to work, used by 31 per cent (10,446). Not everyone had a car, of course, and the Revd Saward, probably speaking for other non-drivers, noted in the 1980s, 'We had managed without a car of our own. It wasn't ideal, but living in London, we were able to survive on public transport.'

The vicar's daughter, Jill Saward, wrote in 1990 that 'South Ealing has lots of small ones [shops], but Ealing Broadway has the chain stores and the biggest shopping precinct.' The shops along the Uxbridge Road altered over the decades. In the 1960s, there were, along the Uxbridge Road, various TV and radio rental shops; there were none by 2012. There were no charity or discount shops or beauty/nail bars in the 1960s. In 2012, there were eight of the former in West Ealing and four in central Ealing, and nine of the latter in West Ealing and five in Ealing Broadway.

Some famous businesses from the past have vanished in recent decades. John Sanders, having survived the bombing in the Second World War, was finally rebuilt in 1958 on the same prominent Broadway site, but moved out of Ealing in the 1980s. A new branch of Marks and Spencer took over the refurbished building in 1991. Sayers was taken over by

Bentalls of Kingston, which moved to the new Ealing Broadway shopping centre when it opened in 1984, but sold it to Beales in 2002 (which was sold and a branch of Primark now occupies the site).

Some industries left Ealing, too, such as the Autotype Works, which relocated to Wantage in 1978. Ottway's were taken over by the Hilger and Watts group, but closed in 1968. Yet Wolf Electric Tools expanded in 1976, acquiring extra office space and factory space on an adjoining site and, in 1978, employed 850 people. Meanwhile, a number of firms had offices along the Uxbridge Road, such as Percy Bilton at Bilton House, Transworld Publishers at Century House, Curry's and Consolidated Pneumatic Tools Co.

West Ealing lost other staple shops, such as branches of W. H. Smiths, McDonalds and Woolworths in the 2000s. Department stores such as Rowse's were lost. Yet not all was doom and gloom; in 2001, London's only farmers' market opened each Saturday off the Uxbridge Road in West Ealing, selling produce made less than 100 miles away, which complemented the fruit and vegetable markets that opened on weekdays. A branch of Wilkinson's opened in 2011. Waitrose opened a store in Alexandra Avenue near West Ealing station and Sainsbury's opened a small branch on the Broadway. Elsewhere, in Pitshanger Lane, and to perhaps a lesser extent, Northfield Avenue, the shops held up well, with a fishmongers and an independent book shop (the only one in the borough).

The number of restaurants and takeaways has soared dramatically, reflecting increased affluence, busier lives and a more diverse population. In 1968, there were three restaurants

Rowse's Ltd.

on the Uxbridge Road W13, including one Chinese and one Indian restaurant, and four takeaway establishments. Likewise in central Ealing, there were nine restaurants serving local cuisine, and two takeaways. Nearly five decades later, the number and variety had bloomed. West Ealing had nineteen restaurants (including four Middle Eastern restaurants, four Indian restaurants and two Polish ones, as well as Asian and Mediterranean cuisine) and sixteen takeaway places. Ealing's Broadway's eateries also increased in number, but less dramatically than to the west. It had, in 2012, twenty-five restaurants (including two Indian, five Asian and five European) and three takeaways.

As in earlier decades, Ealing produced some world-class sportspeople. Lillian Board, who had attended schools in Ealing in the 1950s and 1960s, was a champion runner. She completed in the Commonwealth Games in 1966, won a silver medal at the Mexico Olympics in 1968, and two gold medals in the European championships in 1969, before tragically dying in the following year. Although Ealing did not have a football team, in the 1980s, its Ladies Hockey Team was one of the best in the country, winning the National Indoor Championship in 1986, the Outdoor Championship in 1987 and representing England in the European Clubs' Championships in 1988. However, in the 2000s, it merged with the Barnes club, thus beginning a new chapter for the country's oldest Hockey Club. Mike Brearley, the England cricket captain, played some games for the Brentham club where his father was also involved. Ealing Cricket Club has also been remarkably successful at national level in the early twenty-first century.

As elsewhere, the late twentieth century was not kind to cinemas. The Walpole was closed in 1972 and was demolished a decade later (to be replaced by the inevitable office block), though its beautiful façade has survived on a building at the east end of Mattock Lane. The Lido showed Indian films as the Gosai in the 1970s, but closed and after standing derelict, was demolished to make way for low-rise flats in 2006, called the Lido. The Spanish Cinema closed and was used by the Elim Church, now the Evangelical Christian Centre. Finally, the Forum, later an ABC cinema, despite being converted into a three auditoria cinema in the 1970s, was demolished in 2008 and only its listed Egyptian façade remains, covered in scaffolding. At the time of writing, its fate remains unknown. What cinema that exists in Ealing is now reduced to the Classic Cinema Club and there are films shown at St Barnabas' on Pitshanger Lane (also used as a venue for concerts such as those of the Ealing Symphony Orchestra).

The council had a programme of leisure events throughout the year. In 1984, the Ealing Jazz Festival began in Walpole Park. By 2013, it was a four-day event in August. Ealing town hall used to host an annual beer festival, but accommodation was cramped. From 2010, it was held as a three-day event in July in Walpole Park, with live entertainment in the evenings. Other entertainment was incorporated to include opera and classical music. Although the council closed the swimming pool behind the town hall in 1978, it built a new one, The Gurnell Leisure Centre, in the north of Ealing in 1979.

Ealing Arts Council was established in 1965. It represented about sixty-five arts organisations in the borough who voluntarily affiliated themselves to it, and were split into drama, music, visual arts and recreational arts. The council gave these organisations grants from the rates to support their activities, as well as presenting its own borough entertainments programme. This was organised by the council's entertainments manager who provided

Jazz Festival, 1980s.

numerous events, including, in the 1970s, celebrity and variety concerts, choral and dancing occasions and talent competitions. Outdoor concerts and children's shows were put on in Walpole Park.

The Middlesex County Times changed its name in 1974 to *The Ealing Gazette*, and then in 1986 to *The Ealing and Acton Gazette*, but by 2008 its offices moved from the West Ealing to Hounslow and it is part of Trinity Mirror Southern. It has far more pages than ever, though most are taken up by advertising and is now distributed free of charge. There were also a number of other newspapers in Ealing in these decades, but despite being free, they were relatively short lived. They were *The Ealing Leader*, *The Ealing Times* and *The Ealing Midweek Gazette* (1969–81).

Ealing Film Studios, despite everything, remained as a film producing location. It was owned by the BBC until 1992. Episodes of well known TV shows, such as *Dr Who*, were shot here or nearby. As with the studios in Balcon's days, Ealing's streets were inevitably pressed into service for location shooting – from south Ealing for *Rent a Ghost* to the High Street and Broadway for the *Dr Who* story the Autons in 1970, and not forgetting Monty Python sketches in Elers Road and elsewhere.

After the BBC's sale of the site, the studios' future was at first in doubt; many other film studios in Britain had ceased to exist. BBRK Group bought it in 1992, but went into receivership in 1994. It was briefly back in the hands of the BBC, but in 1995, they passed it onto the National Film and TV School. Fragile Films then acquired it in 2000 for £10 million. It has continued to be used by film makers for numerous films in the early twenty first century, including the modern *St Trinians* films, *Shaun of the Dead* and *The Importance of Being Earnest* (the first film made by the studios in decades and partly shot at Pitzhanger Manor). Scenes for popular TV dramas, such as the servants' hall scenes in *Downton Abbey*, were also shot at the Ealing Studios in 2013.

Ealing town hall was proving too small, even in its expanded post-1930 structure, for the additional staff required for the administration of a hugely expanded borough. It was

Ealing Film Studios.

a problem that Charles Jones would have recognised in the 1860s. One solution was the office block known as the town hall annexe, built behind the town hall, and demolished in 2010. So, when a speculative six-storey office block was built in 1983, at the corner of the Uxbridge Road and Longfield Avenue, the council acquired a lease in 1987, and the building was renamed Perceval House (after the former prime minister and Ealing resident). In 2004, the council finally bought it and, in the following year, radically altered the ground floor to create a modernised public contact centre as part of the Response Programme.

There were a number of occasions when Ealing achieved national prominence in the late twentieth and early twenty-first centuries, though not for the right reasons. There was a major railway crash near West Ealing station on 19 December 1973. A train from Paddington to Oxford, travelling at 70 mph, was derailed. Ten people were killed and nearly 100 needed hospital treatment. The accident resulted from a poorly secured battery box cover on the diesel locomotive, which came open and struck the operating rods of the facing points.

Then there was the violent attack that took place at Ealing Vicarage on the lunchtime of 6 March 1986. The vicar, the Revd Michael Saward, his twenty-three-year-old daughter Jill, and her boyfriend David Kerr were at the vicarage on Church Place. Three young men entered the house and attacked the inhabitants. The two men were injured and Jill was assaulted twice. This caused outrage and a great deal of sympathy towards the victims. The police investigation was efficient and the three criminals were arrested and brought before Ealing Magistrates' Court within the week. The case was heard at the Old Bailey on 2 February 1987. The defendants were Robert Horscroft from South Ealing, Martin MacColl and Christopher Byrne, both aged twenty-two and from Acton. The former was given a fourteen-year sentence and the others ten years each. Many, though, including MPs and the police thought these were too lenient.

On the night of Thursday 3 August 2001, not many years after the much lauded Good Friday Agreement, which aimed to end hostilities in Northern Ireland and elsewhere, there was an explosion in central Ealing. It was caused by a bomb in a parked car, damaging property at the corner of the Uxbridge Road and Station Approach. Mercifully, no one was killed (it had been a wet night and so numbers congregating outside the Town House pub as would have been expected on a summer's night were not there). On the following day, according to Dr Oates, who had attempted to get to his workplace, 'I went into work – or tried to – and found much of the town centre cordoned off by the police. Large groups of workers stood just outside it.' The centre of town was closed for days as forensic evidence was being gathered. Six suspects were arrested and five Real IRA terrorists were convicted at the Old Bailey in April 2003 for this and other explosions.

Then, on the evening of Monday 8 August 2011, following rioting and looting in Tottenham two nights previously, similar acts of violent crime took place in Ealing, chiefly at the north end of Ealing Green and around Haven Green, but there was disorder in West Ealing too. Insufficient numbers of police enabled the crowd of mostly young people to take control for some hours before order was restored. Cars were set alight and shops pillaged. Worse still was that a member of the public, Richard Mannington-Bowes, a sixty-eight-year-old, died in a confrontation with Darrell Desuze, a seventeen-year-old from Hounslow, who was later sentenced to eight years for manslaughter in April 2012. Dr Oates' diary noted, 'Some shops had windows damaged and one had been burnt, but most property was unscathed. One can only have utter contempt for these lawless thugs and sympathy for those people whose property has been damaged.' Most businesses closed in the early afternoon of that day, with concern that the rioting might continue, but these fears were unfounded. The shops on Ealing Green and their owners featured heavily in the news coverage.

In the following days, a more positive force was unleashed as concerned residents (many of them young) helped clean up the mess that the rioters had left behind. More problematic was the lot of the shopkeepers, who faced delays with their insurance providers.

There was also a greater awareness of Ealing's past and the need to preserve it as far as possible. Although the Greater Ealing History Society produced its last journal by the end of 1967, there were two active societies for the promotion of the values it stood for. Firstly, there was the Ealing Museum, Art and History Society. This folded in 2002. More durable was the Ealing Civic Society, founded in 1967, whose interest was primarily architectural and environmental and which has done much to help preserve historic buildings and to award architectural prizes to tasteful modern buildings and alterations to existing ones, such as St Mary's church and Christ Church School.

A number of Ealing's buildings were given statutory protection, but surprisingly only two have Grade I listed status, Pitzhanger Manor and its gateway. Many others, including churches, like St Mary's and St Peter's, were given Grade II listing.

Despite the system of listing, and the energies of groups like the Civic Society, some old landmarks have been swept away. These include one of the water troughs on the common, though the other has survived. No. 47 Castlebar Road, once Sir Travers Humphrey's old home, was demolished in 1971. St Helena's Home on Drayton Green was replaced by flats in 2012.

Shops on Haven Green.

Yet some buildings have had a new lease of life by being converted for another purpose. The Feathers pub, rebuilt in 1929, had its name changed to the Town House in 1998 and stood disused a decade later, but in 2013 became a branch of Metrobank.

Pubs have had mixed fortunes in this period. Some were renamed; The Old Hats became unimaginatively named The Lounge Bar (after it had been an Indian restaurant). Others closed, such as The Granville Arms. The Three Pigeons became a restaurant. Many remained, often changing their emphasis; the Ealing Park Hotel becoming a 'gastro-pub'. The Drayton Court Hotel ceased offering accommodation by the 1970s, but more recently decided to revert to its original residential function as well as being a pub.

Several plaques have been put up to famous local people including Frank Richards, Dorothea Chambers, Fred Perry, Lady Noel Byron, Spencer Perceval and John Compton (to give an incomplete list) on buildings associated with them or on the site of such. There have also been a dozen books dealing with Ealing's past. The council played its part by designating a specific local history department among its library service and appointing a qualified archivist; from 2004 there have been a regular annual series of local history talks at the central library. There are also regular sections in the local press and the council's *Around Ealing* magazine devoted to the topic.

Ealing's recent history has been witness to several broader trends, as well as having to deal with a number of grim episodes, again which have not been unknown elsewhere. Perhaps the most important have been the demographic changes that have brought about changes in religion, shopping and cuisine. Immigration, even from outside the British Isles, was not new to Ealing, but its scale has been unprecedented, with approximately a quarter of its

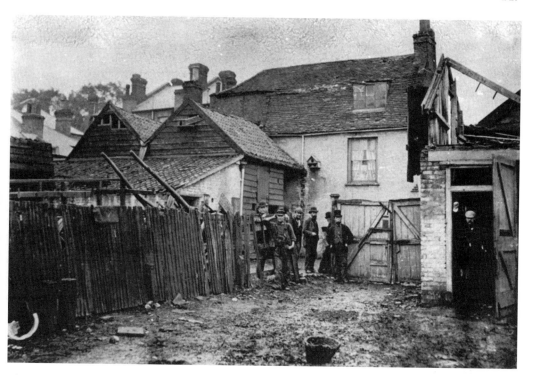

The Old Hat, West Ealing, 1893.

residents in 2011 having arrived in the UK in the preceding decade. Although the Polish arrivals seem to have been most commented on, they are not the only ones. In their wake, new places of worship have been set up, as have shops selling produce aimed at the new arrivals. Meanwhile, the indigenous people have declined in number, and though this is an unstudied aspect of history, it seems safe to estimate that a declining birth rate and a partial exodus are relevant factors.

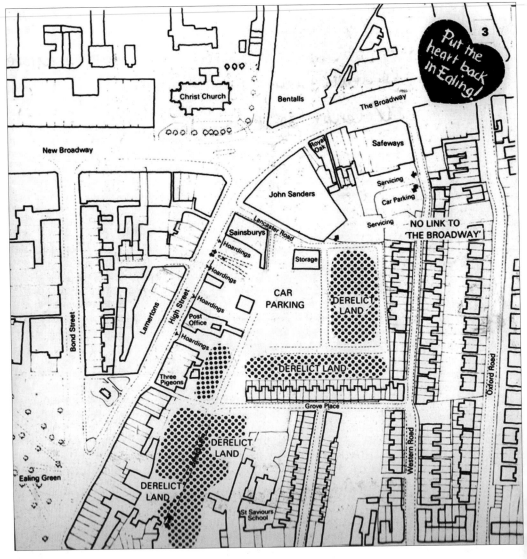

Plan for town centre, 1978.

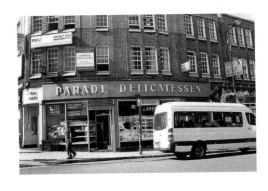

Ealing's famous Polish shop, 2013.

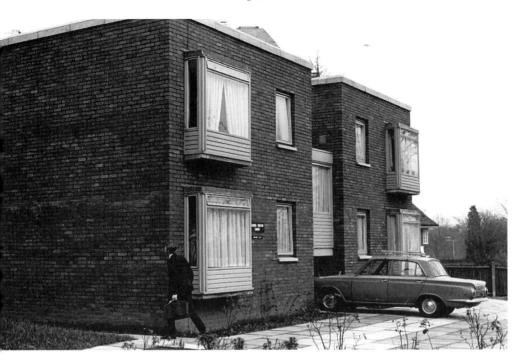

Downhurst flats, 1970.

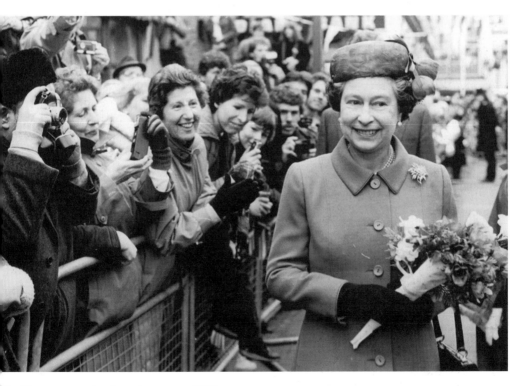

The Queen opens the shopping centre, 1985.

CONCLUSION

Ealing has changed immensely in the past two millennia. The settlers who made up the residents of the scattered hamlets of Gillingas in the seventh century would not recognise the Ealing of the twenty-first century – nor would contemporary residents recognise them. But for most of its recorded history, until at least the end of the Middle Ages, that is what Ealing was – a number of scattered manors with little but geography and the parish church to unite them in any fashion. Ealing was not part of London, but was close by, and London exerted an influence on these settlements even then, by providing a market for its goods and enabling a few of its residents to trade there. Ealing was not an island.

During the sixteenth to the eighteenth century, the parish began to dominate local affairs in a manner that it had not done previously. It levied rates to support the Church, the upkeep of the roads and, most of all, acted to prevent the destitute from being even further in extremis. It was in these centuries that Ealing became more popular as a residence for merchants, gentry, nobility and even royalty. But much remained the same; the economy was mostly agrarian and transport along the main road was cumbersome.

It was the nineteenth century in which the pace of change rapidly accelerated. Spencer Perceval, arriving in Ealing in 1808, would have found the Ealing of 1900 hard to comprehend, whereas he would have found early Tudor Ealing reasonably comprehensible. Population growth was key because that led to an increase in housing and the creation of an infrastructure necessary to cope with these changes. Better transport was also important, especially in the form of the various railway routes, but only because this interconnected with the population rises. From being a rural economy it was now one reliant on commerce and acted as a dormitory town for London and elsewhere.

The twentieth century, or at least 1914, saw most of Ealing, except the much vaunted parks and common land, having been built upon. This was when Ealing was termed, by some, Queen of the Suburb of Brentham, though not all would have felt its apparent delights. It also led to Ealing being physically part of London long before it was administratively so. Ealing's identity was transformed by incorporating a number of neighbouring districts, while retaining its name as the name of the new administrative unit. Ealing's destiny was now intermingled with and influenced by the districts that it was now a part of.

Ealing could hardly be termed Queen of the Suburbs as the twentieth century progressed though the attachment to that term lingers on, especially among outsiders. It is now part of the multicultural, multi-faith Greater London. There are, however, key ingredients that make Ealing unique. There are the film studios, the oldest still in operation in the world. Though

none of its church buildings are ancient (despite St Mary's medieval origins), nor are the schools, perhaps, as renowned as in the days of Dr Nicholas, nor are they to be sneered at and the latter have produced several notable figures in sports, the arts and politics. There is also the fine Pitzhanger Manor, now being overhauled, and the architecturally distinguished early twentieth century 'Garden suburb of Brentham'.

Ealing's identity has changed radically, even in the last century. It can be considered to be the post-1965 London Borough rather than the district within the boundaries of Ealing proper, which only existed as an administrative entity from 1863–1926. Mass immigration has been a force in this development, but so has the expanding nature of London itself in its march westwards. So Ealing today is a more nebulous concept and more culturally, religiously and socially diverse than in Jones' day. Yet its past still exerts an influence on its present and future, with the current developments now taking place at Pitzhanger Manor and the continued film making at the Studios attests. In comparison with some neighbouring districts, Ealing remains an identifiable entity, though, as stated, a vastly changed one.

BIBLIOGRAPHY

Primary Sources

Manuscript

Ealing Rate and Disbursement Books, 1674–1729
Ealing Roll of Honour, 1914–18
Ealing Vestry Minute Books, 1797–1879
Ford, E., Diaries, 1940–47
Goodlet, A.K., Diaries, 1934–40

Published

Allison, K. J., *An Elizabethan Census* (1962)
Ibid and E. D. G. Holt, *Ealing in the Eighteenth and Nineteenth Centuries* (1966)
 The Ambulator (1794)
Brett-James, N., *Middlesex* (1951)
Brewer, J. N., *The Beauties of England and Wales*, Vol, X (1816)
Briggs, M., *Middlesex Old and New* (1934)
The Buckinghamshire Advertiser, 1861–69
Calendars of Middlesex Quarter Sessions, 1547–1709
Calendar of Close Rolls
Calendar of Patent Rolls
Calendars of State Papers Domestic, 1509–1704
Censuses, 1801–11, 1841–1911
Census abstracts, 1921–2011
The County Handbook (Middlesex), (1938).
Ealing Blue Books (1951, 1962)
Ealing Borough Guides (1910–90)
Ealing Corporation Bill (1952)
Ealing Illustrated Magazine (1858–59)
Ealing Parish Magazine (1860–61)
Ealing Roll of Honour, 1939–45

Ealing Year Book (1938)

Findell, H. J., *Rambling Reminiscences* (1961)

Fountain, R., *Diaries, 1849–1850*

Harper, C. W., *Rural Nooks around London* (1906)

Humphreys, C., *Both Sides of the Circle* (1978)

Ipswich Journal, 1729

Kellys's Middlesex and Ealing Directories, 1845–1940

Kemp's Directories, 1950–75

Mee, A. *The King's England: Middlesex* (1939)

The Middlesex County Times (1869, 1880, 1899, 1926)

Saward, J., *Rape: My Story* (1990)

Saward, M., *A Faint Streak of Humility* (1999)

Smith, H., *Perambulation of Ealing in 1760* (*c.* 1970)

The Times (1804, 1820, 1848)

Thorne, J., *Environs of London* (1876)

Tremenheere, H., *Agricultural and Educational Statistics of Middlesex Parishes* (1843)

Walford, E., *Greater London* (1882)

Pigot's Directories (1826–1840)

Secondary Sources (Published and Typescript)

Anon, *Development of Tramways in Ealing, Hanwell and Southall* (1979)

Burford, J. R., *The emergence and development of Secondary Education in Ealing, 1902–1944* (PhD, 1986)

Eborall, C., *Stitch Up in Ealing* (2012)

Faulkner, T., *History and Antiquities of Brentford, Chiswick and Ealing* (1845)

Fitzmaurice, P., and others, *Little Ealing: A Walk Through History* (2003)

Forty, F.J., *Lectures on Ealing* (1938)

Greater Ealing Local History Society Journals (1962–67)

Hankinson, C., *A Political History of Ealing* (1971)

Hounsell, P., *Ealing and Hanwell Past* (1991)

Hounsell, P., *The Ealing Book* (2005)

Huq, R., *On the Edge* (2012)

Jackson, E., *Annals of Ealing* (1898)

Jahn, M., *Suburban Development in Outer West London, 1850–1900* (1982)

Jones, C., *Ealing: From Village to Corporate Town* (1901)

Jones, C., *A Decade of Progress* (1911)

Jones, M. E. R., *Bygone Ealing* (1959)

Kirkman, P., *Ealing: A Study of Suburban Growth* (*c.* 1960)

Knight, L., *Parish Life in Eighteenth Century Ealing* (*c.* 1960)

Lightning, R. H. , *Ealing and The Poor* (1966)

Lysons, D., *Environs of Middlesex* (1795)

McEwen, K., *Ealing Walkabout* (1984)

McVay, M., *Some Notes on the History of Ealing* (1960s)
Neaves, C., *Greater Ealing* (1931)
Oates, J., *Foul Deeds and Suspicious Deaths in Ealing* (2006)
Oates, J. and P. H. Lang, *Ealing through the Ages* (2013)
Oxford Dictionary of National Biography
Pointing, N., *Hanger Hill Garden Suburb* (1987)
Pugh, *A History of Ealing in Elizabethan Times* (n.d.)
Reid, A., *Brentham, 1901–2001* (2000)
Robbins, M., *Middlesex* (1953)
Rousham, A.D., *Evolution of Settlement in Ealing* (1958)
Saint, A., *London Suburbs* (1999)
Scouse, F., *Ealing 1901–1951* (1951)
Stearn, B. D., *Urban Leisure* (1966)
Stolarski, P., *Ealing in the 1960s* (2013)
Taylor, H., *London Trolleybus Routes* (1994)
Upton, D., *Ealing at War* (2005)
Victoria County History of Middlesex Vol. VII (1987)

Electronic

London Borough of Ealing website (www.ealing.gov.uk)